To my good friend and
companion lithographer
hoping the colour section
will be useful.

1940, T E. Griffits

Presented to
Barnett Freedman

THE PLEASURES OF PRINTING

THOMAS GRIFFITS AT VINCENT BROOKS,

DAY & SONS AND THE BAYNARD PRESS

RUTH ARTMONSKY

Published by Artmonsky Arts

Flat 1, 27 Henrietta Street

London WC2E 8NA

Telephone 020 7240 8774

Email ruthartmonsky@yahoo.co.uk

ISBN 978-0-9573875-0-8

Designed by Webb & Webb Design Limited

Printed in England by Empress Litho

My thanks go primarily to my designers Brian Webb and Laurie-Ann Ward, whose enthusiasm for the subject was maintained throughout the project. Most of the material and images came from my own collection. I must thank London Transport archives for their permission to print their posters, and Naomi Games for the reproduction of her father's work. But St. Bride's Print Library staff get the blue riband for their perseverance over a number of days in order to discover one date for me.

The cover design is adapted from The Baynard Press house publication *The Pleasures of Printing No.II*, c1956.

CONTENTS

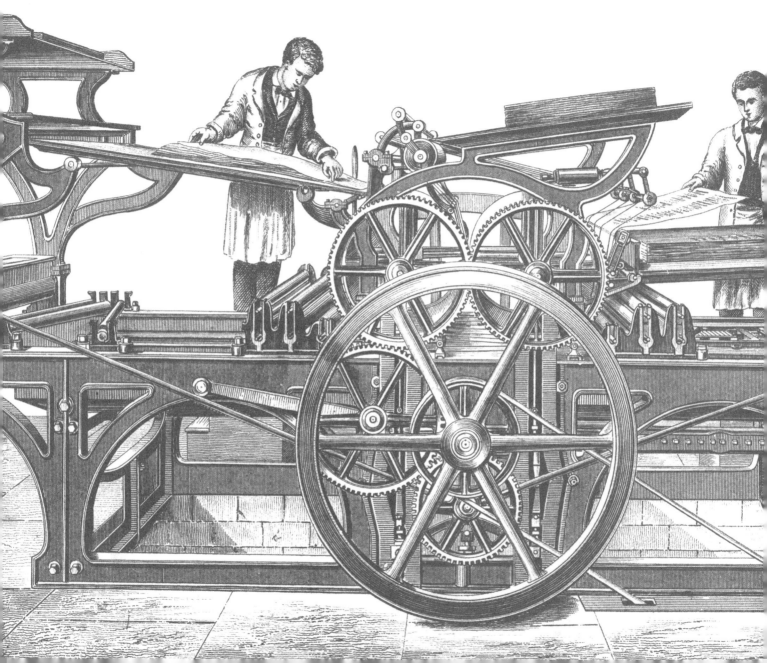

INTRODUCTION

his business of printing: which I am heartily tired of and repent I ever attempted. It is surely a particular hardship that I should not get my Bread in my own country (and it is too late to go abroad) after having acquired the Reputation of excelling in the most useful Art known to Mankind; while everyone who excels as a Player, Fiddler, Dancer etc. not only lives in Affluence but has it in their power to save a Fortune.

JOHN BASKERVILLE (18TH CENTURY BRITISH PRINTER)

In 1910, a paper was presented to the Royal Society of Arts by one of the most distinguished London printers of the time – Vincent Brooks. Amongst other bees in his bonnet he complained about printer anonymity – that a good deal of the output from the presses omitted the printer's name; he felt that this was particularly bad when it came to posters and Christmas cards.

Left, Double cylinder gripper perfecting machine, William Mackenzie, London, late 19th century. There are many varieties of gripper machines; the most popular are the Wharfedale, a single, and the double gripper

Some one hundred years later, when researching for this book and looking for work produced by Vincent Brooks, Day & Son and Sanders Phillips/The Baynard Press, both printers for whom Thomas Griffits, the main subject of this book, worked, I felt a fellow feeling with Vincent Brooks. Talking to book and ephemera dealers it seems nowadays that it is sufficient to know the title of a book and its author, or the subject matter of some piece of ephemera. When asked for the name of a book's publisher or illustrator there seemed to be some resistance to bother turning the pages, and absolute astonishment when the name of the printer was requested. On much printed material one needs good eyesight and a magnifying glass to discern the printer's name, if it is given at all, and not, as Vincent experienced, merely declared as 'printed in England', or wherever.

Yet, well into the twentieth century, when the profession of graphic designer was only in its infancy, it would have been the master printer who, frequently, would have to take the roughest idea of a layout or image and work it up to produce the finished piece. This was particularly so when it came to illustrated work, much of which was produced by lithography.

It is told that an American firm of printers besported T-shirts with the slogan 'Damn you Senefelder', the name associated with the early development of lithography, presumably referring to the difficulties and pitfalls of working with the process, but, just as likely, the trials and tribulations of working with artists and designers who were experimenting with auto-lithography or having their work reproduced by the printers.

Alois Senefelder 'discovered' lithography in the late eighteenth century, and came to London in 1800 to exploit his invention, and to secure a patent for it. His process was taken up by a number of London printers including Day & Son (later to be taken over by Vincent Brooks' firm), who practised it under licence from 1823 onwards.

Thomas Griffits, one of the most illustrious practitioners of the process, said that as a lithographic printer he always found difficulty in explaining to people what lithography was, and much preferred demonstrating it. Here, from Griffits'

Vincent Brooks, Day & Son Ltd advert, 1925

own *The Rudiments of Lithography*, is his attempt to take the reader through the process:

Lithography is a process whereby a drawing is made with liquid lithographic ink or lithographic crayon on stone, though nowadays zinc or aluminium plates are frequently used. The drawn plate or stone is then given a coating of gum etch. This has the effect of making the surface of the plate or stone grease repellent, but it is sensitive to water and does not interfere with the drawn ink portions. Gum etch does not bring the drawn portions into relief: it acts as a desensitizer only. Printing is done by damping the surface of the stone or plate, and passing an inked roller over the stone or plate. Only the greasy portions take up the ink from the roller – the damp portions refuse the ink. A sheet of paper is then laid on the stone or plate and pulled through the press. On lifting the paper the inked portions are found to have adhered to the paper and show as a clear print – proof that under these conditions 'grease and water do not mix.'

This description does not cover the additional challenges of colour lithography – the decision as to which colours to use and in which order, each colour requiring

A REMINDER THAT **THE BAYNARD PRESS** IS STILL DOING DISTINGUISHED PRINTING

RELIANCE 1211
CHRYSSELL RD. LONDON, S W 9

The Baynard Press advertisement, 1942

a separate stone or plate involving the delicate task of exact alignment to produce the required result.

With auto-lithography, the artist draws on the stone or plate directly, without any intervention of a copier or lithographic printer, and the prints resulting can be claimed to be originals. Where the artists are helped by the printer or where the printer takes over the reproduction of a work of art, a considerable rapport between artist and printer is essential.

Paul Nash wrote caustically in the *Penrose Annual* for 1936 of the printer's contribution:

In a mood of pessimism, I once propounded a theory to the director of a vast print selling organization that all colour engravers were colour-blind.

He was complaining that most printers worked by rote, trying to reproduce *exactly* the image they had received, but thereby failing to catch the spirit of the piece, the artist's intent being lost in translation.

Harold Curwen was to put the printer's viewpoint in the *Penrose Annual* (1938):

…it is doubtful whether any large proportion of designers, working specifically for reproduction, have even an approximate idea of the process involved in the carrying out of their designs… for the most part, the designs are

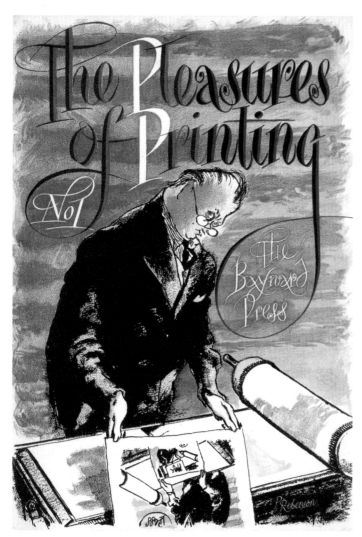

just painted or drawn on a piece of paper… Thereafter, the printer 'gets on with the job'.

Curwen argued that lithography generally, and auto-lithography in particular, brought the artist to grips with the printing process and with workshop practice.

Aldo Crommelynck, who printed some of Picasso's work, defined the most effective relationship between artist and printer:

A good collaboration ensues when a printer understands completely the intention of an artist and proposes the technical means which enable him to express it.

Thomas Griffits was one such printer. Barnett Freedman, one of the greatest exponents of auto-lithography in the twentieth century, who learnt his skills from Griffits, wrote of him:

Mr. Thos. Griffits of the Baynard Press has a just and sympathetic understanding of the artist's aim, and such a profound knowledge of the workings of lithography, that a lithographic copy done by his hand, or under his supervision, invariably retains the vitality of the original work, and indeed in many cases improves and clarifies it.

Griffits referred to his inputs as 'playing about', and certainly all the evidence suggests he found printing fun. This book is dedicated to the handful of printers in Britain today who find pleasure in what they do – who, whilst geared to the latest technology, work with a romantic nostalgia for the Thomas Griffitses of the past, and with a sense of the history of their industry.

Covers from The Baynard Press *The Pleasures of Printing* numbers One (1955), illustrated by P. Roberson, and Two (c1956), illustrated by Leonard Applebee, promoting services and showcasing work

THE PLEASURES
OF *PRINTING*

luc to m e th son le su esti
as transferred artists were er
t free-lance s and weari
 d to e drawing of c
 sented themselves for
 ints and colour streng
 scretion, for he was l
 ght Griffits his trade

VINCENT BROOKS, DAY & SONS LTD

The nineteenth century saw a plethora of printers, publishers and book dealers springing up around Holborn, Covent Garden and Fleet Street. In just one road, Henrietta Street, from the mid-nineteenth to the mid-twentieth centuries there were, at one time or another, Williams and Norgate (publishers of foreign books), Henry Bohn (publisher and book seller), Macmillans (publishers to the Victorian greats – Kingsley, Kipling etc.), Gerard Meynell (the Westminster Press), Curtis Brown (literary agents), Victor Gollancz (left-wing publisher), and Dorling Kindersley (publisher of educational and children's books). The number of printing companies servicing these firms in the area bounded by New Oxford Street and High Holborn to the north and The Strand and Fleet Street to the south was sufficient for the St. Bride Foundation Institute Printing School to be established in 1894 to serve indentured apprentices.

Left, Buxton Braithwaite & Smith's single-cylinder perfecting machine, 1888. The perfecting machine consists of two large cylinders, inner and outer, having intermediate drums between for turning or reversing of the sheet

13

Vincent Brooks, Day & Son Ltd, with whom Thomas Griffits was to serve his apprenticeship and to develop his distinguished career, were typical of many of the printers in the area, moving site with expansion and amalgamations, yet staying within their original territory. The Day part of Vincent Brooks, Day & Son had originally started up at 59 Great Queen Street and then moved just across Kingsway to Lincoln's Inn Fields, at 17 Gate Street. On Day's merging with Vincent Brooks the firm remained in Gate Street until a fire necessitated a move to Parker Street. Vincent Brooks previously had had premises in King Street and Chandos Street (now Chandos Place), in Covent Garden.

Vincent Brooks, Day & Son can be traced back to a small firm of radical printers set up by one, John Brooks, in the early nineteenth century at 421 Oxford Street. Not a great deal is known about the firm but John Brooks moved in literary circles and printed works by Shelley, Lamb and Coleridge. He was politically active, particularly in relation to the Reform Bill extending franchise,

and is thought to have printed pamphlets and leaflets for the cause. Eventually Brooks moved to Jersey, where he became more of a stationer and paper merchant, leaving the London printing business to his son, Vincent.

Vincent Robert Alfred Brooks was born on the 25th October, 1815. He trained as an artist colourman elsewhere before taking over the reins of his father's firm in about 1843, at the age of twenty-eight. Vincent's considerable enthusiasm for colour lithography enabled him to teach classes in the subject at Marlborough House (the origin of the Royal College of Art), and to take prizes for his lithographic work at the Great Exhibition of 1851. Through his interest in colour printing Vincent met up with George Baxter who had developed a complex process, using twenty blocks per image, and although the collaboration did not prove financially successful it exemplifies Vincent's preparedness to experiment beyond traditional methods.

48 Parker Street when the family business moved there finally in 1923

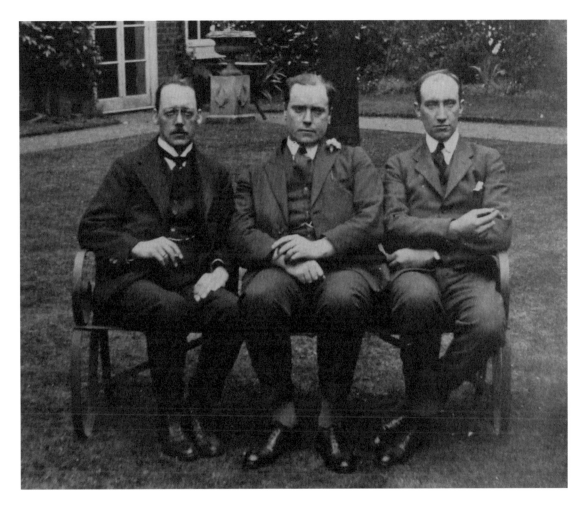

After Frederick's death, control of Vincent Brooks, Day and Son was passed on to Wilfred Vincent Brooks (*centre*), and Frederick Allan Brooks (*right*). Thomas Griffits (possibly) is seated on the left

By 1864 the firm had taken additional premises in High Street, Lambeth, where letterpress and colour block printing was carried out. Not long after this the firm acquired Day & Son Ltd, which had gone into liquidation in 1867. William Day senior was a lithographer operating from the early 1820s, initially 'Lithographer to the King', and subsequently 'Lithographer to Queen Victoria'. William Day died in 1845 and his son, William, carried on the business. Day & Son, like Vincent Brooks, also showed their lithographic work at the Great Exhibition. It is not clear why the company went into decline for it had been one of the foremost lithographic printers of the time, with a reputation as good as, if not better than, Vincent Brooks. Although the two companies had been competitors, the merger was said to have been handled harmoniously by the diplomatic Vincent Brooks.

A key commission for Vincent Brooks, Day & Son was from Gibson Bowles, who launched his magazine *Vanity Fair* in 1868. It may not be quite an accurate comparison to describe *Vanity Fair* as a Victorian *Private Eye*, but it certainly acted as an exposé of the foibles of Victorian 'society' with contents ranging from critiques of cultural events to gossip on the latest scandals; Bowles was to write much of the copy himself. From the very beginning Vincent Brooks, Day & Son printed a full page colour lithograph, of a celebrity of the day, for each issue. Hundreds of these were produced, by different artists, who customarily signed their work with a nickname, as with the Frenchman, Jacques Tissot, who signed Coide. The most prolific of the *Vanity Fair* artists was Leslie Ward, who, most frequently, signed himself Spy. These lithographs are still, now, to be found, framed, in many a city head office or law firm, their subjects all but forgotten. Work for *Vanity Fair* was to become a mainstay for Vincent Brooks, Day & Son, and the magazine, in turn, was to owe much of its popularity to the pioneering lithography of Vincent Brooks. *Vanity Fair* ceased publication in 1914, after forty-five years, throughout which Vincent Brooks, Day & Son had been its main printer of the caricatures, although other companies seem to have been commissioned towards the end of its life.

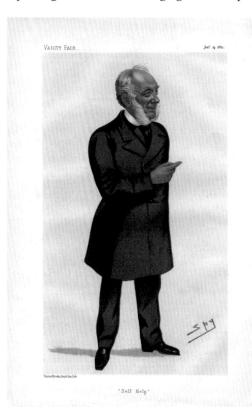

'Self Help' (Samuel Smiles) by Spy, *Vanity Fair*, 1882

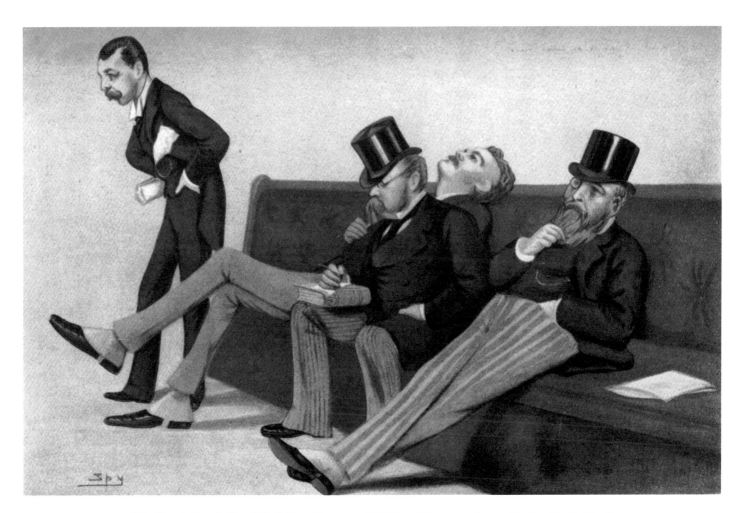

'The Fourth Party'. Churchill, Balfour, Drummond-Wolff and Gorst as caricatured by Spy (Leslie Ward) in *Vanity Fair*, December 1880

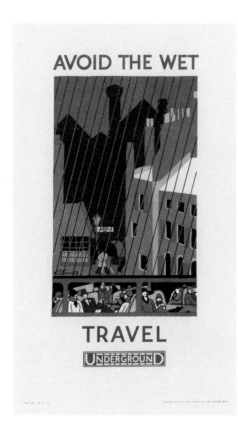 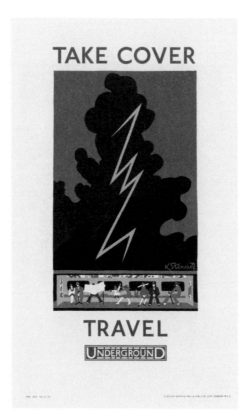 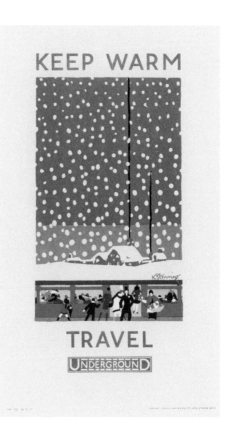

Above, Kathleen Stenning, *Avoid the Wet*, *Take Cover* , and *Keep Warm*, 1925.
Opposite, E. McKnight Kauffer, *Museum of Natural History*, 1923

Vincent's son, Frederick Vincent Brooks (born 21.12.1848) had, de facto, been running the firm some time before his father's death in September 1885. An obituary in *The Times* described Frederick's career:

(he) was the hereditary head of the old lithographic firm of Vincent Brooks, Day & Son Ltd. and a leading authority on all subjects connected with lithography and suncopying, on which matter he wrote articles in the latest edition of the Encyclopaedia Britannica. He was also Chairman of G.W. Bacon & Co. Ltd. map publishers... He was not only a master craftsman but a real artist in his own line, as may be judged generally by the work of the firm (VBD) ever since it won the gold medal at the Great Exhibition...

Frederick died in 1921 and was succeeded by his sons Frederick Allan Brooks and Captain Wilfred Vincent Brooks. It was from this date that Vincent Brooks, Day & Son came into its own as printers of posters, in particular for the railways and the underground.

The Design & Industries Association (DIA) had been launched in 1915. One of its most evangelical founders was William Lethaby who, as Principal of the Central School of Arts and Crafts, was active in bringing design and product together,

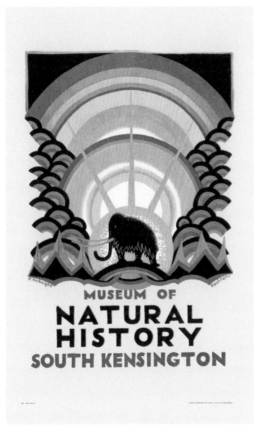

MUSEUM OF
**NATURAL
HISTORY**
SOUTH KENSINGTON

the artist and technician working in partnership. Lethaby was interested in the potential of lithography which, at the time, was being rehabilitated by the Senefelder Club, named after the originator of the technique. Lethaby and Frank Pick, of London Transport, both members of DIA, both intent on good design, turned to the Senefelder Club when it came to the improvement of graphic design, in particular for posters. Spencer Pryse and A.S.Hartrick, both members of the Club and teaching colleagues of Lethaby, were to be to the fore as poster artists from the 1910s through the 1920s. Vincent Brooks, Day & Son had been appointed printers to the Senefelder Club in 1912 and it was, therefore, a natural choice for Pick to use Vincent Brooks, Day & Son as his printers when he started his poster campaigns. Vincent Brooks, Day & Son would print countless London Transport posters during the inter-war years including many by McKnight Kauffer, its most frequently commissioned designer.

Over the same period, but to a lesser extent, Vincent Brooks, Day & Son also printed posters for the various railway companies, especially those produced by Fred Taylor. The railway posters tended to be in a

traditional style – views of rural or coastal scenes – compared to those of London Transport whose posters became increasingly 'modernistic' both in the style of the images and in the typography.

Vincent Brooks, Day & Son's reputation was not only as a leading colour lithographer, but as one that especially encouraged a close collaboration between artist and printer. This was greatly furthered by Thomas Griffits, whose name could well be placed alongside those of Harold Curwen and Fred Phillips (of Sanders Phillips/The Baynard Press), all three printers being members of the elite Double Crown Club dining club, established to promote printing and the graphic arts.

One curiosity which Vincent Brooks, Day & Son printed was a journal that only ran for a short period but is worthy of note because of its owners – Robert Graves and William Nicholson. *The Owl* was one of a multitude of 'little magazines' of the inter-war years, frequently launched with much optimism and flourish, then becoming irregular, and eventually disappearing without trace.

Cover of *The Owl*, William Nicholson, May 1919

The first issue of *The Owl* in 1919 bore an eccentric foreword expressing an intent that seemed to presage its demise:

'All Owls are Satisfactory', Lewis Carrol begins his essay on these birds: we accept the omen gratefully. It must be understood that 'The Owl' has no politics, leads no new movement and is not even the organ of any particular generation – for that matter sixty-seven years separate the oldest and youngest contributors. But we find in common a love of honest work well done, and a distaste for short cuts to popular success. 'The Owl' will come out quarterly or whenever enough material is in the hands of the Editors.

In fact, between 1919 and 1923, there appear to have been only three issues from Graves and Nicholson, the last 'The Winter Owl', but for its short existence the magazine contained poems, essays, playlets and colour illustrations, from such eminent figures of the times as Thomas Hardy, John Masefield, Siegfried Sassoon, W.H.Davies, Max Beerbohm and John Galsworthy; and artwork by the likes of Randolph Caldecott and William Orpen, many of the plates clearly marked Vincent Brooks, Day & Son Ltd.

Fable

The Serpent and her Mother

One day a young Adder was caught by her
Mother in the act of trying on a new bonnet
"where are you going" asked the fond parent
"O nowhere at all" replied the startled
daughter "not even into the garden"

Illustrated pages from *The Owl*, May 1919. *Left*, Pamela Bianco 'Girl's Head'. *Right*, William Nicholson, 'Fable'.
He based *The Owl's* cover image on the decoration of an 18th century slipware bowl

DEPARTMENT OF AGRICULTURE AND TECHNICAL
INSTRUCTION FOR IRELAND.

METROPOLITAN SCHOOL OF ART,

KILDARE STREET, DUBLIN.

Wilfred Vincent Brooks not only ensured high standards in his firm, but was a key player in the training of printers generally, particularly in London. He was a member of the Colour Lithography Committee of the London Master Printers' Association and was Chairman of the Education Committee of the London County Council's School of Photo-Engraving and Lithography in Bolt Street, off Fleet Street (later to morph into the London College of Printing and, nowadays, the London College of Communication). Wilfred was also to serve as an inspector of the London printing schools for the Board of Education.

With such leadership and such a reputation it is not easy to understand why Vincent Brooks, Day & Son went into decline whilst other printers flourished. Although the 1920s seem to have been profitable years for the firm, by the late 1930s finance had become so difficult that the lease of their premises had to be sold in 1939, and a winding up order was made in 1940 – the Directors named, at the time, as Wilfred Vincent Brooks, Mrs. Marjorie Mary Brooks and Douglas Coulson. The Official Receiver was reported as trying to keep the business in operation but as doubting its viability, being too specialized and with outdated plant. This latter could well have been the major contributory cause of Vincent Brooks, Day & Son's demise albeit the Directors would relate it rather to the onset of war; the Parker Street premises were, in fact, demolished in the Blitz. Although it is not clear what happened to the business immediately after the war, there are Double Crown Club menus still being printed in the late 1940s and early 1950s with Vincent Brooks, Day & Son as printers. The record gives 1960 as the date when the Baynard Press took over what remained of Vincent Brooks Day.

Above, Double Crown Club menu, 1948, designed by T.E.Griffits.
Opposite, illustrated page from *The Owl* by (Sir) William Orpen

THOMAS GRIFFITS AT VINCENT BROOKS, DAY & SONS LTD

 homas Griffits was a precocious child – from an early age he seems to have had a clear idea of his likes and dislikes, his strengths and weaknesses and, whilst still a teenager, to have marked out the direction his career should take.

Griffits was born in London on the 25th of March 1883. At school he was totally absorbed by drawing and was reluctant to tackle any other subject but art. At home he had developed more than a cursory interest in the books that he had received for birthdays, Christmases and as prizes, and was particularly interested in how they were constructed and illustrated; he was determined to be involved in the business of making them.

At the time, and indeed well into the twentieth century, printing tended to be a family business: not only did sons follow fathers in the ownership of printing works, but, right down to journeymen, generations proudly and protectively followed each other into the industry; even women, daughters following

Left, Wharfedale single cylinder machine. For half a century, it dominated world markets. It continued to be manufactured right up to modern times

mothers or elder sisters, when it came to binding and some types of 'art' work.

The Griffits family had no connection whatsoever with printing, the father working in a bank. There is mention that Griffits' mother was an amateur artist and that she both supported and furthered his career choice by getting the first door opened for him. Some kind of disaster had occurred, possibly a fire, so that neither parent was averse to his leaving school early and, through a contact of his mother's, Griffits was sent to see a Mr. W. Witham, a partner in a firm of lithographic printers – Henley & Co. – in Wild Court, behind Great Queen Street, Holborn; Witham was the business man and Alfred Henley the technical printer. Initially Griffits was started as a printer's devil:

I was a sort of odd-job boy! I had to fetch the money from the bank on Saturdays, 'take-off' on the machines, help the pressmen, and touch up any work on the machine plates that went wrong in printing.

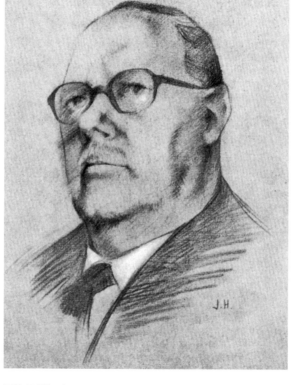

T.E.Griffits from a sketch by Juliet Heseltine, September 1954

Although Griffits appears to have been indentured as an apprentice he does not seem to have had a particularly rigorous training schedule of organized education and 'on-the-job' experience. Henley felt he, himself, could teach Griffits all he needed to know. Griffits doubted this and set about learning things for himself, showing exceptional self-motivation.

Griffits soon found himself transferred to the 'studio', pretentiously so called, for Henley & Co. employed no artists, but merely provided facilities for free-lance artists visiting to work on specific commissions. Griffits would eagerly offer to help, and would, if the artist absented himself, attempt to add to whatever work was in progress, frequently having to be restrained from 'interfering'. Griffits is sometimes described as 'intaught' improving his knowledge and skills through whatever opportunities arose, and, as when a child, he gradually became aware of his strengths and limitations when it came to printing:

Although I could draw, I was not very good at thinking up ideas. What I could do well, however, was to interpret other people's work and get it down on stone.

Griffits' 'apprenticeship' was interrupted, however, by the firm becoming bankrupt. Henley had been experimenting with a basic kind of litho-half-tone process, but was frustrated by finding that it made colour registering more difficult, and Witham could not raise the finances to redress the money lost. The firm closed, the plant was sold, and Griffits, aged sixteen, found himself unemployed.

This time his father came to his aid. Griffits' father had a friend in the City who knew Frederick Vincent Brooks, by then a senior partner in Vincent Brooks, Day & Son at Parker Street. Griffits went for an interview and is said to have taken with him, as an example of his work, a humorous sketch for a pantomime poster for 'The Babes in the Wood' with the 'babes' driving through the wood in a car. Whether because, or in spite, of this, he was allowed to transfer his indentures from Henley & Co. to Vincent Brooks, Day & Son.

TWO COLOURS OVERPRINTED AS SHOWN ON GROUPS 15 to 21.

Del. et Lith. Thomas E. Griffits

An example of overprinting from *Colour Printing*, 1948

Even in this altogether more sophisticated firm Griffits did not appear to go through what, later on, would be recognized as a formal apprenticeship. Brooks, as Henley, seems to have seen the potential in the youngster and to have adopted a monitoring role towards him. Griffits wrote of the relationship:

He often took the line that I was capable of tackling specific jobs when I myself was totally without confidence in my ability to deal with them. But he spurred me on, and I always accepted his challenge, although sometimes my heart was in my mouth.

As at Henley's, Griffits found little help from his journeymen fellow workers who were often secretive about the tricks of the trade they had developed for themselves. Although Griffits found this frustrating, in actuality it increased his self-reliance and his determination to develop his own style of operating.

I never got much help from the journeymen craftsmen there. They were inclined to cover up their work when I tried to see how they worked. One of them once said to me 'Well young Griffits, you don't say much, but you are a perfect devil for looking aren't you?'

One aspect of the traditional use of lithography which irked the young Griffits was the use of colour – what colours to choose and in what order to use them to attain the desired effect. He later described his exceptional understanding of colour as learnt, to a considerable extent, by closely examining flowers and other plants:

You might imagine that a violet, for instance, is violet-coloured. But it isn't – even one petal will have a variety of shades of violet in it.

Griffits' experimentation with colour and colour sequences, at Vincent Brooks, Day & Son, led to his developing his own ideas that he later published in his *The Technique of Colour Printing* (1944).

Griffits' first major project at Vincent Brooks, Day & Son, for the Spy caricatures, exemplified Brooks' confidence in him and provided him with the opportunity to work out some of his ideas. Leslie Ward (Spy) was not the easiest person to work with, inclined, as he was, to tantrums if things did not go his way. For many years his caricatures were reproduced by

Take the Broom, Edward Bawden, 1952

Arthur Duke, but Ward felt he was beginning to receive rather routine treatment from Duke, with rather drab colour work. After one of Ward's outbursts Brooks, in desperation as the firm was so dependent on the *Vanity Fair* commission, turned to Griffits, at the time still only in his early twenties.

For heaven's sake go and see Ward and see what you can do with him. I think in the future you had better draw the Vanity Fair jobs on the stone yourself.

At first Brooks tested Griffits out by getting him to work on only two caricatures at a time (it was usual to do four together). The two were of a celebrity golfer and a general. Griffits remembered this as being something of a challenge in that the colour overlays were to be printed together, with only six colour printings allowed, yet the golfer had a sunburnt face and grey tweeds whilst the general sported a pale pink face and a red uniform. It was this problem that led Griffits to break with tradition by printing the lightest colour last, in this case yellow, as he realized that the

Take the Broom was one of six tales drawn by Edward Bawden for his children, in 1944, and redrawn in 1952

for George Rainbird and Ruari McLean. Printed in an edition of 350 copies

Above and opposite, pages from *The Rime of the Ancient Mariner* by Samuel Taylor Coleridge, 1910.

Letterpress and line illustrations printed by Vincent Brooks, Day and Sons

yellow chrome, being opaque, could be used to modify the other colours as required. Soon Griffits was tackling four caricatures at a time and had established a satisfactory rapport with Ward. One of Griffits' most striking colour effects was for the caricature of the youthful Winston Churchill who, at the time, sported remarkable ginger hair with a rather reddish face.

After some years working almost exclusively on the *Vanity Fair* commission Griffits looked for more varied experience and Brooks appointed him manager of Vincent Brooks, Day & Son's studio in 1906, at the age of twenty-three. There he found himself having to turn his hand to whatever came along and he reported finding some of the most enjoyable work being entertainment posters – for theatres, music halls and, later on, the cinema. For the last Griffits described the buzz of excitement on receiving the roughest of clues from the film distributors as to what the film was about, and, from this scant information, preparing the stones for the latest Mary Pickford film. These posters could frequently only be completed by working overtime over a weekend with the pressure to have them ready for the next week's showings.

Griffits saw all this as great fun, and as providing opportunities to use what he himself rated as his rather modest imagination.

Another rewarding project for Griffits, prior to World War One, was his work with Willy Pogany, the Hungarian illustrator. Pogany spent some time in London before emigrating to America. It was during his London stay that he worked with Griffits to produce what are considered his four masterpieces – Coleridge's *The Rime of the Ancient Mariner* (1910); and Richard Wagner's *Tannhäuser* (1911), *Parsifal* (1912), and *Lohengrin* (1913). All the Wagner books were printed by offset lithography on dark-toned paper. As with 'Spy', Griffits was able to introduce Pogany to novel ways of reproducing his works, in this instance using mechanically grained transfer papers, which made the lithographed chalk sketches look like fine line drawings.

By the start of World War One Griffits had married a German girl, not only of different background but of a very different temperament. His marriage proved very happy and provided him with a warm bolthole from his exacting working life.

Wartime brought a continual flow of work to Vincent Brooks, Day & Son but of a more technical than 'artistic' character, as for example pictorial training aids for pilots. Yet even with such as these Griffits was to use his inquiring, innovative nature to devise speedier production methods to meet wartime pressures, not particularly popular with his more diehard, older employees. Brooks rewarded Griffits' efforts by appointing him Advisory Director and Works Manager. Although this was to take him away from working on the stone, he nevertheless made the time to go back to the 'coal face' when exceptional jobs came in.

The post-World War One period brought Griffits in touch with the Senefelder Club. With Vincent Brooks, Day & Son as the Club's official printer, Griffits' experience of colour printing was especially useful to the Senefelder artists who had mainly worked in monochrome, or at most with a two-tone effect. He was to work with some of the best known artists of the day such as George Clausen, Augustus John, Charles Ricketts, Maurice Greiffenhagen and Edmund Dulac. It is known he contributed to a series of lithographs commissioned by Heals of Tottenham Court Road on the theme 'The Ideals of War' but what is not clear is whether these were, in fact, the same as the Ministry of Information series of similar name for which the printers are usually stated as 'unknown'.

There is an anecdote of an occasion when Griffits was working with Greiffenhagen and Dulac and the former was making heavy weather of using Griffits' 'jumper', his heavy handled knife. Dulac said that the way he himself used the jumper produced the effects he wanted and therefore was the correct way, and Griffits

Above, International Horse Show, by SY, 1938, *opposite,* Clifford Barry *Dairy Show,* 1937

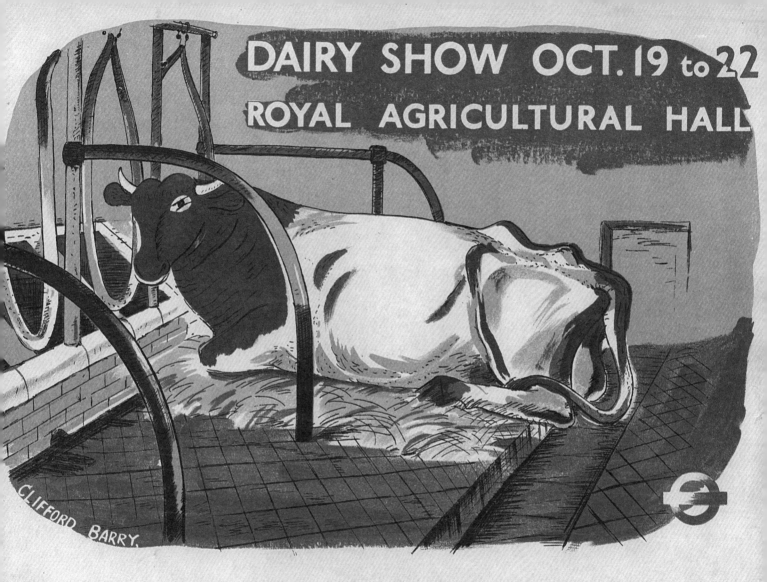

DAIRY SHOW OCT. 19 to 22
ROYAL AGRICULTURAL HALL

CLIFFORD BARRY.

BY UNDERGROUND TO ANGEL or by BUS or TRAM

95.15,000.

VINCENT BROOKS, DAY & SON, LTD. LONDON. W.C. 2

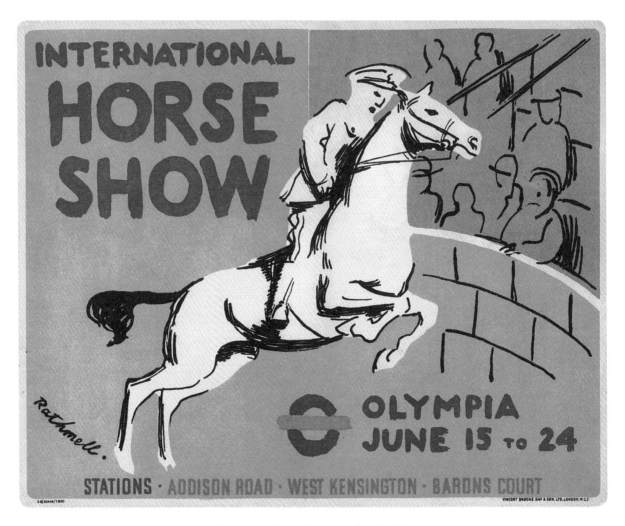

International Horse Show by Rathmell, 1939

was said to have taken this on board, ever ready to learn from others.

In the 1920s Griffits worked with the artist Spencer Pryse on a series of large posters for the Empire Marketing Board (EMB). The EMB had been set up in 1926 to strengthen Britain's relationship with its 'Empire' – to fund colonial development schemes, further scientific research on Empire – produced products, and, generally, to promote the sale of Empire foodstuffs in Britain as well as to boost the sale of home products. Publicity was an essential element in the scheme, with posters as the main medium, along with exhibitions, films, lectures and 'shopping weeks'.

Key figures were appointed to advise the Board including William Crawford, the advertising guru, Frank Pick of London Transport, and an insider, something of a maverick, the 'imaginative civil servant' Stephen Tallents; all three were sponsors of good design and could attract artists to the cause of imperial trade. EMB used a number of different printers for their posters including Waterlow & Son Ltd and Eyre & Spottiswoode Ltd. Vincent Brooks, Day & Son made their contribution working with

British Empire Exhibition poster by Spencer Pryse, 1924

Spencer Pryse, who had specifically asked for them to be used so that he could work with Griffits.

Not only did Pryse want to work on lithographic stones in his Chiswick studio rather than at the printers, but the stones he chose were of an exceptional size and weight so that Vincent Brooks, Day & Son had to devise a special apparatus – an easel with a block and tackle – to facilitate his demands. Griffits would make frequent visits to Chiswick. Pryse made rather rough black sketches and Griffits would use these as guides for the addition of colours. Once Pryse gained confidence in Griffits he gave him a free hand, as Griffits' daughter described it – to have fun with 'shining skies, dresses caught in the wind', and the likes, depicting tea growers or rice planters or whosoever.

Griffits described his relationship with Pryse – the technician and the artist – as ideal:

I drew a good many of these colour separations on those large stones, using the 'free-est' possible treatment. This sort of experience broadened my horizon. Every artist with whom I worked had a different technique, a different aim, and there was a real feeling of adventure in collaborating with each one of them.

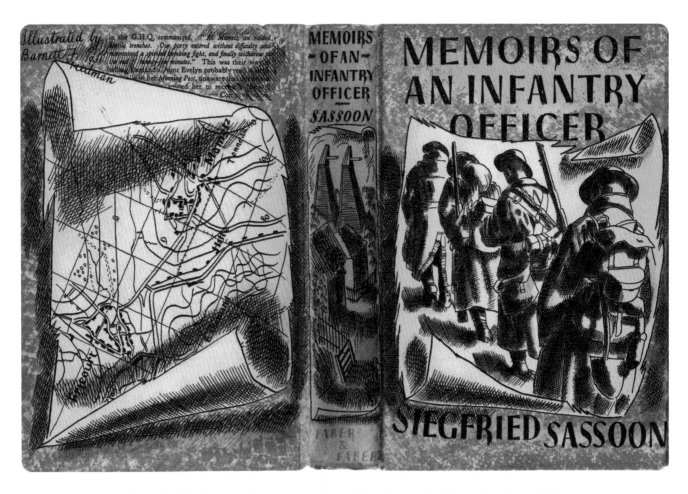

Above, Siegfried Sassoon, *Memoirs of an Infantry Officer,* illustrated by Barnett Freedman, 1931.

Opposite, an invitation to Barnett Freedman from Thomas Griffits to meet for 'an informal celebration'

For Pick, at London Transport, Griffits worked along with a number of artists, but the one he best remembered was Fred Taylor, a prolific poster artist of the time. One anecdote tells of Taylor so trusting Griffits that on one occasion, when he was in a hurry to get away on holiday, he left an uncompleted job for Griffits, saying airily, 'Tommy Griffits can put all my errors and botches right.'

But the artist to whom Griffits became closest was Barnett Freedman. Both Ian Rogerson and Michael Twyman have written enthusiastically of the pair working together on Siegfried Sassoon's *Memoirs of an Infantry Officer* published in 1931. Both authors have stressed the importance of Griffits in the history of twentieth century book design and illustration. Twyman, whilst appreciating that Griffits had no particular merit as an artist, saw him as having an exceptional understanding of colour, and an outstanding skill in interpreting the intentions of others.

Griffits virtually acted as tutor to Freedman in the use of colour auto-lithography, sharing with him many of the eccentric, but effective, techniques that he had developed for himself over the years, such as running a knife over the bristles of a toothbrush charged with lithographic ink so that tiny dots fell randomly on the stone, or placing a minute piece of thin crayon on the tip of a finger for circular movements. And then there was Griffits' 'jumper' which was moved sideways in such a way that it jumped from one point on the stone to another to produce sets of lines. Rogerson lauds Griffits as a 'trade' printer, but one who was so capable of combining his intuitive sense of the artist's aim with his own brilliance as a lithographer as to truly retain the vitality of the original in the final product. Enid Marx, a fellow student and close friend of Freedman's at the Royal College of Art, also wrote of Griffits' influence on Freedman, telling of Griffits' claim that 'he could simulate any medium by lithography, be it oil painting or water colour' by his selection of colours and his use of transparent and opaque colours. It has been suggested that Griffits, being quite a strong

character, would like to take over a job and dictate its outcome, but Freedman was also a spirited character and would hardly have allowed this to happen, and certainly never wrote of Griffits' mentoring in this way. Freedman would work with Griffits after he had moved to the Baynard Press where, amongst other work, Freedman's set of illustrations for Tolstoy's *War & Peace* is now considered one of the best examples of colour lithographic work of the period.

Griffits became increasingly important to Faber & Faber, the publisher of *Memoirs of an Infantry Officer,* who used Griffits for dozens of subsequent books and book jackets, as well as their famous company Christmas cards. Freedman so looked to Griffits as his mentor that when commissioned to design stamps for the Jubilee in 1935, although he worked on the designs at home, he finished his art work at Vincent Brooks, Day & Son. The GPO Film Unit's 'The King's Stamp' not only includes the frontage of the Vincent Brooks, Day & Son printing works, but shows Freedman working on the lithographic stone and taking proofs off the press, helped by an unidentified printer. It is not beyond the bounds of possibility, that Griffits might have been caught on film.

It would appear that it was Freedman who had a hand in Griffits' move to the Baynard Press for there exists in the Freedman archives, at Manchester Metropolitan University, a letter dated 9.5.35 from Fred Phillips of the Press to Freedman:

> *My thanks are also due for your introduction to Mr.Griffits and your opinion of him has already been confirmed in two interviews.*

The same archive possesses a spoof document in the form of an apprentice's indentures, drawn up by Griffits for Barnett Freedman as an invitation card to a celebration at the Café Royal in April 1946. Griffits described Freedman as his most outstanding apprentice.

for Photographic Reduction.
Working Lithograph for Silver Jubilee Stamp Drawings 1935

Above, proof of Silver Jubilee Stamp, 1935. *Opposite,* stills from 'The King's Stamp' film, 1935. Barnett Freedman is seen arriving at Vincent Brooks, Day & Son's, Chryssell Road works and then working on the litho stone

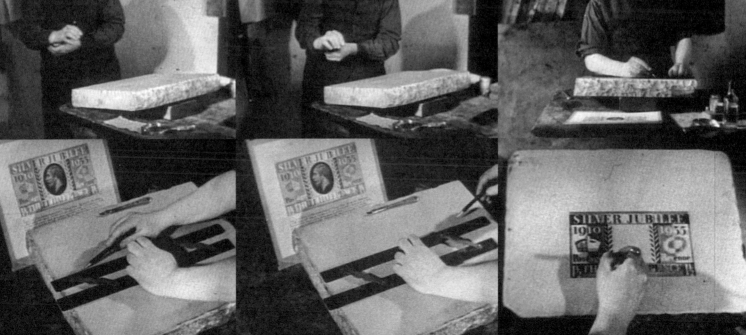

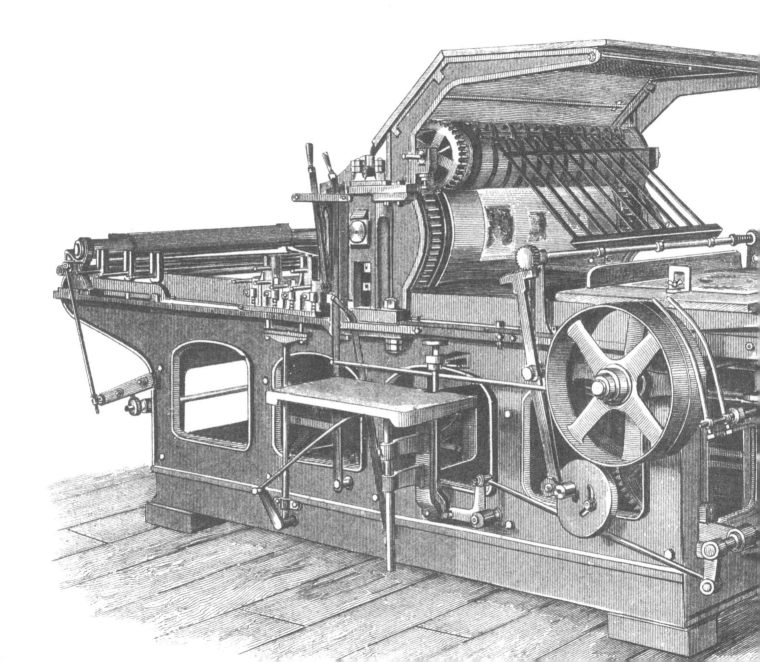

FRED PHILLIPS OF SANDERS PHILLIPS/ THE BAYNARD PRESS

 he Baynard Press (Sanders Phillips & Co.) is a modern printing establishment which has demonstrated triumphantly that good design is good business.

COMMERCIAL ART 1933

Sanders Phillips & Co. Ltd, more commonly known as the Baynard Press, was founded by Frederick Sanders Phillips in 1894. Sanders Phillips, although receiving a sound education at Dulwich College, found himself a teenager, adrift, with no particular bent and no career in mind. After leaving school he spent some years in France, working as a clerk in a firm of coal importers in Marseilles and later in unspecified jobs in Paris. He only really found his feet when, on returning to England, he met up with an old school friend, John Farquharson Roberts.

Roberts was already established as a master-printer operating as a one-man band in two rooms in Higgins Lane in the City. Sanders Phillips' father was prepared to invest money in Roberts'

Left, Wharfedale single cylinder machine top feeder

business in order for his son to join, which he did in 1880. Working together the business grew and they were soon able to take bigger premises, a three-storied building in Upper Thames Street. There they introduced steam presses and, in addition, set up a small lithographic plant in Hatcham, near New Cross Gate.

Although the two men worked together for some fourteen years, Roberts proved a difficult partner and they separated in 1894. Roberts held on to the lithographic side of the business, and this eventually became the British Colour Printing Company. Sanders Phillips remained in Upper Thames Street, his part of the partnership becoming Sanders Phillips & Co. Ltd, nowadays better known as the Baynard Press. The name Baynard is said to have been adopted because the Baynard Castle (built by Ralph de Baynard, a Norman coming over with the Conquest) had existed at a nearby site in Upper Thames Street. By the last decade of the nineteenth century the firm employed four compositors, four wharfedale machine minders, and a couple of warehouse men, and its business was largely made up of stationery for the City – invoices, forms, leaflets and the like.

Fred P. Phillips, chairman of the Baynard Press

Frederick's son, Fred P. Phillips, joined his father in 1896, at the age of seventeen. Fred, as he became known (perhaps to distinguish him from his father, perhaps reflecting his more relaxed personality), received 'on-the-job training' with periods in both the composing and the machine rooms as well as spending about a year with Flint & Co, bookbinders with whom Sanders Phillips was associated. His father, determined to build Fred into a sound all-round manager, also sent him out on the road as a representative.

Fred, on his rounds, was wont to drop into local second-hand bookshops, and it was not long before he was hooked as a 'bibliomaniac', building up his own collection, and thereby his knowledge, of fine book printing. All of this began to make him frustrated with the relatively simple commercial jobs the firm was handling. His own attempts at 'designing' layouts were

not well received by his father's workmen, being conceived as 'new-fangled' if not 'barmy'.

By his enthusiasm for fine printing and by his persistence Fred began to win over not only the firm's employees but its clients. The bulk of jobbing printers of the time would probably have been largely unaware of the burgeoning 'private' press movement where the look of a book mattered at least as much, if not more, than its contents.

Fred would work all hours to provide typographical layouts for the compositors, who had not been used to working from layouts at all, let alone from those of someone who had not been formally indentured. Sanders Phillips had been using the extravagantly ornate type of the time, but Fred, on becoming a Director in 1903, was allowed to rationalize the firm's type, scrapping the majority and introducing the clean, simple shapes of Caslon Old Face and other types similarly 'fit for purpose'.

Frederick Sanders Phillips gradually began to slow down and give Fred a free hand, guided by R.B.Simnett (whose son C.R.Simnett was later to become Managing Director of

The firm's Upper Thames Street billhead printed c1890 in the then fashionable 'aesthetic' style

Baynard). Simnett senior had worked with Frederick from the old Farquharson Roberts days, and was now the Company Secretary.

It was about this time that Fred met Joseph Thorp, who was working for W.H.Smith. Thorp was a major player in the printing industry and was to write one of the first books attempting to introduce the layman to the skills of printing – *Printing for Business*. Thorp not only got Sanders Phillips work from W.H.Smith, but introduced Fred to Fred Taylor, the poster artist, with whom the Baynard Press would work. Fred, as Vincent Brooks, also came under Lethaby's influence, which was to further Fred's interest in the 'design' aspects of printing. Fred became associated with Lethaby in the founding of DIA and this brought him in touch with such DIA members as Harold Stabler and Frank Short. Later Fred was to serve on the DIA Council, which he recalled with some humour:

When we met, people used to bring with them small objects as illustrations and table them for discussion. The talk was lively, and generally the people present did not give very clear reason for either their likes or dislikes. So I had a little slip printed with the single word 'Why?'

and I would throw it across the table to a man and get him to scribble down his reason. It was all great fun.

When Frederick senior died in 1914, Fred became Chairman and Managing Director of the firm, alongside R.B.Simnett, who attended to the financial and administrative side of the business.

By attracting investors Sanders Phillips was able, in 1919, to move to a new plant of some 20,000 square feet in Chryssell Road, near the Oval Cricket Ground. Within eight years the firm so expanded as to take over a further 30,000 square feet in adjoining premises. With the firm running successfully on 'bread and butter' work, Fred could turn his attention to his own more artistic interests.

For these he needed suitable craftsmen and he arranged for his composing room apprentices to spend two years of their indentures attending classes at the Central School of Arts and Crafts, the creation of his mentor Lethaby. One example of the enthusiasm this aroused in the young trainees was with H.A.W.R. Thomas, who not only became an outstanding typographer but remained loyally

Above, advertisement by Graham Sutherland and *opposite,* litho insert by Barnett Freedman from *Signature,* 1935

with the firm until his death in 1950. It became normal practice to groom the firm's 'design' typographers from the composing room as 'hands-on' experience was considered essential to 'ground' new ideas.

It was during the 1920s that Fred would build the firm's reputation for fine lithographic printing and its imprint – 'The Baynard Press' – became aligned to the likes of the Shakespeare Head Press, the Pelican Press and the Curwen Press. Fred was one of the founders of the Double Crown Club, of which Vincent Brooks was also a member. From the start there were no more than half a dozen printer members – Harold Curwen, Walter Lewis (Cambridge), Gerard Meynell (The Westminster Press), Bernard Newdigate, H.V.Strong (Henderson & Spalding Ltd) and Herbert Simon (brother of Oliver and also at the Curwen Press). Fred became a close friend of Harold Curwen although their printing interests were to diverge.

Fred is said to have had something of a coup by appointing F.C.Herrick as the firm's head of its design studio. Herrick became well known as he had designed the 'Lion' device for the 1924 British Empire

BAYNARD

PRESS

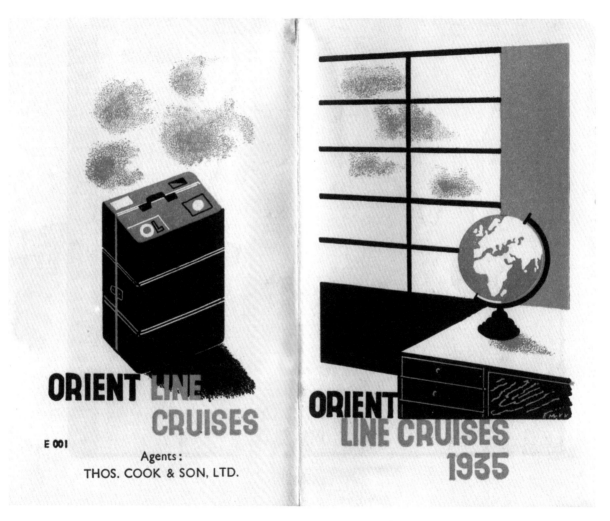

E.McKnight Kauffer, *Orient Line* leaflet design, 1935

Exhibition. He designed a Baynard Alphabet which served as a standard for lettering throughout the Exhibition. Fred found himself increasingly at ease with artists and able to persuade his customers to use good design, and to pay for it; and by buying the plant and the goodwill of Lochend Printing Co. he further built up Baynard's lithographic work. Fred was later to commission further alphabets for his press from Barnett Freedman and from his wife, Claudia, in 1935.

One of Sanders Phillips' major clients was the Orient Line, for whom the firm printed from as early as 1904, and were to continue to do so through to the 1950s. One of young Fred Phillips' earliest jobs was to carry down to Portsmouth two copies of the Orient-Pacific Guide – a tome of some 456 pages of letter-press with a cloth case – to present them personally to the Duke and Duchess of York who were travelling on the Line's *Ophir* to Australia. Throughout the inter-war years the company printed for the Orient line, influencing it to move from its preference for flamboyant Victorian type to Old Style, to Monotype Garamond, and then to Gill Sans. Fred's 'fitness for purpose' approach to printing particularly

Abram Games, *Orient Line* poster, 1956

chimed in with the ideas of the young Colin Anderson, who had taken charge of the Orient Line's design from the mid-30s. The firm was to print much of the Line's ephemera – posters, advertisements, brochures, ships' menus and the like – for Anderson's innovative projects for the exciting new ships, from the *Orion* onwards. One of the designers used by Colin Anderson was E.McKnight Kauffer. Although, in his biography of McKnight Kauffer, Mark Haworth-Booth says that Kauffer was 'probably' working with Griffits on his *Orion* commissions, Kauffer's quote '…I have used all kinds of instruments common to most contemporary painters, such as tooth brushes, cheese cloth, wire netting etc. – in fact anything to suggest interesting textures' is more than suggestive of Griffits' influence.

And as with Vincent Brooks, Day & Son, Sanders Phillips/The Baynard Press (sometimes under one name, sometimes the other, sometimes both) was to print a large number of posters for London Transport. It was Fred Taylor who introduced Fred Phillips to Frank Pick and, as a result, the firm worked on London Transport posters for nearly fifty years. A good

number of these posters, in the 1920s and 1930s, were designed by Frederick (F.C.) Herrick in the Baynard Press studio. Fred Phillips and Pick became close friends, not only discussing commissions with each other but visiting galleries together to share their views on art. Fred became a Governor of the Central School of Arts & Crafts, and, for some ten years, was a Governor of the Royal College of Art; this must have been an exceptional appointment for a printer, recognition of his contribution to the 'art' of printing.

Sanders Phillips/The Baynard Press also provided a lot of print work for the railways, estimated to have been over seven hundred items in all, such as posters, notices, leaflets, booklets etc. These were mainly done for Southern Railway (Southern Region as it became under British Rail), many designed by Charles Shepherd (Shep). Shep had worked with the stained-glass artist Paul Woodroffe in Chipping Campden, but after World War One he joined The Baynard Press, working at first as assistant to Herrick, and then, in 1926,

★ NORTH AFRICA MEDITERRANEAN ★
★ CANADA INDIA BURMA JAVA ★
★ THE ATLANTIC AUSTRALIA ★

GREECE NORWAY HOLLAND AMERICA OF STATES UNITED THAILAND SOMALILAND AFRICA SOUTH SUMATRA BELGIUM FRANCE

MALTA SICILY ITALY MALAYA SINGAPORE BRITAIN ICELAND DENMARK THE PACIFIC CEYLON GIBRALTAR PALESTINE GERMANY

NEWS FROM BAYNARD
FINAL VICTORY EDITION

NUMBER 51
CHRISTMAS 1945

★ RUSSIA MIDDLE EAST CHINA ★
★ MADAGASCAR ARCTIC CONVOYS ★
★ EGYPT EAST AFRICA WEST AFRICA ★

Newsletter sent to staff in the forces around the world

he, himself, became head of the studio. Shep was to produce three or four posters a year for Southern Railway. Into the 1950s Baynard's was still printing railway posters produced by such artists as Abram Games, Clive Gardiner, John Minton and the 'supremo' of railway artists, Terence Cuneo.

By 1936 the Baynard Press had some eighteen departments, including a 'literary' one supplying copy, a photographic studio, a typographical department and a studio, and was frequently being reviewed in the design and advertising press in glowing terms.

In World War Two the firm produced a regular newssheet 'News from Baynard' to keep employees, now in the services, in touch with each other and with what was going on in the firm. In an early edition Fred wrote of the newssheet:

The child is getting quite a big boy and, like most grandfathers, I am inordinately proud of him. He is a cheerful looking chap (typographically) don't you think… You friends are seeing the world, and we old 'uns would love to hear what you think about it.

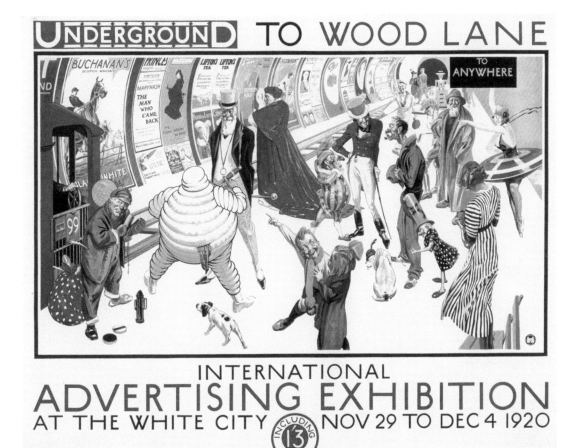

The Kodak Girl, Johnnie Walker, Mr Punch, Bibendum, Nipper the HMV dog, the Skipper Sardine's fisherman, the (Grate Polish) Cardinal, Pears Tramp and other well known advertising characters of the time, on the way to the *International Advertising Exhibition* in F.C.Herrick's poster for London Transport, 1920. Baynard included their own Castle, bottom right

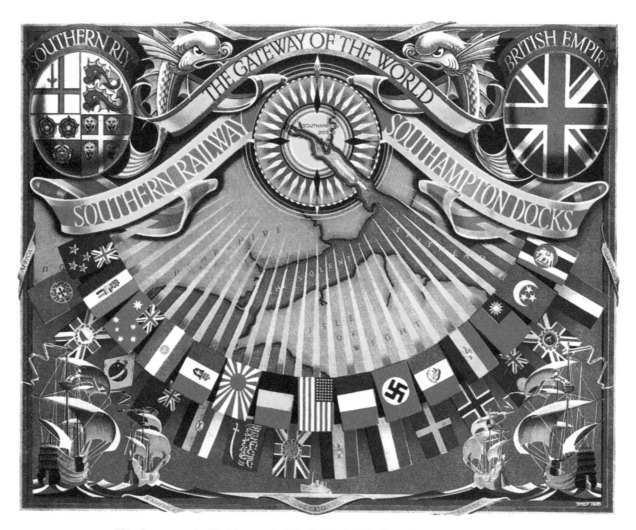

'The Gateway to the World' poster by 'Shep' (Charles Shepherd) from *Art & Industry*, 1937

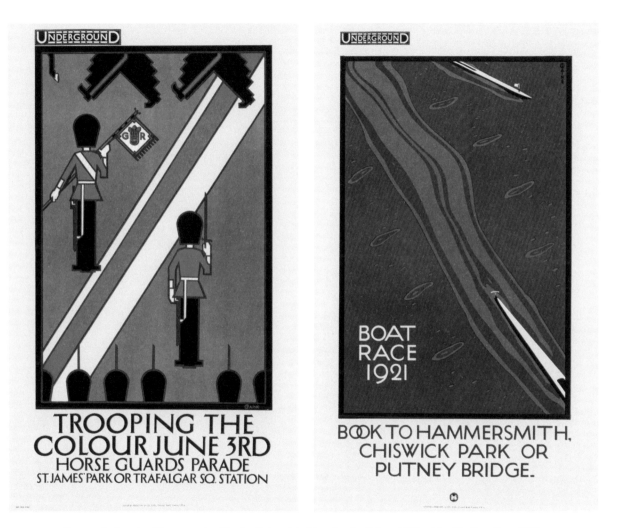

Posters for London Transport by Charles Paine: *left*, *Trooping the Colour*, 1922, *right*, *The Boat Race*, 1921

The newssheet was printed throughout the war with dozens of reports from the Press's employees, then scattered across the world. The news was largely from the outer world in, but occasional snippets were provided of what was happening at Chryssell Road, this one hinting at some of the economies having to be made:

More 6pt is now used at Baynard in a week than was formerly used in three months, whilst the content of the 12pt cases – which are so much more easily handled – gradually acquire that layer of dust which turns one's thoughts to gardening more than type-setting.

During World War Two, and immediately after, the Press, amongst its bookwork, produced some of the most charmingly lithographed children's books. Enid Marx's books, on wartime activities, albeit restricted by rationing in ink and paper, are a delight, as are the books illustrated by Jack Townend

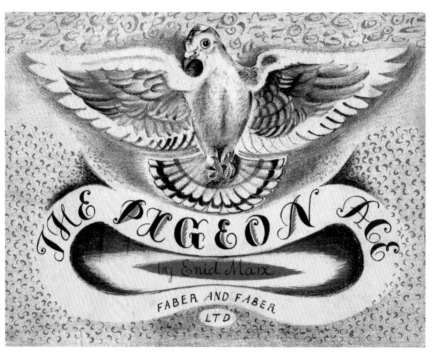

The Pigeon Ace, story and illustrations by Enid Marx, 1944

and Leslie Wood; all now rare collectors' items. Of his work with Baynard Leslie Wood declared that 'it was not the good fortune of every artist to receive from the printers the enthusiasm shown by Mr.Griffits', and the 'boundless and lovely effects that could be achieved by overprinting colours lithographically'. Griffits, himself, wrote of the concern taken with the colour for Wood's illustrations to the *Little Red Engine*:

The colours printed were the usual tricolor inks, but they each had about 2 percent of their complementaries added i.e. violet added to yellow, emerald green added to red, and orange to the blue. This produced an atmospheric hue to the designs and made them good reproductions of the sketches, which were painted in water-colours of pastel shades. A great variety of light tints of each colour with quite a good density of the dark colours were obtained.

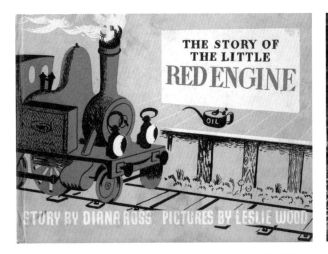

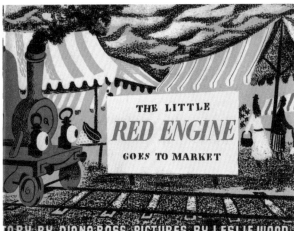

Two of the Diana Ross *Little Red Engine* stories illustrated by Leslie Wood, 1945 and 1946.

Overleaf, double page spread from *The Little Red Engine Goes to Market*

Although the majority of the Puffin Picture Books for children, published by Penguin from 1940 onwards, were printed by W.S.Cowell and others, the Baynard Press printed seven between 1942 and 1947. For some of these the Press did the entire lithography, but for others they printed from the artists' drawings on plate as with Phyllis Ginger's *Alexander the Circus Pony* and S.R. Badmin's *Village and Town*. This last proved to be one of the most popular of the series, remaining in print for more than ten years and running to many printings. Noel Carrington, the Editor for the Puffin Picture Books, wrote of it as 'the most ambitious and beautifully printed Puffin to date'.

By the 1940s Fred had begun to wind down, but was still making regular visits to Chryssell Road into the 1950s when he was in his 70s and still Chairman of the company. He died in March 1965. C.R.Simnett died May 13th 1974 and the Baynard Press closed its doors the day after. One of the Baynard Press's declared statements of intent, over the years, had been:

To use the designs of modern artists appropriately and fine type intelligently. To put beauty of simplicity into every printed thing.

This was to be Fred's legacy to the printing industry and Thomas Griffits was to be his ally in this.

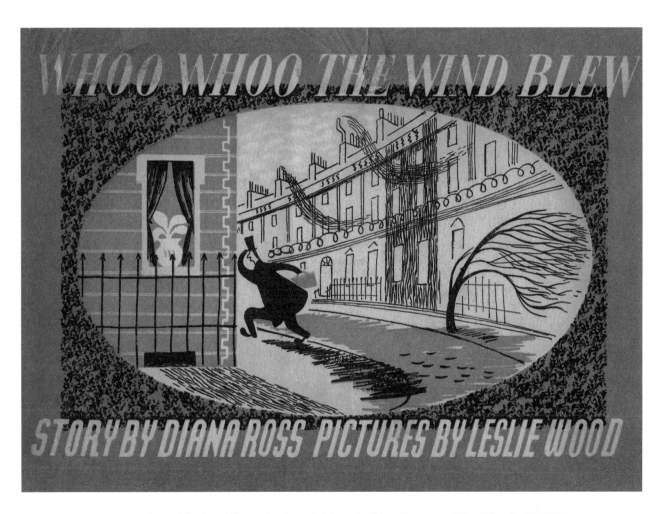

Cover (*above*) and illustration (*opposite*) from the Diana Ross story *Whoo Whoo the Wind Blew*
illustrated by Leslie Wood, 1946

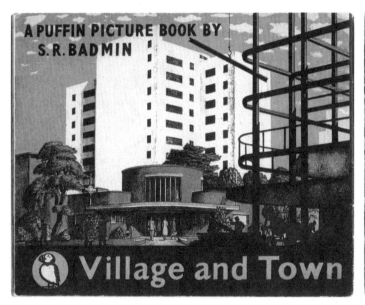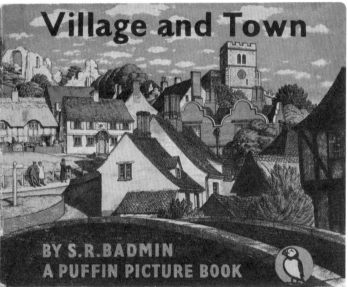

Front and back covers (*above*) and spreads (*opposite*) from the
Puffin Picture Book *Village and Town*, no.16, written and illustrated by S.R. Badmin

THE VILLAGE CHURCH

Here is a simple church building that you might find in any English village. It was built just as well as the local craftsmen knew how. This church has thick walls, solid buttresses and small windows in order to support the thrusts of the roof. When better methods of building were discovered, windows could be built much larger. Some village churches are much grander than this, almost like cathedrals.

The tombstones round the village tell the history of the village families. You will find the same names over and over again. Inside the church are monuments and brass plates to the squires of the district. The church tower was for the bells to ring for church services or for alarms.

Bell Tower Porch Side Aisle Nave Chancel 8

THE CATHEDRAL

9

Cathedrals were generally special churches built by the monks as part of great monasteries. They soar above all the surrounding buildings. With their buttresses and flying buttresses, all taking their share of the outward thrusts of walls and roof, they are, if you think of it, magnificent feats of engineering—engineering in stone. Their builders were very daring men. Sometimes they were too daring and towers or roofs fell down. But the best stand till to-day.

A TIMBER, PLASTER AND THATCH VILLAGE

The close and the more decorative timbering of the 15th century can be compared with the more open work of later years. The church spire is covered with wooden 'shingles'. Decorated thatching and plaster work can be seen. There is also a flint wall with brick edging, while the thatched wall is made of earth coated with plaster.

A BRICK AND TILE VILLAGE

This shows a 16th century timber framing filled with brick 'nogging'; a tile-hung house; weather boarding; and the simplicity of an 18th century 'stucco' covered house. At the top of the street is a low-fronted shop of the same period, and beyond a 17th century house in the new style.

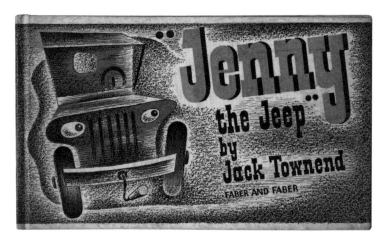

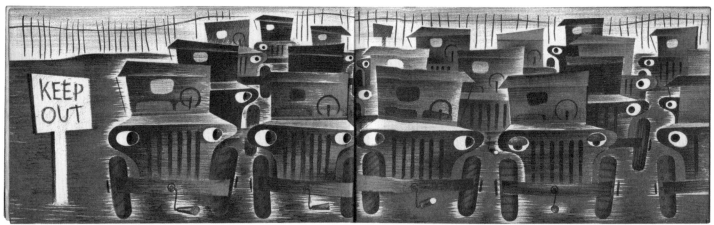

Jenny the Jeep, written and illustrated by Jack Townend, published by Faber & Faber, 1944

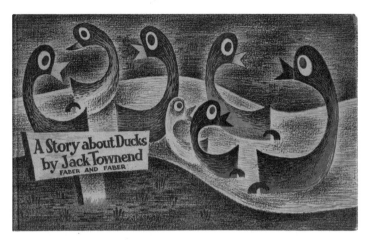

A Story about Ducks written and illustrated by Jack Townend, published by Faber & Faber, 1945

The Clothes We Wear

Cover and pages by Jack Townend for Puffin, no. 64, *The Clothes We Wear*, 1947

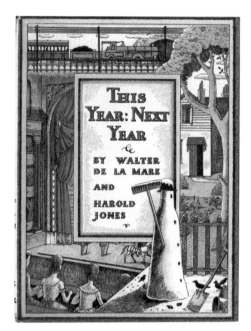

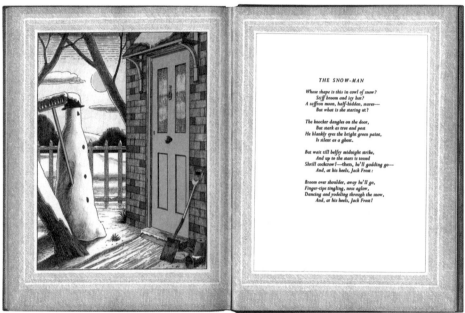

THE SNOW-MAN

Whose shape is this in cowl of snow?
 Stiff broom and icy hat?
A saffron moon, half-hidden, stares—
 But what is she staring at?

The knocker dangles on the door,
 But stark as tree and post
He blankly eyes the bright green paint,
 Is silent as a ghost.

But wait till belfry midnight strike,
 And up to the stars is tossed
Shrill cockcrow!—then, he'll gadding go—
 And, at his heels, Jack Frost:

Broom over shoulder, away he'll go,
 Finger-tips tingling, nose aglow,
Dancing and yodeling through the snow,
 And, at his heels, Jack Frost!

Above, This Year: Next Year, verses by Walter de la Mare and illustrations by Harold Jones,
published by Faber & Faber, 1937. *Opposite,* booklets for Guinness, *What will they think of next?*
illustrated by Antony Groves-Raines, 1954, and *Untopical Songs,* illustrated by Ronald Ferns, 1953

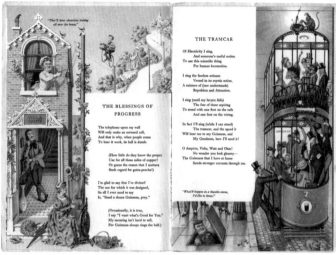

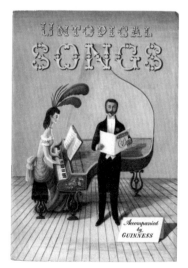

TO YOUNG WEAVERS

TO YOUNG WEAVERS

IT is indeed a compliment to receive an invitation to speak on Textiles in Lancashire, and I must first of all thank your Committee for inviting one from the North into this atmosphere of young weavers. I am sorry to say it is now difficult to find such gatherings in Scotland. In former days, as you know, Glasgow and Paisley were weaving centres second to none in the world, but a generation or two ago young men seemed to forsake weaving as a vocation, with the result that a great deal of the special work formerly done there gravitated to Lancashire.

I have an idea that many young folks did not look upon weaving as an important enough industry, and were attracted by newer industries more talked of, such as ship-building, engineering, electrical work and the like. So in case there should

To Young Weavers, a promotional leaflet published by Morton Sundour
with illustrations by Charles Paine, 1927

66

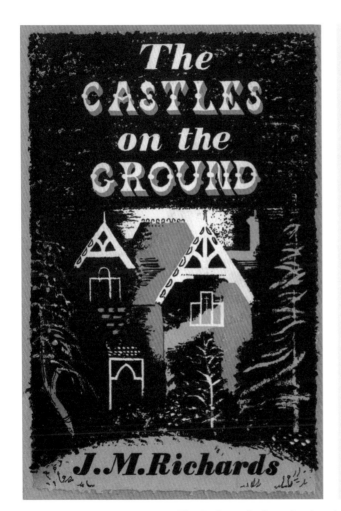 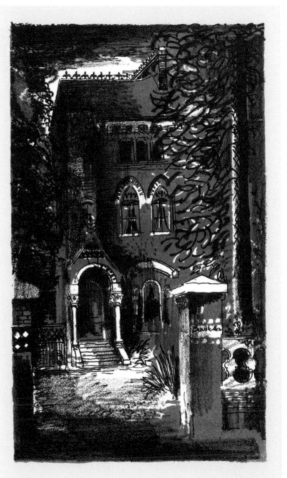

The Castles on the Ground, written by J.M.Richards, illustrated by John Piper,
published by The Architectual Press, 1945

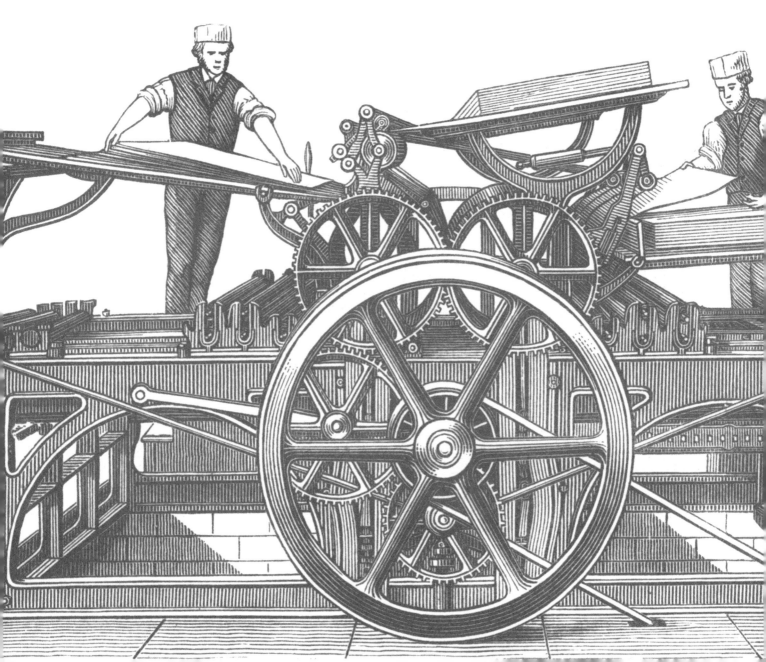

THOMAS GRIFFITS AT SANDERS PHILLIPS/ THE BAYNARD PRESS

r. Thos. Griffits of the Baynard Press, has a just and sympathetic understanding of the artist's aim, and such a profound knowledge of the workings of Lithography, that a lithographic copy done by his hand, or under his supervision, invariably retains the vitality of the original work, and indeed in many cases improves and clarifies it.

BARNETT FREEDMAN, *SIGNATURE*, MARCH 1936

Although one can appreciate why the Baynard Press might have wanted to take on Griffits, by the 1930s considered one of the most outstanding lithographic printers of the time, it is not so obvious why he would have wanted to leave Vincent Brooks, Day & Son, a firm to whom he owed a considerable loyalty for the training and opportunities it had given him. Accounts of his career make no mention of his motivation for leaving the one and joining the

Left, the double cylinder book machine evolved during the 19th century with 'set off' sheet apparatus

69

other, and in fact, barely adequately describe the remaining twenty or so years of his working life with his new firm. Shortly before his death in 1957 Griffits was still going into London two or three days a week actively concerned about his role as Chairman of Vincent Brooks, Day & Son (by then part of The Baynard Press) and as Emeritus Printer to the Press itself – these post-war years were those of the 'grand old man', the doyen of lithographic printing.

It was in these years that Griffits began to put down on paper some of his ideas about printing in general and colour lithography in particular. He had never been much of a self-publicist or a public speaker, but in three modest books and a few journal articles he managed to synthesize a good deal of practical advice. *The Technique of Colour Printing by Lithography* was first published by Faber & Faber in 1940, with several reprints to follow; *Colour Printing,* (introduction and charts), came out in 1948, and *The Rudiments of Lithography* in 1956, a year before his death.

It says a good deal for Griffits' stature in the industry that the foreword to the first of these books was provided by Frank Pick, and for the third by Robin Darwin, then principal of the Royal College

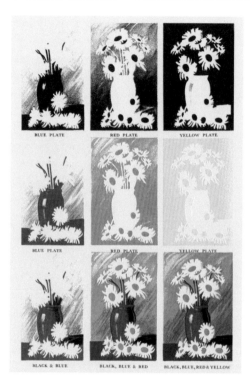

Above, progressive plates from *The Technique of Colour Printing,* 1940. *Opposite, Claudia* alphabet by Barnett Freedman

of Art. In his first volume Griffits gives a very brief but clear statement as to what lithography is, and of its origin, and then, as with any good recipe book, he details the stages involved with additional comments on materials and equipment needed and the contribution of the artist. An appendix provides hints of some of the tricks of the trade he had developed. The writing is succinct – no anecdotes or extraneous homilies – only at the end he exhorts the reader:

Now go and prove thyself by experience, for use and exercise bringeth man to perfection.

As a kind of homage to Barnett Freedman, each section is started with a letter from Freedman's Baynard Alphabet. *The Rudiments of Lithography* is in a rather more discursive style, with a fuller history of the technique.

Although Griffits joined Sanders Phillips in a senior position, heading up Vincent Brooks, Day & Son when it became part of the firm, he could not resist keeping his hand in on the shop floor. One amusing little piece of work, bearing his name, which he must have done soon after his arrival at the Press, was a menu for the Double Crown Club's 51st dinner – a spoof of Freedman's Coronation stamp of 1935.

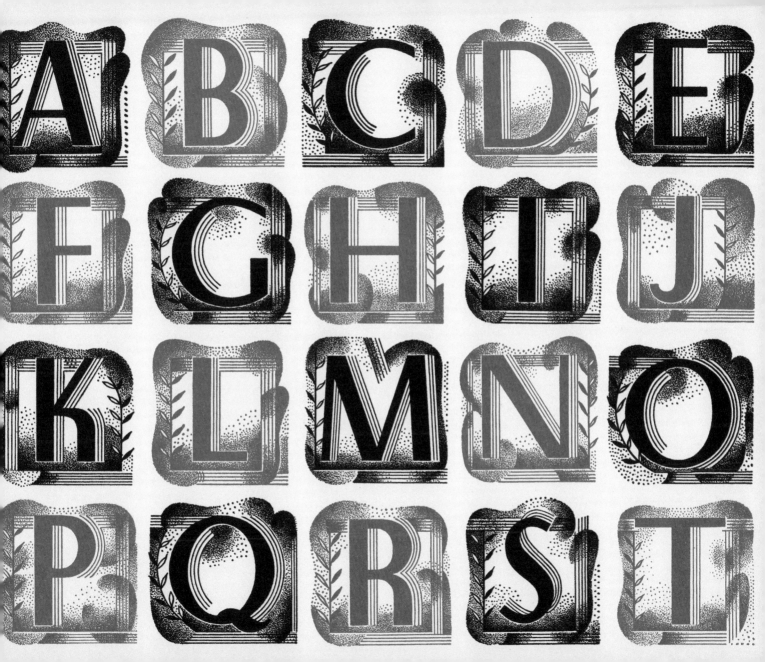

An altogether more taxing task was when he was commissioned by Penguin to produce colour plates for a book on the Bayeux Tapestry in its King Penguin series. Allen Lane wrote of his intent with the series:

These have not been planned to coincide with the public's growing appreciation of art, but rather to appeal to the general liking for illustrated keepsakes of special projects… The original idea for King Penguins came from the small Insel-Verlag books which were published in Germany before the war…

In all there were seventy-six King Penguins. The series was first edited by Elizabeth Senior, who was killed in an air raid in 1941, after which Nikolaus Pevsner took over the editorship, with R.B.Fishenden as technical editor. As Griffits' King Penguin was produced in 1943 it presumably came under their joint supervision. *The Bayeux Tapestry* by Eric Maclagan CBE, the Director of the Victoria and Albert Museum, had a cover designed by William Grimmond, but it was Griffits who drew and printed the eight colour plates.

Of course the tapestry was not available for examination as France had been occupied, so Griffits had to fall back on using photographs held at the V&A. He made key outlines and took these to the Museum in order to make notes on the coloured parts. He described the process in *The Rudiments of Lithography*:

These key outlines were used to make set-offs on to zinc plates, and the complete designs were drawn in a kind of 'pothook and hangar' outline and shaded with fine lines to produce a tapestry effect for the filling in of the colour areas, which was quite a finicky job! In 1949 I went to Bayeux to check the details and obtain the correct colouring.

Griffits was to claim that his eight colour lithographs were the last example of hand-drawn reproductive lithography to be produced in this country, but Twyman records that the technique lingered on for a good few years. It is a curious claim, for Griffits, himself, was certainly involved in the series of lithographed prints, known as The School Prints, produced just after the war, as he had possibly been involved in producing some of Robert

Double Crown Club menu drawn by Griffits substituting
Alois Senefelder, the inventor of lithography, for King George V, 1935

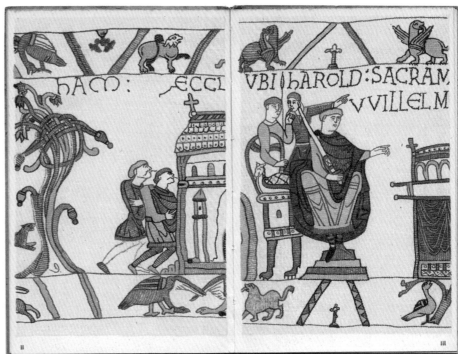

The Bayeux Tapestry, King Penguin, no.10, written by Eric Maclagan with
colour cover drawn by William Grimmond and plates drawn by T.E.Griffits, 1943

'Nursery Frieze I and II', *Contemporary Lithographs* by John Piper, 1936. Too big for Baynard, printed at Waterlows

Wellington and John Piper's 'Contemporary Lithographs', also meant for schools, printed just prior to the war. Brenda Rawnsley, the commissioner of the School Prints, when in her nineties, spoke of taking artists down to the works to meet Griffits, but, unfortunately, was no longer able to recall any of the details of these visits. And indeed Barnett Freedman was involved in a further notable series of lithographed prints for Lyons, the caterers, into the 1950s (produced at Chromoworks), teaching some of the artists involved how to auto-lithograph, and producing some of the prints himself.

Griffits' name is sometimes linked to what are known as the National Gallery lithographs, reproductions of which were intended to be hung in wartime office and factory canteens to boost morale. Certainly the four images – Stanley Spencer's 'Shipbuilding on the Clyde: Burners 1940', Edward

'Shelter Scene' by Edward Ardizzone, published by the National Gallery, London, 1941

Ardizzone's 'Shelter Scene', Paul Nash's 'Battle of Britain' and Barnett Freedman's '15 inch Gun Turret, HMS Repulse Aug. 1941' – were printed at the Baynard Press and Ian Rogerson in his book on Freedman mentions Griffits as being involved but does not detail Griffits' actual contribution.

Griffits was definitely 'hands on', however, for the book *The Queen's Beasts*, which was published in 1953 with Vincent Brooks, Day & Son named as the printer. This came out in the year of the Queen's Coronation with the intention of bringing 'the pageantry of a thousand years of history to the twentieth century'. The publishers had obviously considered it opportune to record the history of such heraldic beasts as the Griffin of Edward III, as ten heraldic statues of beasts, designed by James Woodford, were being placed outside Westminster Abbey. The book's text was by H.Stanford, a Fellow of the Society of Antiquaries,

who had advised Woodford. Photographs of Woodford's statues were included in the book along with brilliantly coloured plates, five designed by Edward Bawden, whilst Cecil Keeling supplied five black and white linocuts. Unfortunately no accounts could be found of how the artists worked with Griffits on the plates – the ease or difficulties found in the printing of the book – but there is a note that one version of The Griffin, by Bawden, coloured by Griffits, was rejected for the book but later reappeared as a Christmas card.

In 1956 a party was thrown for Griffits to celebrate his sixty years in lithography. His reputation was such that many of the great and good of the publishing and printing world attended, including Jack Beddington (formerly of Shell, and then at Colman, Prentis, Varley), R.B.Fishenden (editor of the *Penrose Annual*), Richard de la Mare (of Faber & Faber), Allen Lane (of Penguin), Vernon Nye (who had succeeded Beddington at Shell), F.A.Mercer (of *Modern Publicity*), Barnett Freedman (Griffits' 'best apprentice'), and C.R.Simnett (then Chairman

The Queen's Beast introduction by Hugh Stanford

of Baynard's). Few printers, either before or since, could have attracted such a distinguished assembly, except, perhaps, Fred Phillips himself. A menu card for the event is held in the Manchester Metropolitan University archives. An article in *The Modern Lithographer*, describing the occasion, said of Griffits:

When 'Griff' goes on a colour conjuring hunt it is not just experience at work, it is an artist seeking realization in a vision.

Perhaps the fullest description of Griffits' contribution to the development and evangelism of colour lithography is that of Robin Darwin in his introduction to Griffits' *The Rudiments of Lithography*:

Mr. Griffits as an unrivalled translator and interpreter of other artists' ideas by lithography, may be compared to someone sitting on the branch of a tree and busily sawing away at it on the side nearest the trunk, at imminent risk of life and limb. For it is perhaps his greatest claim to fame that he has spent his long years in persuading artists to draw on the plate or stone themselves and so render his own great skill redundant.

The Queen's Beasts, illustrated by Edward Bawden (*left*) and Cecil Keeling (*right*),
and designed by John Lewis, published by Newman Neame, 2nd June 1953

One of four auto-lithographs, by John Piper, illustrating *The Traveller*
by Walter de la Mare, published by Faber and Faber in 1946

He has always realized that the true beauty of any medium is revealed only when the work of art is designed especially for it. And he has persuaded numerous artists to try their prentice hands on this medium of which he is the master and has helped them over its many bewildering difficulties with never failing encouragement and advice.

Thomas Griffits died on May 5th, 1957. His daughter described him as simply a contented family man, devoted to his wife and proud of his three children and of his grandchildren. But in his profession he was a giant, a maestro – a master lithographic printer, generous in his mentoring of others, one of the few printers to be elected an honorary member of the Society of Industrial Artists and Designers, and an honorary life member of the Association of Teachers of Printing and Allied Subjects. He, himself, declared that Lithography was the joy of his life, a joy that was contagious to all who worked with him.

ST. JAMES' COURT

Thos. E. GRIFFITS

Apprenticed to A. Henley & Co. April 1st, 1896
Transferred to Vincent Brooks, Day & Son, Ltd. 1899
Joined THE BAYNARD PRESS 1935
Completing 60 years in Lithography 1956

Tuesday, 17th April, 1956

A dinner in celebration of T.E.Griffits, 1956. Chairman & Director, Vincent Brooks, Day & Son, Ltd., (Est.1823); Director and associated with the Lithography Department, The Baynard Press; Author of *Colour Printing, The Technique of Colour Printing by Lithography* and *Rudiments of Lithography*. Hon. F.S.I.A., Hon. F.A.T.P.A.S. The guests included Barnett Freedman, Jack Beddington (Shell), Richard de la Mare (Faber), Sir Allen Lane (Penguin) and Harold Hutchinson (London Transport)

REFERENCES

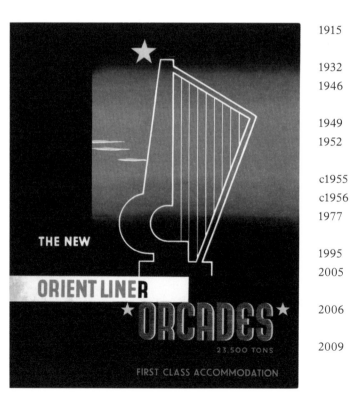

1915 F. Vincent Brooks 'British Lithography in 1915', *Journal of the Royal Society of Arts, February*

1932 'The Baynard Press', *The British Printer,* May–June

1946 Leslie Wood 'The Artist's Attitude to the Process of Lithography', *Art & Industry*, November

1949 Eric Newton 'The King Penguin Books', *The Penrose Annual*

1952 Ellic Howe 'The Life and Work of a Master Printer, Fred P. Phillips': reprint of articles in *The British Printer* May, June, July,

c1955 The Baynard Press, *The Pleasures of Printing No.I,*

c1956 The Baynard Press, *The Pleasures of Printing No.II*

1977 Caroline Hawkes *The Pleasure of Colour Printing,* a biography of Thomas Griffits craftsman 1883–1957

1995 Enid Marx 'Design and print in the 30s', *Matrix* 15

2005 Gaye Smith, curator *Colour & Autolithography in the 20th century,* Manchester Metropolitan University Special Collections

2006 Ian Rogerson & Michael Twyman *Barnett Freedman master lithographer,* The Fleece Press

2009 David Hughes 'Apprentice Days at the Baynard Press', *Matrix* 10

GRIFFITS' WRITING

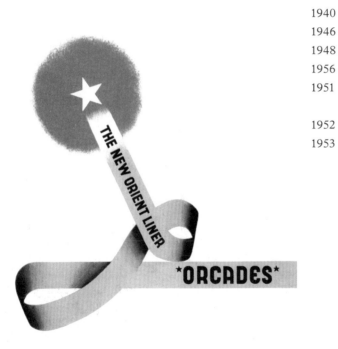

1940 *The Technique of Colour Printing by Lithography*, Faber & Faber

1946 'Lithography and when to use it', *Art & Industry*, January

1948 *Colour Printing*, Faber & Faber

1956 *The Rudiments of Lithography*, Faber & Faber

1951 'The Herkomer lithographic technique and applications',
 The Penrose Annual

1952 'Texture in Autolithography', *The Penrose Annual*

1953 'Designing for print: autolithography, lithography, photolithography',
 January, *Art & Industry*

Opposite, front cover, and, *left*, back cover designs by E.McKnight Kauffer
for the Orient Line's *Orcades*, c1935

THIS IS A PRINTING OFFICE
CROSS-ROADS OF CIVILIZATION · REFUGE
OF ALL THE ARTS AGAINST THE RAVAGES
OF TIME · ARMOURY OF FEARLESS TRUTH
AGAINST WHISPERING RUMOUR · INCESSANT
TRUMPET OF TRADE · FROM THIS PLACE
WORDS MAY FLOW ABROAD NOT TO PERISH
AS WAVES OF SOUND BUT FIXED IN TIME
NOT CORRUPTED BY THE HURRYING HAND BUT
VERIFIED IN PROOF · FRIEND YOU STAND ON
SACRED GROUND · THIS IS A PRINTING OFFICE

Plaque that originally hung in the offices of the Baynard Press in Chryssell Road

BAYNARD'S CASTLE

This castle hath a pleasant seat; the air Nimbly and sweetly recommends itself Unto our gentle senses SHAKESPEARE

There is no castle in Chryssell Road, SW9 – there never was. In Shakepeare's time, and up to the beginning of the nineteenth century, there were green fields where the Baynard Press now has its home.¶ Many years ago, when we were in Upper Thames Street, our building was near the site of the original Baynard Castle, built by Ralph de Baynard, a Norman who came over with the Conqueror. And so the name of the Press was therefore a natural choice. ¶ Although there is nothing in Chryssell Road, SW9, to commend itself to an antiquarian, printing of a very high standard is done there – at The Baynard Press. Printing for industry and commerce, for institutions and learned bodies; printing by letterpress and lithography, done in good black ink or in many colours. ¶ There are larger firms (although we are not small), and there are cheaper ones. But Baynard Press 'quality', which is traditional, and the informed and intelligent approach to the problems of creative printing displayed by the Press have made many good friends for us during the past six decades.

THE BAYNARD PRESS

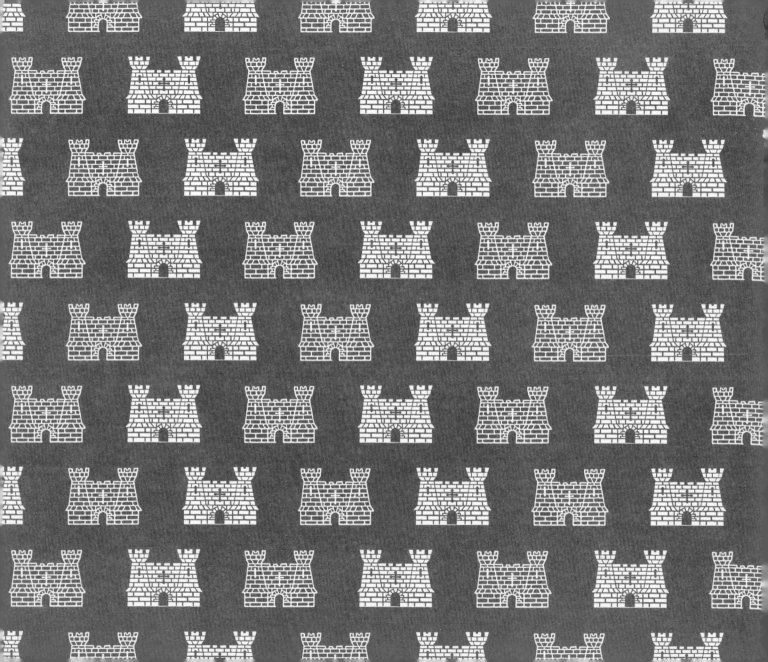

from the Bill of Rights on to the walls of the House of Commons and sentenced to one month's imprisonment in the Second Division. Considering herself to be a political prisoner, Wallace Dunlop refused to be treated as a common criminal and went on hunger strike to secure full rights as political prisoners for herself and others. Succeeding prisoners followed her example, including Lady Constance Lytton and the family of Emmeline Pankhurst. When her sister Mary was imprisoned, Emmeline wrote to C.P. Scott, editor of the *Manchester Guardian*, pleading with him to use his influence with the Home Secretary to help her sister, who 'is very weak and depressed and I fear that although in hospital she will have better food and more comfortable surroundings these will do her little good because she is in absolute solitude ... know from my own experience how nerve destroying the solitary system is'.[53] Mary Clarke was not alone. Sylvia Pankhurst, though never Christabel, went on several hunger and thirst strikes. From this time on, large numbers of suffragettes refused to eat, both as a protest against the prison regulations,[54] and because they were subjected to being treated as common criminals rather than political prisoners. In theory, the hunger strike was not 'the official policy of the Union but a matter for individual decision'.[55] In practice, this was not the case. Marie Brackenbury remembers being told by Emmeline 'not to hunger strike on this occasion'.[56]

At first, hunger strikers were released from prison, but soon the government introduced force-feeding for women who consistently refused to eat. In September 1909 the first woman was force-fed at Winsom Green Prison, Birmingham. Almost immediately Emmeline and Christabel Pankhurst, accompanied by their solicitor, left for Birmingham to act on behalf of the prisoners, only to be informed that they would not be allowed to do so. Forcible feeding, despite some public protest, was to be used repeatedly on large numbers of hunger-striking suffragettes.

Other suffrage leaders disagreed with this new direction in suffrage activities. Ethel Snowden wrote to Millicent Fawcett that she was having a 'wordy duel' with Emmeline over the stone-throwing of the suffragettes but feared she was having little effect.[57] Millicent Fawcett replied that the NUWSS needed to distance itself from the WSPU and show that it stood for peaceful persuasion. The recent outbreak of criminal violence by the WSPU, she went on to say, 'was not caused by a few excitable members getting out of hand but was obviously premeditated

come to the Hyde Park meeting place. Of course, not all were sympathetic and both Emmeline and Christabel were heckled.

Following the success of the June event in London, various demonstrations were held in the provinces. On Saturday July 18th 1908 a great demonstration of between 20,000 and 30,000 people took place in Nottingham. At the mass meetings that inevitably followed these demonstrations Emmeline was often subjected to continuous interruption by the disruptive element in the crowd. 'It was in vain that she tried to make her voice heard above the din going on. When there was a temporary lull she pleaded for a fair hearing, but the only answer she received was the chorus of some popular song and jeering and shouting continued throughout the time she was on her feet. Only now and again was she able to speak a completed sentence.'[42] A demonstration that same month in Manchester that drew 50,000 people proved to be much more successful, largely because of her past local reputation. She strongly urged that 'if women had sufficient intelligence to earn their own living, to pay their rent, and obey the laws which 7½ million men in the country were making for them, surely in justice the vote should be given to them. Concerning the laws affecting women and children, marriage and divorce, women had a special right to make their voices heard The conditions of women's labour, she contended, also called for the making audible of women's views. Then there was the protection of their sex. There should be something more than a law that only protected the virtue of the working-class girl up to the age of 16, whereas among the wealthier classes the mere property of a person was protected up to the age of 21. They claimed also that the interests of children demanded that women should have the vote.'[43] Later that month she led a demonstration of approximately a hundred thousand people from Victoria Square, Leeds, to Woodhouse Moor, where she initially encountered hostility and ridicule. She also supported the Sweated Industries Exhibition, which publicised the plight of low-paid women workers.

As well as participating in demonstrations, she spoke at meetings all around the country, most often to working-class women. Some meetings were held on Sundays because it was the only day that working women could attend. Members were urged to recruit tea-shop girls and to make 'a point of visiting every teashop in their district The same applies to all shops.'[44] Shop assistants, mill workers, nurses, ex-pupil teachers,

working-class wives, postal telegraphists, tailoresses and leading Trade Unionists would be invited to speak at these events.[45] Emmeline's speeches generally focused on the concerns of working-class women. At a meeting in Edinburgh she drew attention to the necessity of the vote for working women, arguing that the Sweating Bill introduced that year by Churchill was a by-product of suffragette agitation.[46] By now she was an exceptionally accomplished speaker, at ease with any audience, capable of tackling hecklers and of targeting her speech to any given audience. She was a strong draw at the Free Public Meetings. These were held every Monday afternoon between 3 and 5 p.m. at the London Pavilion in Piccadilly Circus and on Thursday evenings between 8 and 10 p.m. at the Steinway Hall or Essex Hall. Meetings were also held regularly at the Albert Hall. Ticket prices ranged from 6d to 2s 6d but there was free admission on the night to women. Gradually, of course, meetings became opportunities for militant action. It is doubtful if any other suffragette, save her daughter Christabel, rivalled her in oratorical effectiveness. Henry Nevinson thought Emmeline's speech at the Albert Hall in March 1908 was excellent, although he considered that Christabel was the 'greatest living speaker.'[47] In speech after speech she kept before women the issues at stake in the suffrage and communicated to them her confidence in eventual victory.

Each year Emmeline led a 'Self-denial' week, an idea copied from the Salvation Army, in which WSPU members were urged to make a special effort to raise funds for the movement by personal sacrifices. During this week WSPU members and sympathisers made and sold sweets and flower arrangements, swept crossings, bootblacked and collected money from City offices, singers and violinists amused theatre queues and artists drew pictures on public pavements in an attempt to raise money.[48] One man went without his cigars for a week, one woman gave up butter, and one went without her servant, while another took a barrel organ around Torquay.[49]

During the summer months, when Parliament was in recess, suffrage activity tended to decrease so that everyone could rest until Parliament reconvened in the autumn.[50] During this period the WSPU targeted holiday towns like Felixstowe, Cowes, Ilfracombe, Torquay, Dartmoor and resorts in the Isle of Man and Scotland. In August 1909 they visited 33 different resort towns to sell their literature and gain support for votes for women.

In 1909 an exhibition held at the Prince's Skating Rink, London, drew thousands of visitors. Here Emmeline sat selling millinery among stalls selling flowers, sweets and children's toys; bands and entertainment were provided by the Actresses' Franchise League; there were ju-jitsu demonstrations and reconstructions of polling booths and prison cells. Cartoon models of Asquith in the dock and Emmeline Pethick-Lawrence in the witness box were added attractions, as were demonstrations by Cradley Heath chain-makers.[51] Exhibitions may have provided the suffragettes with a short respite from militancy but the suffragette leader was obviously bored, probably missing the excitement of militancy, possibly not wanting to be reminded of the failure of other business ventures. As Rachel Ferguson, founder of the young WSPU, stated: 'I can hear her uninterested, dispassionate voice saying "Pretty little vase, a shilling".'[52]

CONCLUSION

Under Emmeline's leadership the WSPU flourished, thus justifying her commitment to this new-style organisation. In 1908 through to 1909 its income tripled, the number of paid organisers doubled to thirty, the office at Clement's Inn grew larger and eleven regional offices were s up in Aberdeen, Birmingham, Bristol, Edinburgh, Glasgow, Lee Manchester, Newcastle, Preston, Rochdale and even Torquay. Monday afternoon meetings attracted audiences of up to a thous and the circulation of *Votes for Women* increased considerably. Mili had escalated. A Young Hot Bloods group, known as the YHB formed for suffragettes under the age of 30 who were commit 'danger duty'. Emmeline Pankhurst witnessed suffragettes such a engage in ever-increasing militancy. They heckled cabinet mini meetings, led deputations to Parliament, chained themselves to ings outside 10 Downing Street or to the grilles of the Ladies in the House of Commons, embarked on window smashing stamped graffiti on parliamentary walls and threw stones from

In response, suffragettes were banned from Liberal mee those engaged in illegal activities were duly imprisoned. Ins cumbing to prison treatment some went on hunger strike, in released when their condition was critical. The first hunger Wallace Dunlop, had been arrested in July 1909 for wr

and would get more violent'. Millicent Fawcett also criticised the government for releasing Lady Constance Lytton and Mrs Brailsford, who were on hunger strike simply 'because they have influential relations'.[58] Even so, the NUWSS could not condemn the WSPU too openly in case it offended its membership. In a letter to Millicent Fawcett, Helena B. Dawson stated that she 'could not carry on in the society in Nottingham without the people who would resign over a too strong condemnation of the WSPU'.[59]

On October 13th 1909 Emmeline left Britain and suffragette activity for an American lecture tour. She had agreed to visit the United States to raise funds for the WSPU and, more importantly, for medical treatment for her son Harry, who was partly paralysed as a result of contracting pneumonia. Harry Pankhurst, now aged 20, had given full support to his mother's organisation, campaigning at general elections and by-elections, helping at suffrage exhibitions, marching on demonstrations and being violently thrown out of meetings for his actions. Harry was taken to Margate and left in the care of the rest of the family. When Emmeline returned in early December, she found that Harry's health had deteriorated and he was now completely paralysed. It would only be a matter of time before he died.

6

DEEDS NOT WORDS 1910–12

Emmeline Pankhurst believed in leading by example. In 1911, on a secluded part of Hook Heath in Surrey, in the south-east of England, she had her first lesson in window breaking. As she practised throwing stones at a large fir tree, the 'first stone flew backwards out of her hand', narrowly missing Ethel Smyth's dog.[1] Only on her third attempt did she manage to hit her target, so it is not surprising to learn that, when she later tried to break the windows of 10 Downing Street, she missed. Emmeline may have coined the phrase, and gained her reputation for, 'Deeds not Words' yet, even at the height of militancy, she continued to advocate and practise peaceful methods alongside violent. In 1910 *Votes for Women* outlined three main categories of work: educational (i.e. holding meetings and publishing newspapers and other literature), organisational (i.e. organising a network of regional and metropolitan groups) and militant action.[2] Nonetheless, as time went on, militancy took on an increasingly aggressive and physically destructive form and gradually superseded the other two categories.

In 1910, still fully occupied with the suffrage campaign, Emmeline witnessed the death of her mother, her sister and her only living son. Harry Pankhurst died, aged 20, on January 5th, just a few weeks after her return from America. A young WSPU activist, Helen Craggs (who later married Frederick Pethick-Lawrence), was in love with Harry and was with him at his death.[3] According to Sylvia, her mother was jealous of this relationship and at his death looked 'broken as I had never seen

her; huddled together without a care for her appearance, she seemed an old, plain, cheerless woman'.[4] Sylvia had earlier complained that her mother always sacrificed personal relationships to the greater good, but this may be unfair and probably tells us more about Sylvia than it does about her mother. Emmeline used work to overcome her deep sadness rather than, as Sylvia suggests, sublimate personal feelings for a cause. In a letter to Elizabeth Robins, just after Harry had died, she wrote that 'in the time of self reproach for things left undone and bitter regret for what might have been perhaps prevented had I rightly understood, your letter gave me comfort. I am sticking to my work as best I can. I dare not give myself up to grief it would be selfish and hurtful in every way.'[5] 'Work,' she wrote later, 'is the only cure for the thoughts I find so uncontrollable just now'.[6]

In the spring Emmeline's mother, Sophia Jane Goulden, died of double pneumonia. Aged 75, she was buried beside her husband at the cemetery of Kirk Braddon church, the church where they were married. Emmeline was not present. Nonetheless, she signed the acceptance of her mother's will, which was divided into ten equal parts. Her mother's estate was valued at £789 15s 1d, and the will made it clear that 'the share which any female shall take under this my will shall be for her sole and separate use independently of any husband and of his debts'. However, after her mother's mortgage and other debts had been paid, Emmeline, along with the rest of her brothers and sisters, received an inheritance of £36 12s 6d.[7] On Christmas Day, her sister Mary Clarke, newly released from prison, died from heart failure. Emmeline wrote of Mary: 'we who love her and know the beauty of her selfless life feel it hard to restrain our human desire for vengeance Violence has been done to us, and I ... have lost a dear sister in the course of this agitation. She died within three day of coming out of prison ... she would have been proud and glad to die for the cause of freedom.'[8] 'It was,' she said, 'very hard to see my sister go in that awfully sudden way in spite of all we tried to do for her. She was always very good and loving to me and the children and I owe her much and now we can never repay except by renewed devotion to the cause she loved.'[9]

Purple, white and green outfits were abandoned in favour of black dresses. Mourning the loss of three of her close relatives, she wrote to C.P. Scott that the year had 'seen the breaking for me of three of my closest bonds in this world my boy, my mother and my dearest sister.

Can you wonder that today I want beyond all other things to end this fight quickly and get rest?'[10] Angry with herself and angry with a government that had helped kill her sister, her grief spurred her on to even greater militancy. Her remaining family, Christabel, Sylvia and Adela, all helped to further the cause which had once been their mother's but which now – especially for the eldest two girls – had become their own.

POLITICAL RELATIONSHIPS

Nevertheless, the WSPU and its leader continued to campaign for women's suffrage during elections and by-elections, this time targeting Labour as well as the Liberals. The year 1910 was a watershed for the Liberal Party, which was only kept in office by the support of the Irish Nationalists and the Labour Party. Aware of Liberal political vulnerability, she called upon the Labour Party to use the tactics of the nineteenth-century Home Rulers: she urged them to adopt an anti-government policy and vote against the government until Asquith was forced to concede votes for women. Not surprisingly, Labour abided by its 'secret' electoral pact and declined to do so. And because the Labour Party refused to oppose the government, the WSPU announced in October 1912 that it would confront the official Labour Party and heckle Labour MPs in the same way as Liberals. 'So long as you keep in office an Anti-Suffrage Government,' she insisted, 'you are parties to their guilt, and from henceforth we offer to you the same opposition which we give to the people who are kept in power by your support.'[11]

Support was withdrawn even from Keir Hardie, one of the best advocates of women's suffrage in the House of Commons, when he refused to operate a blanket opposition to all Liberal policies. Nevertheless, the WSPU remained faithful to those MPs who put women's suffrage before party loyalty. When George Lansbury, Labour MP for Bromley and Bow in the East End of London, resigned his seat late in 1912 to fight as an Independent in protest at the Labour Party's lack of commitment to women's suffrage, Emmeline canvassed in his constituency. During this campaign Emmeline was asked why Lansbury stood up for women and not the poor, and she replied that women were the poorest people in Britain and that the WSPU campaigned for the vote to improve the economic position of working-class women. 'What better lesson could

there have been in the need for Woman's Suffrage?' she maintained. 'What better refutation of the stupidly dishonest charge that the Suffrage movement is a class movement, a movement on behalf of the few and idle rich?'[12]

Increasingly, the WSPU declared its independence from all male politicians, insisting that men would do better to work apart from women since 'the place for a man politician is not on women's platforms talking to women's audiences – that is work that women can do for themselves and do far better. The duty of men is to wage war upon the Government responsible for withholding Woman Suffrage.'[13] Emmeline paid tribute to Henry Nevinson and Frederick Pethick-Lawrence and others who helped the WSPU in this way.[14] Eventually, however, she proclaimed: 'Give Us a Tory Government'. This pronouncement was not a step towards her slow conversion to Conservatism. At this point, her support for the Conservatives was less a shift in political allegiances than part of her political manoeuvres. Emmeline, somewhat naively but logically, held that a Conservative government – forced in the same way as Disraeli had been – might be more likely to grant votes for women than a Liberal government. Moreover, because it was a progressive measure, there would be no opposition from the Liberals or Labour if the Conservatives brought in women's suffrage.

By this time, the WSPU was believed to have abandoned its commitment to the working-class, favouring the recruitment of upper-class women – allegedly it was only Sylvia who kept her father's idealism alive by working in the East End of London. It is also often assumed that Emmeline turned away from working-class issues to focus solely on the vote. She might have no longer identified with working-class men – and given the sexual harassment faced by suffragettes at demonstrations and meetings this is perhaps not surprising – yet she still viewed the vote as a means to end social and economic inequality. Women's suffrage, she was sure, would enable the evils of sweated labour and low pay to be overcome. Moreover, the unity of women was seen to be more important than the division of class. In appealing to women of all classes to unite, Emmeline was also suggesting that the subordination of women to men was more significant than class oppression. Indeed working-class women were given support in their struggles against perceived injustices. When barmaids had their livelihoods threatened, they received

support from Emmeline Pankhurst and the WSPU. In 1910, when the chain-makers of Cradley Heath in the Black Country went on strike, they too were given significant press coverage in *Votes for Women*.

One of the most famous working-class campaigns supported by the WSPU was the pit-brow women workers' struggle to maintain their jobs. On August 2nd 1911 a House of Commons Select Committee decided that collieries should not employ women other than as cleaners or office workers. If the proposed bill became law, it would mean the loss of approximately 6,000 female jobs. This was, according to Emmeline, a male conspiracy to stop women's right to work. The WSPU, along with the pit-brow women, waged a campaign against the Select Committee and the Miners' Union (who supported this government initiative) to keep women in work. Later, in May 1912, *Votes for Women* gave publicity to the women's tailoring strike, again arguing the connection between lack of suffrage and low pay. Most importantly, Emmeline saw the franchise as a means of achieving greater social and economic justice for all women, regardless of their status in the community. Their struggle in support of working-class women makes it clear that the WSPU and its leader maintained a strong working-class integrity and were not entirely focused on middle and upper-class women.

Issues concerning working-class women continued to occupy Emmeline's attention, particularly the question of enforced prostitution. By 1912, when the question of white slavery was being discussed in Parliament, this issue had become a leitmotif of her speeches. Speaking at the Albert Hall in October 1912, alongside George Lansbury, she discussed the White Slave Traffic and its relationship to women's suffrage. As always, she drew from her own experiences and told the audience about her work as a Poor Law Guardian in Manchester, where she had encountered a 13-year-old girl who was pregnant and venereally diseased. She went on to relate the time she met an 11-year-old girl in a Salvation Army hostel who had been on the streets for more than a year.[15] 'Until women have the Vote,' she argued, 'the White Slave Traffic will continue all over the world. Until by law we can establish an equal moral code for men and women, women will be fair game for the vicious section of the population.'[16] Eventually, in December 1912 a new Criminal Law Amendment Act was passed, which tightened up the laws against prostitutes and prostitution. She criticised this Act for not targeting those who created the market for prostitution – the male cus-

tomers. The Act, commonly known as the White Slave Act, revoked the 'reasonable cause to believe' clause that allowed men to claim that they thought the girl with whom they had had sexual intercourse was over 16. (Men aged 23 or under and charged with a first offence were exempt from this later amendment.) The Act also permitted suspected procurers to be arrested without warrant; increased the fine for brothel owners to £100; required landlords to evict tenants convicted of using their homes for prostitution; and permitted men convicted of procuring young women to be whipped. Emmeline Pankhurst pointed out the futility of this Act, arguing that if there was 'no demand there would be no traffic since business does not exist if there is no demand for it'. She also condemned the Liberal government for being the 'biggest white slave trading firm that we have got'.[17] It had, she argued, reduced women's wages in its army and navy clothing factories, paid women low wages elsewhere and sanctioned prostitution in India and the other colonies to save the health of the men in the armed forces.[18] In her view, the White Slave Trade Act 1912 was little more than 'wolves' legislation for lambs, because if there was not a demand for white slave and white slavery you would not have a white slave traffic and the demand certainly does not come from our sex. Why does this slavery exist? Because women did not get the same opportunities to earn a living as men get. Fancy trusting men to legislate for the white slave traffic! Why, they are tarred with it themselves.'[19]

Working-class women responded and attended the various meetings and demonstrations organised by the WSPU. They were also involved in illegal militant activities.[20] Moreover, when in January 1910 Lady Constance Lytton famously disguised herself, it was to make the political point that working-class women suffered more in prison than those from a higher social class. Constance, who had been imprisoned many times, was never forcibly fed and believed that the prison authorities treated her well because of her family connections. She therefore disguised herself as a working-class woman and called herself 'Jane Wharton' to test her theory. Her fears were proved correct: as 'Jane', Constance was forcibly fed and treated contemptuously by the prison authorities.

PEACEFUL PROPAGANDA

For short periods in both 1910 and 1911 the WSPU and its leader rejected militancy altogether and gave themselves over to supporting

various private member's bills. Truces were declared to provide the Liberal government with a breathing space to reconsider the issue of women's suffrage. A general election in January 1910 had reduced the Liberal majority so much that any private member's bill needed support from across the parties. In 1910 a Conciliation Committee was formed, composed of twenty-five Liberals, seventeen Conservatives, six Nationalists and six Labour MPs. The reporter H.N. Brailsford, Secretary of the Committee, and Lord Lytton, Chairman, joined them. The Conciliation Committee drafted a bill to enfranchise women who already possessed the municipal franchise, leaving women property owners, women lodgers and women university graduates excluded. There were to be three Conciliation Bills, one in 1910, a second in 1911 and a third in 1912. All were lost.

In private Emmeline was unhappy about the first Conciliation Bill because it excluded lodgers and other women.[21] The first Bill was introduced on June 14th 1910 and passed its second reading on July 12th. Doubtful that the Bill would succeed, she wrote to a number of WSPU activists, inviting them to be part of a deputation should the Bill fail. 'The Prime Minister, and those who share his views, aim, we know, at building up an unassailable male autocracy I know that the members of this Union will not fail the women's cause at this time of grave crisis. Our power as women is invincible, if we are united and determined.'[22] In spite of her scepticism, Emmeline spoke at several meetings, urging the predominantly female audience to support the Conciliation Bill and not engage in illegal activity while the Bill was being discussed in Parliament.

On Saturday June 18th 1910 the WSPU, in conjunction with the Women's Freedom League, organised the largest demonstration seen so far in the campaign. There were approximately 10,000 marchers and Emmeline, still in mourning for her son Harry and dressed in black, headed a column of over 600 ex-prisoners, each carrying a prison arrow. These were followed by a group of elderly suffrage pioneers, women graduates dressed in their university gowns, actresses dressed in pink and green, sweated workers dressed in their best clothes and the first woman mayor. One block contained 'boot machinists, box-makers and skirt-makers ... hot and toil-worn but unfaltering'.[23] One year later, on Saturday June 17th 1911, the WSPU joined with other suffrage societies to lead one of the most colourful and spectacular of all the women's

suffrage demonstrations. The demonstration, called the Coronation Procession in honour of the new King, George V, was headed by General Drummond on horseback, a standard colour bearer and a suffragette dressed as Joan of Arc. Emmeline Pankhurst and the rest of the WSPU Committee followed them. Next came women dressed up in various costumes, including a prisoners' pageant with suffragettes in prison uniforms, an historical pageant including Abbess Hilda with attendant nuns, a pageant of queens, including Boudicca and Queen Elizabeth, and the WSPU provincial sections. There was also an Empire Pageant with women from the colonies dressed in their national costume and an international contingent in national dress. Various other suffrage societies, such as the NUWSS, wore the colours of their organisation and women professionals dressed up in their university gowns. 'The purple, white and green of the WSPU; the red, white and green of the NUWSS; the green, white and gold of the WFL; the blue, white and gold of the Conservative Union; the pink and green of the Actresses; the black, white and gold of the writers; the blue and silver of the Artists and the blue, orange and black of the Suffrage Atelier ... the University Graduates in their gowns and robes; the women doctors, the teachers, the nurses and numberless other sections'[24] must have made a striking display. Men, along with sympathisers, marched last. The procession, with women marching five abreast and singing the new song *The March of the Women*, composed by Ethel Smyth, attracted over 40,000 demonstrators.

Emmeline Pankhurst also promoted other non-militant activities. She suggested that women withdraw their subscriptions from various colleges, hospitals and universities and donate the money saved to the campaign.[25] She adopted the WFL initiative of the Census boycott because of the 'determined refusal of the Government to give to women the status of citizenship'. 'The Census,' she argued, 'is a numbering of the people. Until women count as people for the purpose of representation ... as well as for purposes of taxation and of obedience to the laws we advise women to refuse to be numbered.'[26] On April 2nd 1911, the day of the census, large numbers of women from across the suffrage spectrum made elaborate arrangements to be away from home for the night, thus avoiding the census enumerator. In Edinburgh a large café was hired by the WSPU so that women who wanted to evade the census had somewhere safe to stay overnight. Some stayed at the WSPU

headquarters and other places or else went to all-night entertainments organised by the various suffrage societies.

Throughout most of this period Emmeline continued to speak at meetings all over Britain, consistently arguing for the vote to improve the lives of working-class women. At Newport she spoke on 'The Industrial Position of Women', arguing that 'women workers were worse off today than men workers had ever been at any time of their existence. They could only improve the conditions of women by making them the political equals of men, by giving them the rights of citizenship.'[27] During just one month, in October 1910, she spoke in Cork, Dublin, Belfast, Dundalk, Derry, Birkenhead, New Brighton and Newport, Wales. In the first six months of 1911 she toured the country, drumming up support for women's suffrage.

THE FAILURE OF THE CONCILIATION BILLS

Emmeline Pankhurst had only deferred, rather than abandoned, militancy. If the Conciliation Bill was to be killed, 'there will be an end to our truce'.[28] 'Like all good soldiers,' she said, 'we have our powder dry and our arms polished ... we have laid down our weapons, but we can take them up again.'[29] On Friday November 18th 1910 the first Conciliation Bill failed. When suffragettes heard the news, there was an outbreak of derision and rage at the Caxton Hall meeting where Emmeline was waiting with other suffragettes to hear the outcome of the debate. At once, Emmeline headed a deputation consisting of Hertha Ayrton, Elizabeth Garrett Anderson, Mrs Cobden Sanderson, Mrs Saul Solomon and seven other well-known women to Downing Street. Asquith, again, refused to meet the deputation. The police treated the 300 or more suffragettes who had marched with her to the House of Commons with unexpected brutality.[30] The police, instructed not to arrest demonstrators, forced the women back, kicked them, twisted their breasts, punched their noses and thrust knees between their legs. The suffragettes subjected to this offensive and humiliating treatment believed the police to be acting under an almost unlimited licence to abuse them as they pleased and held Winston Churchill, Home Secretary, responsible.[31] Suffragettes quickly dubbed the event 'Black Friday'. Approximately 115 women and 4 men were arrested but, on the following day at the police court, all charges were withdrawn at

the request of Winston Churchill – except in the cases of women who had broken windows.

Four days later a second battle took place when over 200 suffragettes invaded Downing Street in protest at the earlier debacle. On this day, according to Henry Nevinson, who was with Emmeline Pankhurst, 'we drove the two lines of police more than half way up the street, and for about 20 minutes there was a terrible conflict. Other police came and slowly drove us back out of the street.'[32] He stated that 'Mrs Pankhurst did not pause or slacken for a moment. With that look of silent courage and patient, almost pathetic, determination that everyone now knows so well, she walked straight up against the police, straight into the midst of them ... the whole length of the street from the official residences down to the entrance was one wild turmoil of struggling men and women, swaying this way and that, the women continually striving to advance and the police continually thrusting them back.'[33] Again, no charges were pressed.

These two explosive encounters with the police did much to convince Emmeline that militancy, rather than constitutional protest, was the way forward. She repeatedly drew comparisons between the violence done to women and that done by them. At a speech in February 1912, given at a reception for released prisoners, she asked: 'why should women go into Parliament Square and be battered about and be insulted, and, most important of all, produce less effect than when they use stones? We tried it long enough. We submitted for years patiently to insult and to assault. Women had their health injured. Women lost their lives. We should not have minded that if that had succeeded, but that did not succeed, and we have made more progress with less hurt to ourselves by breaking glass than we ever made when we allowed them to break our bodies.'[34] She complained that the violence shown towards the suffragettes was significantly greater than that perpetrated by them, and blamed the government for instigating savage attacks upon women by its thuggish use of violence and encouragement of police brutality and police harassment.

When Asquith rejected a Second Conciliation Bill for women's suffrage in November 1911, suffragettes responded by shattering windows rather than making more formal protests. The Home Office, the War Office, the Foreign Office, the Board of Education, the Board of Trade, the Treasury, Somerset House, the National Liberal Club, Guards Club,

the *Daily Mail* and the *Daily News* all had windows attacked. Emmeline Pankhurst was abroad at this time, but she gave the suffragettes her full support in her letters from America. Soon after she returned, on March 1st 1912, Emmeline threw her first stone at a public building. According to a member of her bodyguard, she 'would never let us do anything that she was not prepared to do herself, so it was decided for her to start a widespread window-smashing campaign at No. 10 Downing Street'.[35] This she set out to do but, as we have already noted, her aim let her down. Later that day, a first relay of women smashed glass in the Haymarket and Piccadilly; a second relay targeted Regent Street and the Strand and a third smashed windows in Oxford Street and Bond Street. The WSPU leader, held responsible for all this militant activity, was duly charged and arrested.

Three days later, when a Third Conciliation Bill was being debated in the House of Commons, windows were attacked in Knightsbridge. At this time, the fortunes of women's suffrage in the House of Commons were closely bound up with Irish politics. Asquith, in favour of Home Rule and opposed to women's suffrage, needed the Irish Nationalists to keep the weakened Liberal Party in power. In return, Irish Nationalist MPs wanted to make sure that Asquith remained Prime Minister until Home Rule was granted and pledged their support to him in the face of a divided cabinet on both Home Rule and women's suffrage. Consequently, the defeat of the 1912 Conciliation Bill was more or less a foregone conclusion. This time the WSPU refused to call a stop to militancy while the Bill was being debated, and this fresh outburst of window smashing was the result. On March 28th 1912, the Third Conciliation Bill was lost by fourteen votes because most Liberal MPs wanted the issue of Home Rule settled before that of women's suffrage.

Emmeline Pankhurst may not have been the architect of militancy, but she applauded it when it happened and held herself responsible for its continuation. Suffragettes would have been encouraged by her argument that the Liberal government cared for property 'far more than they care for human life Property to them is far dearer and tenderer than is human life and so it is through property we shall strike the enemy.'[36] Mistress of the revolutionary aphorism, her proclamation of 'Deeds not Words' became the motto of the WSPU. Her daughter Sylvia insisted that, once her mother had adopted militancy, she 'flung herself into it with a zeal that knew no stay, finding therein a movement which fitted

her like a glove. Her love of dramatic adventure found full vent. ... It became a great company of high-spirited women gathered in adoration about its leaders, zealous to excel in service and sacrifice.'[37] Emmeline was an inspirational leader with a keen political instinct for what would work. Her ideas were rarely original; her originality lay in collecting ideas that were in the air and putting them into action. She seized every opportunity to publicise the WSPU, making it the most notorious female political grouping of the twentieth century. Window breaking attracted widespread publicity and therefore gained the WSPU leader's retrospective endorsement as official policy. When Emmeline remarked that 'the argument of the broken pane of glass is the most valuable argument in modern politics',[38] she gave further licence to the window smashers. Her almost supernatural talent for sensing the suffragette mood and giving it voice was perhaps her greatest political gift. Soon window smashing became part of a well-orchestrated campaign and suffragettes travelled long distances (even from Scotland) to take part.[39] Women taking part in marches and deputations risked being physically attacked, and window smashing had become a favoured method of protest for many suffragettes. She remarked: 'A window can be replaced; a woman's body cannot.'[40]

In July 1912, according to Sylvia, arson became official WSPU policy under Christabel's direction. Officials of the WSPU gave advice to selected members on incendiary devices and how to obtain supplies of inflammable material and housebreaking tools. Emmeline saw herself as a tiny individual battling against the behemoth of the Liberal government, and she became paranoid about security and the confidentiality of information. Meetings of the militant members were clandestine events. She wrote to one aspiring militant to attend a covert meeting at Miss Brackenbury's Studio on February 28th 1912 so that plans could be explained to her privately.[41] When suffragettes met in public places – such as the Gardenia Restaurant, a popular meeting place – women were only allowed in if they presented a card of admittance. Such meetings were surrounded with the utmost secrecy, and Emmeline would typically insist that suffragettes 'on no account reveal the contents of this letter to anyone or speak of it to anyone'.[42] Activists were encouraged to give their names to the leaders: 'Those who wish to take part with me in a particular engagement are asked to give their names to those ladies Sorties and raids are things which form part of guerrilla

warfare. They have to be done as surprises to the enemy.'[43] In Scotland, for example, pillar-box attacks were organised with great precision. Activists met at a pre-arranged time and place to be handed bottles of acid, which had usually been obtained by sympathetic chemist-shop members, and were told exactly when to drop them into pillar-boxes for the greatest effect. All messages were written in code. At first the code word ANNOUNCEMENT was used until the secret was discovered inadvertently by the press, so the more impenetrable PORTUGUESE EAST AFRICA replaced it.[44] Grace Roe, a member of the YHB (Young Hot Bloods), recalled how they regularly met in a teashop in the Strand to discuss practice. No older members, other than Emmeline Pankhurst, were allowed to attend. Grace Roe remembered how the WSPU leader 'froze' in disapproval when they announced their willingness to be arrested, and how she was always scrupulous in not encouraging any militants, especially the very young ones, to court arrest.[45]

Throughout the militant years, Emmeline regularly proclaimed that the militant campaign was always targeted against property and never against life. Her form of terrorism was heavily circumscribed. Respect for the sanctity of human life was paramount, and she insisted that 'it has never been the policy of the WSPU to recklessly endanger human life. We leave that to men in their warfare. It is not the method of women.'[46] Suffragettes seemed to be more careless with their own lives. Ellen Pitfield, who had tried to burn down the General Post Office in London, died of incurable injuries received on Black Friday 1910, and Mary Clarke, Emmeline's sister, died as a consequence of continual hunger strikes. Many others, including Lady Constance Lytton, who suffered a stroke in 1912, were physically weakened as a result of their suffrage work and died earlier than was expected. And in 1913 Emily Wilding Davison died of head injuries after she collided with the King's horse at the Derby.

PRISON EXPERIENCES 1912

Emmeline Pankhurst had not been back to prison since her convictions and sentences in 1908. In 1912 she was charged with two offences, put on trial and imprisoned on each occasion. Her first arrest took place when she was charged with attempting to break the windows of 10 Downing Street; she was sentenced to two months' imprisonment. Since

1908 suffragette persistence had brought about certain basic improvements in the conditions within prisons, so that her prison experience in March 1912 was markedly different from that of her earlier incarcerations. In March 1910 Winston Churchill, committed to widespread prison reform, had accorded a concession of Rule 243a to suffragettes. Under this rule, suffragettes were able to wear their own clothing and keep their hair long, were not required to take a bath on reception and were relieved of cell cleaning if they paid someone else to do it. In addition, they were employed on light and easy work and were able to take regular exercise. They were permitted to receive books, a letter every fortnight, visitors every month and parcels of food once a week.[47]

While in prison, Emmeline was charged with another offence, that of conspiracy, and so, in order to prepare for her defence, she was allowed certain other privileges. Indeed, the prison authorities claimed that the suffragette leader was well treated and suffered no privations: 'When she was here ... this prisoner provided her own food as permitted As part of this food she had half a pint of daily wine. She informed me that her medical attendant has advised her to continue taking wine, the particular brand recommended being Chateau Lafitte. I have not so far seen any medical reason for prescribing wine as part of the prisoner's regular diet, but neither do I see any medical objection to her receiving the wine.'[48] Accordingly, Ethel Smyth sent in 4 bottles of this rare and expensive claret for her friend's sole consumption. Emmeline was also allowed access to press cuttings and permitted to use the services of her secretary to prepare for her forthcoming trial. Even so, prison conditions remained abhorrent; Ethel Smyth wrote to *The Times* complaining about the suffragette leader's incarceration, arguing that, even though she was recovering from bronchitis, she was confined in a damp basement prison cell infested with cockroaches.[49]

Undoubtedly, Emmeline Pankhurst's later trials were big media events. On May 15th 1912 she was put on trial at the Old Bailey with Emmeline and Frederick Pethick-Lawrence and charged with 54 counts of conspiracy. It was alleged that the leaders of the WSPU 'did unlawfully conspire together and with others to solicit and incite divers persons ... to unlawfully commit damage, injury and spoil ... upon the glass windows of shopkeepers in the City of Westminster and in other parts of the County of London.'[50] Although Mrs Pankhurst had been unable to break a window, she was, as leader of the WSPU, held

responsible for the damage caused by others. Her daughter Christabel was also charged, only to disappear to France before her arrest could be effected. The hearing lasted six days, during which the prosecution called 130 witnesses. Frederick Pethick-Lawrence opened the defence, and Emmeline Pankhurst followed with an impassioned speech in which she argued that women had been driven by the unyielding government's duplicity to take the road of militancy. When the judge directed the jury to convict, the jury in turn urged him 'to exercise the utmost clemency and leniency'.[51] In spite of this obvious moral acquittal, the judge sentenced Emmeline Pankhurst to nine months' imprisonment in the Second Division because she refused to apologise for her actions or to promise to keep the peace. A further charge was made against Emmeline and Frederick Pethick-Lawrence to bear the cost of the prosecution.

As soon as the two Emmelines were imprisoned, Keir Hardie and George Lansbury raised the question of their treatment in the House of Commons, and protests were made by various eminent international figures, such as Marie Curie and Olive Schreiner, about their Second Division status. Consequently, the government conceded and gave First Division treatment to the suffragette leaders. Prison officials were also sensitive to public opinion and on one occasion when Emmeline Pankhurst refused to work, it was decided not to punish her. The Home Secretary had recommended that 'if she refuses to work, he thinks it would be better to let the matter slide and take no action' because she 'is passing through the menopausal time of life'.[52] Her age was held responsible for all manner of things. When Adela Pankhurst visited her mother in prison and expressed concern about an outbreak of skin infections on her mother, the disease was attributed to the menopause rather than to the grim environment of the prison.[53] Edwardian medical opinion had not shifted much since the Victorians, and women continued to be defined by their reproductive systems. Nervousness and mental instability were thought to be greatest at the beginning or the end of the menstrual cycle. During the climacteric, as the menopause was known, 'every form of neurasthenia, neuralgia, hysteria, convulsive disease, melancholia, or other mental affliction is rife'.[54] Thus Emmeline's behaviour was attributed to menopausal problems rather than political will, more a product of biological malfunctioning than intelligent choice.

Despite the improved prison conditions and First Division status, the two Emmelines went on a sympathetic hunger strike in protest that

other suffragettes were not given an equally privileged treatment. It was the first time that either woman had done such a thing. Emmeline Pankhurst may not have initiated the tactic of the hunger strike – the first suffragette hunger striker had acted on her own initiative – but she was responsible for encouraging its continuation. She wrote to members attending the demonstration on November 21st 1911: 'you will receive full instructions direct from Mrs Lawrence on Wednesday morning' about when and whether to hunger strike.[55] As leader of the WSPU, she felt compelled to take her own advice and wanted to send the message that she too was unafraid of putting her health at risk for the cause. She also knew about the importance of being at the centre of events – unlike her daughter Christabel, who had fled to France – and about standing alongside and suffering with the women she represented. The hunger strike was not just a means of taking action but of asserting the 'individual will against the power of the authorities'[56] – and probably of asserting the will of the WSPU as well.

At first, hunger strikers were released from prison but in 1909 force-feeding was introduced for women who consistently refused to eat. Historians are divided over the significance of this course of action. Some justify the force-feeding of suffragettes because it saved the lives of those on hunger strike. Roger Fulford dismisses the Liberal government's force-feeding of suffragettes as a harmless procedure that had been in use for years with 'lunatics'. Early feminist historians tend to agree with these interpretations. In particular, socialist feminist historians, often antagonistic to the suffragettes, underplay the brutality of the government towards women. In stark contrast, much of the pictorial propaganda of the suffragettes represents force-feeding as oral rape. For Mary Richardson, later to gain notoriety for attacking a painting of Venus, forcible feeding was as much about moral humiliation as about pain and brutality. Resistance to forcible feeding thus took on a moral as well as a political dimension. Mary Richardson's view that 'to remain passive under it would give one the feeling of sin; the sin of concurrence' underlines the point.[57] Later feminist historians subscribe to this view, arguing that the 'instrumental invasion of the body, accompanied by overpowering physical force, great suffering and humiliation' was little more than rape.[58] Over a thousand women endured what Jane Marcus calls the public violation of their bodies, as they were force-fed through the nostril, the mouth and even, in a few cases, the rectum and

vagina. Sometimes the tubes used were not sterile and had been used before, increasing the sense of outrage in those who were force-fed.

When Emmeline Pankhurst was incarcerated in 1912, 'Holloway became a place of horror and torment. Sickening scenes of violence took place almost every hour of the day as the doctors went from cell to cell'. She heard screams from Emmeline Pethick-Lawrence's cell as they violently force-fed her. Eventually both women were released on medical grounds on June 23rd in a weak and exhausted condition. On the same day George Lansbury accused the Prime Minister of causing unnecessary suffering, shouting that he would 'go down in history as the man who tortured innocent women'. Asquith refused to be moved by this outburst, and Lansbury was ordered to leave the House of Commons. On June 27th 1911, suffragettes, incensed both by Asquith's inhumanity and by the continuation of forcible feeding, went on a window-smashing raid. Emmeline Pankhurst, in desperately poor health, went to France to recuperate, and Emmeline Pethick-Lawrence sailed to Canada to visit a relative.

Asquith, implacably opposed to women's suffrage, refused to yield to suffragette demands. Historians have pinpointed the entrenched position of Asquith, Prime Minister at the height of suffragette militancy, who obstructed any advance towards votes for women and who persistently refused to see women's suffrage deputations. In his first major speech on suffrage in 1892 Asquith gave four main reasons why he was against women's suffrage. Firstly, he argued that the vast majority of women did not want the vote; secondly, that women were not fit for the franchise; thirdly, that women operated by personal influence, and finally that it would upset the natural order of things. Asquith believed that woman's place was in the home rather than in what he termed the 'dust and turmoil' of political life. Indeed, Millicent Fawcett believed that it was Asquith more than any other person who prevented the Liberal Party from becoming the party to enfranchise women.

RESPONSE TO MILITANCY

Militancy added a compulsive and jittery urgency to the suffrage campaign. The government did not relish this, nor did the constitutional suffragists. The two camps – suffragettes and suffragists – were no longer in ideological conflict, since they shared many of the same basic

values. In policy the two wings were complementary and symbiotic; all suffrage societies, whatever their political persuasion, wanted the vote on the same terms as men. Disagreements were not over *policy*, as they had been in the nineteenth century, but over *practice* – they were divided over the means that might accomplish the vote. The WSPU represented a break with the past since it had instigated a new direction in political practice. At first, the other suffrage societies were more condemnatory of the Liberal government than of Emmeline, but as militancy increased year on year the NUWSS became increasingly critical of the WSPU's illegal activities.

Two of the leaders of the WSPU, Emmeline Pethick-Lawrence and her husband Frederick, disagreed with the ever-increasing militancy and criticised such tactics openly. The second major split within the leadership of the WSPU shows its leader in rather a devious light. At their joint trial in 1912 Emmeline acknowledged the Pethick-Lawrences as 'dear personal friends',[59] and when they were released from prison suggested they visit relatives in Canada during August and September in order to recuperate.[60] While they were on holiday recovering, she wrote to the Pethick-Lawrences advising them to stay in Canada rather than return to Britain. This could be interpreted as a kindly and sympathetic gesture, were it not for what followed. The lease on Clement's Inn had expired so, as soon as the Pethick-Lawrences were abroad, the WSPU was moved from its headquarters in Clement's Inn to new office premises in Lincoln's Inn House. When the Pethick-Lawrences returned, they found that no office had been allocated to them in the new building; instead, Emmeline Pankhurst told them that she had severed all connection with them. She never met the Pethick-Lawrences again, confiding to Henry Nevinson that 'no reconciliation or alliance with the Lawrences would even be possible. She spoke with subdued passion throughout.'[61] In public she was more circumspect and told of the 'magnificent and unforgettable service done to the Union' by both of the Pethick-Lawrences,[62] saying that 'although no longer working with us as colleagues our hearts are full of gratitude to both Mr and Mrs Pethick-Lawrence for all they have done with unsparing generosity and unfailing sacrifice of time, energy and devotion for the Union in the past, and the memory of our association with them will always be cherished as a treasured possession.'[63] And in letters to members who questioned her, she wrote that 'the association between those who remain in

control of the WSPU and Mrs Pethick-Lawrence and Mr Pethick-Lawrence has ceased owing to contrary views concerning the policy of the Union as it is affected by the present situation'.

In private, Emmeline Pethick-Lawrence blamed Mrs Pankhurst for the split and for the increasing militancy of the suffragettes, complaining to Henry Nevinson that 'Mrs Pankhurst was the extreme and violent person: they used to call her "infant terrible". Christabel was always moderate and reasonable. Mrs Pankhurst would not let them see Christabel alone before the split, nor Mrs Tuke nor Annie Kenney.'[64] In public the Pethick-Lawrences were also less critical. They published a statement saying that 'a difference of opinion had arisen as to a certain course which the militant policy might take in the immediate future, and the only solution of the difficulty acceptable to Mrs Pankhurst was severance. Mr and Mrs Lawrence realising that no alternative was open to them except to create a split in the ranks of the Union, reluctantly decided to adopt this course.'[65] *Votes for Women*, which remained under the control of the Pethick-Lawrences, continued to refer to Emmeline Pankhurst as a 'wonderful person', 'a very great personality – a woman of rare qualities of courage and devotion, of ripe experience and obvious powers'.[66] The Pethick-Lawrences remained friends with Sylvia, and Emmeline Pethick-Lawrence left an annuity of £50 to Sylvia Pankhurst in her will. After the First World War Emmeline Pethick-Lawrence helped to raise funds for the (by now) impecunious Mrs Pankhurst. In 1930 Frederick Pethick-Lawrence, who helped raise money for a statue in her memory, paid a warm tribute to her when he attended its unveiling. 'Mrs Pankhurst,' he stated, 'was one of those who dared to stand, alone, or with a friend or two, and face unflinchingly the weapons of ridicule and even of physical force.'[67]

At the time of the Pethick-Lawrences resignation from the WSPU, Emmeline Pankhurst could be criticised for acting in a totally cavalier manner by sacking loyal supporters on a whim of political and personal expediency. Granted there may have been issues of personal ascendancy to contend with, but the Pethick-Lawrence strategies would have redefined the WSPU and returned it to the older, less successful methods of peaceful reform. Undoubtedly, Emmeline was in an invidious position. Driven by her commitment to win, she insisted that: 'History has taught us all that divided counsels have been the ruin of more good causes than anything else of which we know'.[68] She justified her actions

by arguing that the WSPU was an army and in 'an army you need unity of purpose. In an army you also need unity of policy When unity of policy is no longer there ... a movement is weakened and so it is better that those who cannot agree, who cannot see eye to eye as to policy, should set themselves free, should part and should be free to continue their policy in their own way'.[69]

Of course, there were many reasons other than policy disagreements for the split in the WSPU. The Pethick-Lawrences were strong Labour Party supporters, whereas by now Emmeline Pankhurst was denouncing the Labour Party for abandoning its socialist principles and for its lukewarm support of women's suffrage. According to Grace Roe, the personalities and official roles of the Pethick-Lawrences made their place in a militant organisation untenable. Emmeline Pethick-Lawrence, although an excellent fund-raiser, was thought to be far too emotional and nervous to undergo further imprisonment, while Frederick, a trustee of the WSPU, was obliged to relinquish money and property to the government for the damages incurred by the suffragettes. Moreover, Emmeline Pankhurst had always found Frederick irritating and disliked his ever-increasing participation in her all-female organisation. In addition, she may have been jealous of the close relationship between Christabel and the Pethick-Lawrences, who, childless themselves, had virtually adopted her favourite daughter. Finally, as founder of the WSPU, she thought that others should leave 'her' organisation when disagreements became insurmountable.

Having forced the Pethick-Lawrences to resign, Emmeline Pankhurst was now free to urge suffragettes to be 'militant each in your own way'. At a WSPU meeting on October 18th 1912 she urged 'those of you who can express your militancy by going to the House of Commons and refusing to leave ... do so. Those of you who can express militancy by facing party mobs at Cabinet ministers' meetings ... do so. Those of you who can express your militancy by joining us in our anti-Government by-election policy – do so. Those of you who can break windows – break them. Those of you who can still further attack the secret idol of property ... do so.' Consequently, when a Women's Suffrage Amendment to the Irish Home Rule Bill was defeated, WSPU militants responded with a window-smashing raid on West End shops, followed by a five-day nationwide pillar-box attack. In just one offensive large numbers of pillar-boxes in the City, Westminster, the suburbs of London, and in

Nottingham and Birmingham were attacked with 'obliterating and corrosive substances'. Newcastle and Bradford also suffered heavily, as did Friern Barnet, Lewisham and Lee Green in London. Other places attacked were Bath, Southampton, Richmond, Edinburgh, Kirkcaldy, Southport, Ilkeston, Hastings and Cardiff.[70] These incidents shifted militancy on to a new level, especially when endorsed by her argument that the Liberal government cared more for property than for human life.

CONCLUSION

Emmeline Pankhurst's unitary command structure, her family cabal of leaders and her dismissal of debate seem to be strangely at odds with her demands for democracy. Moreover, her espousal of a militant strategy seems to hold the principles of the democratic process in contempt. Democracy is usually based on discussion, freedom of expression, constitutional procedures and consensus, and the WSPU leader certainly did not practise only these. In many ways, the increase in militancy, along with the forced resignations of the Pethick-Lawrences, appear to reveal some sort of dissonance between Emmeline Pankhurst's aims and means, between her theory and practice, between her democratic rhetoric and her autocratic style of leadership. A number of points can be made in her defence. Firstly, her charismatic style of leadership meant she could make up policy on the hoof rather than wait for endless committees to debate and agree new decisions. She was highly intuitive, relying more on her inner feelings, on her natural empathy, than on her intellectual processes. She instinctively 'knew' how to respond to the quickening pace of events, where a leader of a bureaucratic organisation might not. Grass-roots members who inaugurated new policy initiatives soon had them adopted and developed by their leader. Secondly, local organisations continued to enjoy a measure of autonomy within the overall umbrella of WSPU strategy. As long as members abided by general policies, they were free to interpret them in their own way. Thirdly, rank and file members certainly adored the WSPU leader and she held her position by the force of her personality rather than by election, by charm rather than by fear. Wherever she went and wherever she spoke, suffragette audiences rose in applause and cheered her repeatedly, preferring to relinquish democracy rather than lose their beloved leader.

Emmeline Pankhurst's presence struck awe into the fibre of Kitty Marion. She wrote of her first meeting: 'I recognised the single-mindedness of her aims, the uprightness of her character, the vigour of her intellect and convincing oratorical gifts, the charm of her personality and above all the magnificent power of her leadership'.[71] Grace Roe, too, insisted that members all felt as one with the leader. One suffragette, much to the annoyance and embarrassment of Emmeline Pankhurst, composed her own partisan parody of the Nicean Creed:

I believe in Emmeline Pankhurst – Founder of the Women's Social and Political Union.

And in Christabel Pankhurst, her eldest daughter, our Lady, who was inspired by the passion for Liberty – born to be a leader of women. Suffered under the Liberal government, was arrested, tried and sentenced. She descended into prison; the seventh day she returned again to the world. She was entertained to breakfast, and sat on the right hand of her mother, our glorious Leader, from thence she went forth to judge both the government and the Antis.

I believe in Votes for Women on the same terms as men, the policy of the Women's Social and Political Union, the equality of the sexes, Representation for Taxation, the necessity for militant tactics, and Freedom Everlasting.

Emmeline might have wanted to command but she disliked such forms of unthinking adulation.

According to those who remained in the WSPU, it could afford to sacrifice leaders like the Pethick-Lawrences but it could not afford to lose Emmeline Pankhurst. Had it done so, the WSPU, like most organisations based on charismatic leadership, would probably have collapsed when she was no longer there. She had three important qualities required for leadership in this type of struggle: monumental charisma; extraordinary personal courage; and an uncanny knack for responding to events quickly. Undoubtedly, she was a great campaign strategist. Moreover, acolytes may have peopled the WSPU, but Emmeline Pankhurst did not lead a docile membership. The suffragettes were used to taking their own initiatives, indeed they were used to challenging the

very basis of British political life. They were hardly likely to support a leader of whom they disapproved. Finally, for Emmeline Pankhurst, votes for women was a cause to which all private interests and concerns had to be subordinated; if she was willing to sacrifice her health, and ultimately her life, then others must do the same. Denied access to the democratic process, she justified her use of extra-parliamentary methods to gain it. The money raised by the WSPU bears witness to her popularity. When the 1912 Conciliation Bill was defeated, the staggering sum of £10,500 was raised at one meeting alone – a record – and subscriptions increased by £4,000 within a matter of weeks.

7

THE HEIGHT OF MILITANCY
1913–14

In July 1914 Emmeline Pankhurst, back in Holloway after a few weeks of freedom, was given seven days' solitary confinement for insubordination. She had refused to dress after being stripped and searched, had lain down naked on the prison floor, had been 'abusive', had used 'offensive language' and had 'hit an officer'. She was accused of shouting at the prison Matron: 'Why don't you be a woman, and not a tool of this filthy Government. Why don't you go on the streets and get a living; it would be more honest than assisting in torturing women who are working to better your conditions; you are no better than a woman who walks the streets for her living'.[1] This behaviour seems totally out of character and can be explained in one of two ways: either it was a fabrication by the prison authorities to strengthen the insubordination case, or it shows that Emmeline Pankhurst had been pushed to her limits. She was released the next day, weak, debilitated and exhausted, after going on hunger strike. Ethel Smyth noted that her skin was so 'yellow, and so tightly drawn over her face that you wondered the bone structure did not come through; her eyes deep sunken and burning, and a deep dark flush on her cheeks. With horror, I then became acquainted with one physical result of hunger striking that still haunts me. It is due, I suppose, to the body feeding on its own tissue; the strange, pervasive, sweetish odour of corruption that hangs about a room in which a hunger-striker is being nursed back to health is unlike any other smell.'[2] By this time, the WSPU leader was so fragile and experiencing

so many problems with her heart and her digestive system that she was carried everywhere by ambulance. Emmeline Pankhurst was very near death.

The Liberal government had imprisoned the leader of the WSPU and other militants, and tried to curtail the activities of the WSPU in a number of other ways. In an attempt to stop potential disruption, women were forbidden to attend Liberal meetings unless they held a signed ticket. Members of the cabinet consistently declined to meet them. The government also refused to accept petitions, banned meetings in public places and censored the press in an attempt to silence the WSPU. The Commissioner of Police, directed by the Home Office, banned suffragettes from holding meetings in London parks and persuaded the management at the Albert Hall not to rent it to suffragettes. The government even prosecuted the printer who printed *The Suffragette* and periodically raided the offices and homes of WSPU members. They had already forced Christabel Pankhurst to flee to Paris, where (under the name of Amy Richard – or love Richard – probably in honour of her father) she tried to direct the movement from exile. Emmeline saw all of this as insufferable behaviour by the Liberals: she knew that the constant raids, arrests, trials, imprisonments and force-feeding of the suffragettes were intended to sap the resolve of WSPU members. The Liberals, she argued, wanted 'to scatter the members, to break their spirit, to make them afraid of their own personal position, to make them fear poverty, to make them fear disgrace'.[3]

In turn, the suffragettes were a constant challenge to the Liberal Party's credentials as the party of progress. At the same time as repressing the WSPU, the Liberals had introduced old age pensions, developed child welfare provisions, put in place National Insurance and were assuming an unprecedented commitment to improving the lives of the poor. To then deny women freedom of expression, and to treat them cruelly when they campaigned for social justice, undermined the fundamental ethos of Liberalism. Nevertheless, Asquith's fundamental objections to women's suffrage meant that it was unlikely to be achieved while he remained Prime Minister.

Emmeline Pankhurst, steeped in the radicalism of the mid-nineteenth century, drew more and more on the words and phrases of other late Victorian female reformers to justify her actions. In an almost perfect copy of a speech made by Josephine Butler in her campaign to

repeal the Contagious Diseases Acts, she claimed that 'if women break these laws, whether they consider them just or unjust, they are arrested by men, they are tried by men, they are sentenced by men'. Women, she insisted, should be part of the law-making process since they had to obey them. Moreover, in her opinion she and the members of the WSPU were treated unfairly compared to other law-breakers. Ireland, as ever, dominated her political thinking. Repeatedly, the treatment meted out to Irish rebels was compared to that meted out to suffragettes. Her own punishment was contrasted with that of Sir Edward Carson, who, in order to avert Home Rule, had led a mutiny in the British army based in Ireland. 'How is it,' she complained, 'that our liberty loving Liberal Government sends women political law-breakers to prison whilst it conveniently closes its eyes to the doings of Sir Edward Carson?'[4] She claimed that the Irish Home Rule Bill and its subsequent failure were due to the militant action of first Catholics and then Protestants, and 'if militancy promotes the cause of the Ulster men, how can militancy put back the cause?'[5]

Throughout the year there were attempts at peaceful protest. The WSPU held a summer festival at the Empress Rooms, London, organised campaigns at various seaside resorts, led self-denial weeks, arranged poster parades, addressed crowds at outdoor meetings and at the Albert Hall, held sessions every Monday at the London Pavilion and organised a deputation to the King. Emmeline carried on with her speaking engagements, continually promoting the claims of working-class women. In her book *Way Stations* Elizabeth Robins gives a vivid account of the WSPU leader coming under attack at a meeting of male strikers from the Amalgamated Society of Engineers because of her defence of female strike breakers. The meeting, held in an upstairs room at a pub, was distinctly hostile because women had taken on the jobs vacated by striking men. Emmeline immediately tackled this antagonism by blaming men for keeping women out of skilled jobs and trade unions. 'Who of you,' she urged, 'blame the men with full stomachs who employ those hungry women as strikebreakers? Who of you blame the people most to blame of all? The husbands, fathers, brothers of those women, who have kept them ignorant and unorganised …. Men shut women out of their Unions and yet expect women to starve for the sake of those Unions. You and your fathers have accepted the tradition that women of your own class shall be overworked and underpaid.'[6] Emmeline justified the

action of the women strike breakers because working-class men had helped to keep them in a subordinate position. By now Emmeline had abandoned much of her support for working-class men, whom she saw as claiming masculine rights at the expense of female ones.

The WSPU leader insisted that she had managed to recruit working-class women and that class distinctions between women had collapsed, as witnessed by the audiences at various meetings. According to the 1913 WSPU Annual Report, the 'most striking feature perhaps of the whole Conference was its universality. It was the world of women in miniature ... poor women, rich women, leisured women, working women, women of genius, ordinary women ... the difference among the members was heightened by their clothes. There were fur cloaks and print gowns; neat, professional coats and skirts, fashionable "creations", fishwives' costumes I saw laundresses and ladies of title sitting cheek by jowl Indeed, the force of Suffrage is such that East is West and West is East, and here the twain shall meet.'[7] Certainly, Emmeline maintained a strong commitment to working-class women, even though her commitment to men and socialist political parties had faded away.

By 1913 Emmeline's views on white slavery had hardened. At meetings she passionately appealed to women to fight against the White Slave Traffic. 'If there is nothing else in the world that you want the vote for,' she insisted, 'you want it so that you may have legislation to protect your daughters, to force men who can only be made to respect women by force, to respect them.'[8] In this same speech she criticised the unequal moral standards which permeated all ranks of society and called for sympathy for 'the poor woman who is called "fallen" ... who goes from serving the vicious pleasure of the upper classes by degrees down to serving those of the lowest'.[9] In her view, the sexual double standard was a moral cancer which ate at the heart of the race: 'the race itself is being destroyed and undermined by these horrible diseases that come of unbridled viciousness in our social life'.[10] In a speech made in Cardiff she compared black slavery in America with the white slavery of the twentieth century in which 'human beings are being bought and sold exactly like merchandise ... in practically every great city in the civilised world, there is a traffic in human beings – in women, girls and little children exactly as there was a traffic in Negro slaves'.[11] White slavery, she insisted, was an international trade. Tens of millions, she argued, were spent in New York on buying and selling children from 4 to 5

years upwards. Moreover, there were at least six rescue homes for children under the age of 12 in Britain, and India had not altered since Josephine Butler had waged her campaign against colonial prostitution.

In the middle of 1913, probably prompted by the case of Queenie Gerald and encouraged by both the speeches of Emmeline and the written tirades of Christabel, the WSPU began a moral crusade against the double standard of morality. Queenie Gerald, aged 26, had pleaded guilty to the charge of keeping a brothel and of living off the immoral earnings of three young girls. She was given three months' imprisonment in the Second Division. The judge justified this light sentence by arguing that Queenie Gerald had pleaded guilty to prostitution, which itself was not a terrible crime, merely human weakness. Moreover, he went on to say, the young women procured by Queenie Gerald 'had very much improved their position because they had been able to come to the flat instead of walking about the streets in all kinds of weather and meeting with indignities and insults.'[12] Emmeline was enraged. She thought Queenie Gerald's plea of guilty was a tactical move to avoid being prosecuted for the more serious crime of procuring young girls and little children. Later that year she visited America with the sole purpose of linking women's suffrage to white slavery and venereal disease. She saw it as her business 'to show the close relationship between the appalling state of social health and the political degradation of women ... through giving women political power you can get that equal moral standard registered in the laws of the country.'[13] 'Votes for Women and Chastity for Men' soon became a leading slogan, especially after Christabel published *The Great Scourge*, which argued that the low moral standard prevailing amongst men resulted in incalculable suffering for women.

As with prostitution, venereal disease was linked to mental deficiency. According to *The Suffragette*, 'the causes of mental deficiency are known and are preventable. Chief amongst them is syphilis, the result of vice. But rather than mend their own morals, men will, it seems, punish the innocent victims of immorality.' In 1913 a Mental Deficiency Act was passed which made it possible for the 'feeble-minded', considered to be potentially immoral, to be detained permanently in suitable institutions upon the certificate in writing of a qualified medical practitioner. Even though one of the people responsible for the Act, Mary Dendy, had once been a colleague, Emmeline

expressed concern that there might be a 'special danger that the Mental Deficiency Act will be used to oppress women who do not properly come within its provisions. These are unmarried mothers whose children are born in workhouses. Unless other women can protect these unfortunate members of their sex, nothing will be easier than to use the Mental Deficiency Act as a means of getting rid by imprisonment of unmarried mothers who have been betrayed and deserted by the father of their child.'[14] Her fears were prophetic, since the effects of the 1913 Act are still working themselves out. Very elderly women, once categorised as 'feeble-minded' and who were often single mothers, still remain locked up in state institutions.

In early 1913, when Lloyd George and Edward Grey put forward a suffrage amendment to a proposed Franchise Bill, the WSPU announced another truce. Just before the debate took place, the WSPU organised a Working Women's Deputation to obtain support from the government by showing them the wide base of suffrage support. Sylvia Pankhurst took the credit for initiating this demonstration while her mother exhorted women to support it, saying that 'more railway fares have to be paid; more hospitality is needed, more conveyances must be engaged to convey the East End delegates to the places of meeting'.[15] Tea was provided free of charge each afternoon at the WSPU shop between 3 and 6 p.m. Working-class representatives travelled from all parts of Britain. East London garment workers, fishwives in brightly coloured shawls and striped skirts, weavers, tailoresses, pen-workers, upholsteresses, tin plate women, laundresses, charwomen, rope-makers, shop assistants, textile workers in clogs and shawls, chain-makers, pit-brow women in their working dress, nurses in uniform and teachers were all present. Twenty women, including Mrs Hannah Ashworth, a cotton worker since the age of 10, and Mrs Hawkins, mother of seven children and President of the Women's Boot Union, were selected to attend the deputation.[16] Emmeline Pankhurst did not attend the deputation, although she spoke at many of the meetings held in support of it. Despite the women's efforts, the Franchise Bill – and the WSPU truce – were withdrawn.

MILITANCY

With Christabel still in exile in Paris, Sylvia working in the East End and the Pethick-Lawrences long gone, Emmeline led WSPU militancy,

inciting women to rebellion whenever she could. She used words to inspire others to do the militant deeds. Indeed, her words sanctified the deeds and gave them a revolutionary respectability. Emmeline legitimised militant action, glorifying and ennobling the violent acts perpetrated by WSPU suffragettes. There was no equivocation. In late January 1913, just after the Liberal government had torpedoed the Franchise Bill, she urged further action. In a typically inspired outburst at the London Pavilion she declared: 'the words for this movement are "War Again" We are in the position of all those who in the struggle for freedom have been opposed by the forces of organised government. Look at Garibaldi, at the great Duke of Brunswick, the rebellions in Mexico, the fight against the power of Austria, the struggles between the North and the South. ... *It is guerrilla warfare that we declare this afternoon.* ... We are in danger of losing faith, not only in politicians, but in average men too What is the answer to this trickery? MILITANCY!'[17] She continued by saying that they were 'going to do as much damage to their property as we can and we shall all meet in the Horticultural Hall and consider what is to be done. We shall be prepared not only for words, but for deeds.'[18] Her resolutely delivered call to arms framed WSPU policy for the next eighteen months and succeeded in its objective of encouraging – and fortifying – the members.

Emmeline Pankhurst encouraged militancy privately as well as publicly. In January 1913 she confided to Henry Nevinson that she did not want to restrain the 'young bloods' of the WSPU because she 'felt that the time for great speeches was gone'.[19] On January 10th 1913 she sent a confidential letter to all members of the WSPU, urging them to be militant and criticising those who were reluctant to engage in any form of direct action. 'There are degrees of militancy. Some women are able to go further than others in militant action and each woman is the judge of her own duty so far as that is concerned. To be militant in some way or other is, however, a moral obligation. It is a duty which every woman will owe to her own conscience and self-respect, to other women who are less fortunate than she is herself, and to all those who are to come after her. If any woman refrains from militant protest against the injury done by the government and the House of Commons to women and to the race, she will share the responsibility for the crime. Submission under such circumstances will be itself a crime Will you therefore tell me (by letter, if it is not possible to do so by word of mouth) that

you are ready to take your share in manifesting in a practical manner your indignation at the betrayal of our cause.'[20]

Suffragettes responded with alacrity to the guerrilla warfare announced by their leader at the London Pavilion. Pillar-boxes were attacked all over Britain. Golf courses at King's Norton, Erdington and Hall Green in Birmingham had 'Votes for Women' scored in the turf with acid. Shop windows and government buildings were broken in London and Dublin. A glass case containing the Crown Jewels was smashed in the Tower of London. On February 20th the Refreshment Pavilion in Regents Park was burnt to the ground. In June that year the ultimate sacrifice was made. Emily Wilding Davison, prompted by a desire to gain publicity for women's suffrage, went to the Derby, rushed out on to the racecourse, grabbed the reins of the King's horse and tried to stop the race. In this she was unsuccessful, but she died of head injuries a few days later and was mourned as the first suffragette martyr.

The previous year Emily Wilding Davison had initiated the first arson attempt by setting fire to a pillar-box. Soon, setting fire to buildings was added to the suffragette armoury. Many of the arson attacks were, like window smashing and other forms of destructive behaviour, a response to particular political events, to Emmeline's impassioned speeches, to her private entreaties and to her constant imprisonments. Although there were a few sporadic arson attacks before 1913, the partial destruction that year of Lloyd George's country house, under construction in Surrey, marked a watershed in suffragette violence. After the damaging of the property, Emmeline declared: 'We have tried blowing him up to wake his conscience I have advised, I have incited, I have conspired ... I accept the responsibility for it.'[21] No one could deny that Emmeline Pankhurst was a skilled orator.

The WSPU leader had assumed responsibility for militancy so was arrested, and then charged, tried and imprisoned for the deeds she had inspired. On Monday February 24th 1913 she was arrested at her Knightsbridge flat and taken to Scotland Yard. She had been arrested for having 'feloniously, unlawfully, and maliciously counselled and procured certain persons' to place gunpowder and other explosive substances in the country home of Lloyd George at Walton Heath, Surrey.[22] She was charged as an accessory to the crime, with the prosecution alleging that an explosion of gunpowder mixed with a number of rough nails and pieces of metal caused damage estimated at between £400 and £500.

Her trial was set for the summer months. When informed of this decision, she complained against the long delay, refused to be bound over to keep the peace for such a long period, was denied bail and remanded in custody.[23] In protest, she went on hunger strike. Within twenty-four hours the authorities changed their minds and fixed her trial for April 1st at the Central Criminal Court. This time she promised not to encourage militancy and was released on bail. Eventually the trial took place on April 2nd at the No. 1 Court of the Old Bailey, where those indicted of serious crimes were tried.

In public Emmeline appeared fearless. Privately, she was worried about not feeling 'fit to face the strain involved in conducting my own defence. The strain of the past six years tells on me more and more, my mind does not work as quickly as it used to and has not yet recovered from the effect of prison. Even young women tell me that it is impossible to concentrate on anything and that it takes some time after one is liberated for this mental paralysis to wear off.'[24] She was now in her mid-fifties so recovery was harder. Even so, she conducted her own defence, thus allowing her to make political speeches. As usual, she used her trial to draw attention to the plight of women, speaking about the inequalities in marriage, in divorce, in work, in citizenship, in sexual exploitation. She remained particularly concerned about moral laws, criticising the divorce laws that created unequal moral standards for husbands and wives and the laws that gave a maximum of two years' imprisonment for sexual abusers. In addition, she denounced immoral judges who administered punitive sentences to girls guilty of infanticide, yet were lenient towards men charged with sexual crimes.

At the trial she referred to prostitution six times, often relating it to class inequality. When she was accused of driving around in a chauffeur-driven car rather than using public transport, she defended the charge by stating that the vehicle was owned by the WSPU. 'There is only one trade that I know of in which women earn enough to buy motor-cars themselves,' she stated, 'and that is the abominable trade of ministering to the vicious pleasures of rich men.' She spoke of one judge found dead in a brothel, of 'an organisation under which young women and even children are being purchased and trained to minister to the vicious pleasures of men', and of 'the fountain of life being poisoned and lives ruined'. In the same speech she compared the way she was treated in law with those men 'who had injured the moral and physical well being of

little girls'. She continued by complaining that she had been given six weeks in the second division for a minor offence, whereas a man 'who had occupied a high position was sent for six weeks in the first division for cruelty to several little girls'.[25]

All these factors, she declared, were the cause and justification of militancy.[26] The jury was told that she would go on hunger strike if imprisoned and was taunted with the words: 'Are you, as human beings, going to condemn another human being to death?'[27] According to one observer, she made a great impression. 'I shall always,' said one sympathiser, 'think of her as she leaned forward, a flush of defiance on her cheeks as she said she would resist to the last, a wave of her hand as she dismissed all thought of her own approaching doom.'[28] The judge was not so impressed by her bellicosity and accused her of 'luring' young women to criminal action by setting a bad example and, as in the previous legal decisions, directed the jury to a vote of guilty. Once convicted, she received three years' penal servitude.

As soon as she was imprisoned, Emmeline went on hunger strike. The Home Office, fearful of awkward questions in the House of Commons, asked for a daily report on her. In a letter sent to Holloway Prison in April 1913 the Home Secretary demanded that 'if Mrs Pankhurst starves herself, the Secretary of State wishes her to be kept constantly supplied with suitable and appetising food. He wishes also, in case any question should arise, that an exact record be kept (1) of the food supplied (2) of everything that is done in the way of inducing her to take food and (3) in the way of medical treatment.'[29] The following food was offered, which she refused to eat.

7 a.m. Breakfast: Tea and thin bread and butter – or toast – with a boiled egg
10 a.m. Cup of hot milk
12.15 Dinner: Fish or chicken with soup vegetables, milk pudding, bread
4 p.m. Tea: Tea, bread and butter – egg – toast
7 p.m. Supper: Hot milk or Bovril[30]

Emmeline was also unwilling to undress or to be medically examined and in a fit of outrage broke all her cell utensils.[31] She refused to either sit or lie down on the prison bed, instead walking round and round the

cell until she was so tired that she lay down on the floor. 'For two nights, I lay on the concrete floor and also a great part of the day. I never took off my clothes or shoes only wiped my face and hands; my head was tied up in a scarf and I did not do my hair! On Tuesday, I said to the Doctors "Two nights I have lain there (pointing to the floor). From now on I will not do that but shall walk the floor till I am let go or die".'[32] In July 1913 she refused to give up her personal belongings or to be searched so was overpowered by several wardresses, who 'all set upon me – I think six ... I was finally overcome. Some held my legs, some my arms, and they stripped me and took everything from me, searched all over my body, and then finally they put some clothes on me again, and took me to my cell.'[33] The prison officers often reported that she was 'bad tempered and excitable' or 'very irritable and more illogical than usual in conversation'.[34]

In July 1913 Emmeline adopted a thirst strike, refusing both to eat and to drink. Speaking of this experience, she commented that 'the body cannot endure loss of moisture. It cries out in protest with every nerve. The muscles waste, the skin becomes shrunken and flabby, the facial appearance alters horribly ... every natural function is suspended and the poisons which are unable to pass out of the body are retained and absorbed. The body becomes cold and shivery, there is constant headache and nausea and sometimes there is fever. The mouth and tongue become coated and swollen, the throat thickens and the voice sinks to a thready whisper.'[35] She also went on sleep strike and 'walked her cell until her legs gave out and when she could walk no longer she propped her body up against the cold stones and forced herself to keep awake'.[36] At this time she was deeply agitated, because Sylvia was on yet another hunger strike and she thought her daughter 'might be in the same plight as herself.'[37] More publicly she spoke of 'my own girl Sylvia – cheerfully and gaily' giving her life to be tortured.[38]

Emmeline, unlike Sylvia and over a thousand other suffragettes, was never force-fed, always being released from prison when her health was thought endangered. In private she 'expressed great dread of being forcibly fed'[39] and used every method of avoiding it. In prison she asked to see a throat specialist, and it was obvious to the prison authorities 'that she means to hunger strike and wants to get a tame specialist to certify that her throat is not in a condition to allow of her being force fed'.[40] In *Votes for Women* she taunted the Home Secretary to give his

authority to force-feed her: 'He dare not. I challenge him to do it,' she urged.[41] The government excused itself by arguing that Mrs Pankhurst was 'not robust physically and is of a highly strong emotional temperament. It has been considered inadvisable on previous occasions to forcibly feed her'[42] because of her heart condition.

Every time she was imprisoned, it excited a strong response from WSPU militants. As one suffragette insisted: 'I had not been incited to what I had done by anything that Mrs or Miss Pankhurst had said, but that I had been very much incited by the government's treatment of Mrs Pankhurst'.[43] Suffragettes tried to destroy valuable works of art as protest against the higher value placed on property than the life of the WSPU leader. The most famous incident was when Mary Richardson, later known as 'Slasher Mary', attacked Velászquez's painting of Venus which hung in the National Gallery. Mary Richardson had wanted to draw a parallel between the public's indifference to Emmeline Pankhurst's health and their respect for a valuable object, saying that 'You can get another picture, but you cannot get a life, as they are killing Mrs Pankhurst.'[44] Velázquez's painting was not the only painting to be attacked. In May 1914 portraits of Henry James and the Duke of Wellington, a painting by Bellini and *Primavera* by George Clauser were all attacked by suffragettes.[45] In the same year a woman spoiled a painting by Romney that hung in Birmingham Art Gallery, while another tried to mutilate a portrait of the King in the Royal Scottish Academy.

Emmeline Pankhurst's conviction in April 1913 was followed, according to the WSPU, by the biggest revolutionary outbreak that Britain had seen since the struggle for the 1832 Reform Bill. Suffragettes damaged a goods train, cut telephone wires, ruined flower beds, broke the glass of thirteen famous paintings in Manchester Art Gallery, damaged several pieces of art elsewhere and destroyed letters and other materials in pillar-boxes.[46] Buildings were also set on fire: country houses in Chorley Wood and Norwich, a house in Potters Bar, several houses and a Free Church in Hampstead Garden Suburb, a grandstand at Ayr race-course, Cardiff and Kelso race stands and a number of public buildings. Suffragettes exploded a bomb at Oxted station and set off an explosion near Dudley Castle. Windsor Castle was closed to the public and heavily guarded. A few months later, when Emmeline was rearrested on her return from America, suffragettes protested by

picketing Exeter Prison and beginning a militant campaign in Devon.[47] They set fire to a local timber yard which, despite the combined efforts of the Devonport, Plymouth and Stonehouse fire brigades to dampen the blaze, cost approximately £12,000 to rebuild and replenish. A copy of *The Suffragette* and two postcards were found at the site, one of which said: 'Our reply to the torture of Mrs Pankhurst and her cowardly arrest at Plymouth'.[48] Another record wave of militancy followed her rearrest in March 1914. The Home Secretary's house was attacked and eighteen windows broken; a cricket pavilion was burned down in Birmingham; the Medical Prison Commissioner for Scotland was horse-whipped; and the inside of Birmingham Cathedral was covered with graffiti saying 'Stop Torturing Women'.

Emmeline always took full responsibility for suffragette illegal activities. In one inflammatory speech she stated: 'we are not destroying orchid houses, cutting telegraph wires, and injuring golf links in order to win the approval of the people who are attacked. ... I am the head and front of the movement, and in many cases have incited people to do these acts. ... I want to say here that for all that women have done up to now, and what women will do in the future, short of taking human life, I take full responsibility ... so long as I am at liberty I shall be plotting and planning.'[49] She constantly challenged the government to imprison her, saying: 'It is very wrong that other women should be sent to prison and punished, as they have been today, while I who have incited them should be at liberty.'[50] When a number of Liberal MPs visited Christabel Pankhurst in Paris to talk about 'some graceful way of allowing the English Government to back out of its present disagreeable predicament', her mother remained obdurate. She refused to negotiate another truce, arguing that the previous 'Conciliation Bill was the last chance we gave the Government of getting out of the situation gracefully'.[51] Militancy, she asserted, would continue.

IMPRISONMENTS AND THE 'CAT AND MOUSE ACT'

On April 25th 1913, because of adverse publicity, the Prisoners' Temporary Discharge for Ill-Health Act – soon dubbed the Cat and Mouse Act by the WSPU – became law. Fourteen out of twenty-one Labour MPs voted for the second reading of the Bill, leading the WSPU to proclaim that Labour MPs had yet again betrayed women. The Cat

and Mouse Act temporarily released persistent hunger strikers from prison to give them time to recover. As soon as their health improved, suffragettes were required to return to prison. Emmeline Pankhurst was the first person to benefit from the government's new strategy of releasing suffragette prisoners on licence. The first licence came under the Special Order of Licence under the Penal Servitude Acts 1853 to 1891 and preceded the licences granted under the (Cat and Mouse) Act. It gave Emmeline Pankhurst fifteen days' freedom (unless she was convicted of some other offence or broke any conditions, whereupon the licence would be immediately revoked). She was due to return to Holloway by 4 p.m. on April 28th 1913. True to form, she declined to hold herself bound by such conditions, auctioned her licence for £100 and continued to campaign for women's suffrage. From then on, Emmeline Pankhurst and the government played their own game of cat and mouse, where she was arrested, imprisoned, refused to eat and was released.

Emmeline Pankhurst's prison record 1913–14 under the Cat and Mouse Act

1913

February 24th	Arrested and charged with incitement
February 27th	Released from Holloway after trial moved to April 1st
April 3rd	Sentenced to three years' penal servitude for incitement
April 12th	Released on licence for 15 days in critical condition after hunger strike of nine days; due to return April 28th
May 26th	Rearrested at Woking (at Ethel Smyth's home) on her way to the Pavilion
May 30th	Released after four days' hunger strike and compelled to return on June 7th
June 14th	Rearrested at Emily Davison's funeral
June 16th	Released after hunger strike in very weak condition
July 21st	Rearrested at London Pavilion
July 24th	Released after hunger strike
December 4th	Rearrested at Devonport after trip to America
December 7th	Released

| December 13th | Rearrested on Dover Express after visit to France |
| December 17th | Released |

1914	
March 9th	Rearrested in Glasgow
March 14th	Released
May 21st	Rearrested outside Buckingham Palace
May 26th	Released
July 8th	Rearrested at Lincoln's Inn
July 11th	Released on four day licence
July 16th	Rearrested Campden Hill Square
July 18th	Released on four day licence; leaves for France instead

As soon as Emmeline was thought to be too weak, in a dangerous condition or else had the 'odour of malnutrition' about her, she was released from prison. Prison doctors justified her release on grounds of age and ill health. They wrote that 'taking into consideration her age, history of heart affection, refusal of all medical examination and the short period that has elapsed since her previous imprisonment I think it would be advisable that she should be discharged tomorrow'.[52] For example, on one occasion in 1913 she was sent home at the end of the third day of her first thirst strike in a condition of jaundice, drinking a glass of her usual brandy and soda before she left.[53]

Her health, never good, continued to deteriorate considerably. 'From her medical case papers, it appears she lost 10lb in weight between May 26th and May 30th 1913.'[54] During a three day imprisonment in mid-July 1914 she 'lost almost a stone in weight. She suffered greatly from nausea and gastric disturbances and was released in a toxic condition with a high temperature and a very intermittent pulse. She is nervously shocked by all she has gone through and is unable to sleep properly, her rest being disturbed by dreams and by neuralgic pains.'[55] At one meeting she needed an invalid chair: 'They put her down on the stage, and she was so weak that all she could do was to lift her hand ... she couldn't say anything, she couldn't lift her head; she just lifted her hand about six inches up.'[56] She had, according to sympathisers, lost her energy, was 'frail and shattered', needing to be 'helped down steps by a

nurse and a friend. When she was seated the deadly pallor of her face betraying a state of collapse'.[57] Emmeline was once again very near death.

After her early prison confinements she would be greeted by large turnouts of women and would go and celebrate. Towards the end, however, she was in too weak a state so would go to stay at a nursing home or to recuperate at the house of another WSPU member, such as Mrs Ayrton at 41 Norfolk Square. At one nursing home she was sent a jacket by a fan, Mrs Harben. 'How very dear of you to think of sending me the pretty "sitting up" jacket. I had sent all my trunks down to the country I am wearing it today, with very great delight.'[58] After Christabel had fled to France, she sometimes went there to recuperate, staying on once to see her oldest childhood friend, Noémie Rocheforte, whom she had not met for years and who now lived in Geneva.[59] In August 1913 she stayed at Deauville as the guest of Ava Belmont, an American suffragist, and while there planned her next American tour.

AVOIDING ARREST

Throughout this period Emmeline Pankhurst resisted rearrest. On a number of occasions this led either to farcical scenes where the police were made to look ridiculous or, more often, to episodes of extreme physical violence. Sometimes she managed to evade the police altogether. The flat in Little Smith Street, Westminster, where she now lived, was under constant surveillance by police detectives, and it was impossible for her to have any freedom of movement. Even so, she managed to escape by using a decoy. Suffragettes often assumed a false identity to evade arrest or to enter buildings: Grace Roe used to wear a vivid blonde wig as her camouflage and many suffragettes dressed up as charwomen to get into buildings before meetings began. Nellie Hall Humpherson used various disguises to avoid arrest, insisting that the best was a white veil with a pattern on it. On one occasion Annie Kenney hid in Marie Lloyd's dress-box to get into the London Pavilion undetected (Marie Lloyd was to appear on stage on Saturday night and the suffragette meeting was scheduled for Sunday, when the theatre was officially closed). On July 19th 1913 a woman, heavily veiled and dressed in clothes identical to those of Emmeline Pankhurst, came out of her flat. She appeared to be in a collapsed condition and was sup-

ported by a nurse. The police, assuming it was the leader of the WSPU, promptly arrested her and placed her in a taxi bound for Holloway. Police complained that 'on leaving the house we were subject to abuse from the women who were still waiting on the doorstep and in the vicinity of the house'. The language used was 'cowards', 'pigs', 'dogs', 'brutes', 'syphilis and Gonorrhoea', the last two words being doubtless inspired by the recent article in *The Suffragette* headed 'To Cure White Slavery'.[60] Some time later, when the woman lifted her veil, the police officers discovered their mistake. The Mouse, yet again, had escaped the Cat. Meanwhile, Emmeline had driven off to Ongar, where she was entertained to a 'merry supper party' that night and spent the next day reclining in a deckchair in the garden.

If the WSPU could not defeat the police by cunning, then they put up a fierce struggle to stop the arrest of their leader. By this time Emmeline had her own bodyguard of women trained in ju-jitsu – two nieces of a famous QC pretended to be her housemaid and parlour maid.[61] When police tried to arrest her at the London Pavilion in July 1913, the bodyguard, under the leadership of General Flora Drummond, made its first appearance. The bodyguard made 'no appeal to the aid or protection of men Experience proves that Suffragists will, politically speaking, never stand on firm political ground, until they are able to make themselves independent of the help of men.'[62] Because of the bodyguard's defence 'pandemonium followed. Women and police struggled for the possession of Mrs Pankhurst. Down the passage they swayed, a struggling surging mass.'[63] She was eventually recaptured and taken to Holloway. Not surprisingly, many people, especially men, were injured when policemen deliberately targeted them. One man was beaten several times with a stick, cutting his head severely and causing 'the blood to stream all down his face and to splash all over the floor and on to the literature table'.[64]

After this episode, she was not rearrested until the beginning of December, which she (wrongly) attributed to the government's intention to abandon the Cat and Mouse Act. She was therefore able to speak at a number of the WSPU weekly meetings uninterrupted by police – indeed the police were notable by their absence – unlike previous meetings which had been swamped by 'blue uniforms and helmeted figures'. Between October and November 1913 Emmeline toured America. When she returned in December 1913, she was rearrested for the fourth

time under the Cat and Mouse Act. She had arrived on the White Star liner, the *Majestic*, at Portsmouth on Thursday morning to be met at the dock gate by a crowd of about 5,000 people – and her bodyguard. Just before the liner docked, two war ships obscured the view of the ship from the visiting crowd and blocked the path of a WSPU tug that was steaming out to warn her of her impending arrest and perhaps rescue her from it. In another vessel a wardress and six police officers sailed up to the liner, boarded it, arrested Emmeline and took her on shore, not to the usual landing place at Plymouth but to a landing stage at Devonport used exclusively by government ships and inaccessible to the general public. There she was put into a waiting motor car and conveyed to Exeter prison. Meanwhile, forewarned of her impending arrest by a suffragette wireless, she had made her own plans. Anxious that the police would confiscate the money she had collected in America, she entrusted it to Rhetta Dorr, her travelling companion and amanuensis. Rhetta Dorr sewed nearly 20,000 dollars inside the lining of her corset and took it to the home of a sympathiser, who forwarded it to Christabel in Paris.[65]

Emmeline Pankhurst was released on Sunday December 7th 1913 after her usual hunger and thirst strike. From there she travelled in an ambulance carriage to Victoria station and caught the train to Paris to see Christabel and regain her strength, only to be rearrested less than a week later on the returning train.[66] Fearful that the women's army would rescue her, detectives met the boat from Calais and travelled to London in the train compartment adjoining hers. Stringent precautions were taken when she arrived at Victoria station and only uniformed police officers, detectives and women accompanied by men were allowed on the platform.[67]

Early in 1914, when she tried to speak in Campden Hill Square, the police tried to arrest her, only to be fought off once again by her female bodyguard. Any attempt at arrest was met with resistance. On this occasion the police were badly harassed, punched and struck over the head with sticks by the bodyguard. Several times policemen were thrown to the ground and later confessed that it had been the toughest fight for them. Again, fooled by disguise, they arrested the wrong woman and Emmeline slipped away.[68] Later that month she moved to Glebe Place, Chelsea, where she addressed a crowd of some thousand strong from the balcony of the house. When the police tried to arrest

her, the women's bodyguard, now armed with clubs, leapt into action and a fierce and violent tussle took place. Emmeline again went free.

One of the most serious fracas took place on March 9th 1914, when, just after being released from prison, she spoke to an audience of 5,000 women and men at St Andrew's Hall in Glasgow. The hall platform was defended with barbed wire several feet high concealed under green muslin drapes, to prevent the police from climbing on to the platform. When the police attempted to arrest Emmeline, her bodyguard 'took up flower-pots, water bottles, glasses, buckets of water, chairs, forms and everything they could use and commenced to assault the police'.[69] In response, the police wielded their batons and several women had their heads cut open down to the bone.[70] To add to the confusion there were explosions, flashes and revolver shots. In the midst of this turmoil the heavily guarded WSPU leader was knocked down twice by the police and dragged half-fainting to a taxi, where she was flung on to the floor and struck several times on the back by the detectives arresting her.[71] Police broke the chain around her neck into several pieces, tore off her fountain pen and ripped off a velvet bag that was attached to her waist. After this skirmish an injured Emmeline had, according to her doctor, 'numerous bruises over her ribs and on her limbs; both her ankles were cut, and the left one was swollen and discoloured. These injuries must have been sustained either at the time of her arrest or while she was being conveyed to the police station.'[72] The police naturally denied this and claimed that the doctor who examined Emmeline was too sympathetic to the suffragette to report her condition accurately. At the nearby police station she was put into a cell that was in a very neglected and dirty condition. A medical doctor noted: 'I found her standing in a large and dirty cell entered by a door consisting of vertical iron bars about six inches apart. The floor was concrete; the walls of glazed tiles originally white but so thick with dust that people had written on them with their fingers. There were two wooden chairs and in one corner was a leaking insanitary convenience.'[73] At about midnight a mattress and some rugs were brought in so that she could sleep. Next day Emmeline was put on the train to Euston and the carriage doors of other suffragettes were locked so that they could not protest when police carried her out at an unscheduled stop near Kilburn. Five days later, on March 14th, she was released from Holloway and driven in a cab back to the house of her friend in Campden Hill Square, Kensington. The seemingly endless

sequence of rearrests took its toll on the suffragette leader. When she was rearrested for the last time, on July 16th 1914, she was in danger of becoming the second martyr to the suffragette cause.

CONCLUSION

Militancy may have galvanised debate but it did not always win public sympathy. It is argued that it turned the WSPU into an association of vigilantes, simultaneously irresponsible and apocalyptic. Far from winning fresh support, it alienated even those who would otherwise have been sympathetic. Andrew Rosen claims that just before the First World War all the best minds had deserted Emmeline Pankhurst and the WSPU because of its increased militancy. However, Leah Leneman's research contradicts Rosen and indicates that the 'traffic was by no means only one way':[74] many former suffragists, fed up with the failure of the Conciliation Bills, switched their allegiance to the WSPU because they feared that non-militant methods were failing. Leah Leneman shows how women like Fanny Parker, a niece of Lord Kitchener and former suffragist, joined the WSPU in 1912 and, less than two years later, was caught trying to fire the cottage where Robbie Burns was born. Moreover, the financial contributions continued to roll in; between March 1913 and February 1914 the WSPU collected over £28,000 in subscriptions alone. Meetings too raised large sums; one organised by Annie Kenney drew £16,350 in promises from the audience.

The split with the Pethick-Lawrences was not the first and it was to be by no means the last. In January 1914 Sylvia, summoned to Paris by Christabel and her mother, was informed that she must either 'toe the line' or sever all links with the main section of the WSPU. At this family meeting Christabel criticised her sister for speaking at a meeting in support of an Irish Trade Unionist who had been sentenced to prison for sedition. Sylvia was firmly reminded that 'those who wish to give an independent lead, or to carry out either a programme or a policy which differs from those laid down by the WSPU must necessarily have an independent organisation of their own.'[75] On January 27th 1914, at a meeting held at Bow, Sylvia's group decided to become a separate organisation from the WSPU and to call the new organisation the East London Federation of Suffragettes. Two days later Emmeline Pankhurst wrote to her 'dearest Sylvia' saying that neither she nor Christabel

approved of the new name 'because the use of the word "suffragettes" would be altogether misleading to the public'. She suggested alternative names: East London Women's Federation for the Vote; East London Working Women's Franchise Union. Sylvia ignored her mother and continued to use the name ELFS until the middle of the First World War. Adela, the youngest of the daughters, was also summoned to Paris in 1914. Once there, she was given the fare to Australia, a letter to an Australian suffragist (Vida Goldstein), £20 and some woollen clothing. She sailed for Australia on February 2nd 1914 and was never to return to England or see her mother again.

By early 1913 the message of conformity was a strong one. As usual, the suffragette leader eschewed democratic discussion in favour of direct action and the WSPU Annual Report strongly urged that 'there is now, as always in the past, one policy, one programme, and one command. The WSPU was founded by Mrs Pankhurst and Miss Christabel Pankhurst and it is they who now, as always, frame its policy and programme and give the word of command.'[76]

Since the age of 27 Emmeline had expressed her readiness to sacrifice her freedom for her political principles. In 1885, when she accused a judge of allying himself with the Tory Party, she could have been convicted of contempt of court; in 1896 she had, with Leonard Hall, been summonsed for her actions at Boggart Hole Clough. The suffragette years were her apotheosis – her principles were put to the hardest test of all. This tiny, ethereal, middle-aged and menopausal woman faced trials and imprisonment that would have challenged the courage and resilience of someone much younger. She endured hunger, thirst and sleep strikes and managed to overcome her personal fastidiousness and the impediments presented by her physical frailty. Her determination to win the vote at whatever cost to herself, to her family, her friends and the members of the WSPU inspires amazement if not awe. Christabel remained out of harm's way in Paris; her daughter Sylvia, who endured an experience similar to her mother's, was visibly weakened from her several hunger and thirst strikes; and her sister, Mary, had died from heart problems exacerbated by her prison experiences. Exhausted and dangerously weak, Emmeline Pankhurst embarked on lecture tours to America and Canada, which, although physically arduous, would provide a much-needed respite from the tortuous conditions she had imposed upon herself in Britain.

8

INTERNATIONAL FUND-RAISING
1909–13

On October 25th 1909 Emmeline Pankhurst, wearing a purple velvet frock with green lining and a white bodice, a necklace of amethysts, emeralds and pearls and a corsage of violets, white gardenias and green foliage, stepped out on to the stage at Carnegie Hall, New York. Dressed, if not to kill, then certainly to disarm, she wore her suffragette colours as a military and militant emblem. In this elegantly feminine political attire she began the meeting with the words: 'I am what you might call a hooligan.'[1] The audience, almost entirely made up of women, erupted in applause: Emmeline Pankhurst had arrived in America.

It may have been Emmeline's first visit to the USA but it was not her first contact with American suffragists. Since her youth she had made friends with leading women's suffragists from across the generations, Susan B. Anthony, Elizabeth Cady Stanton and her daughter Harriot Stanton Blatch, Alice Paul, Lucy Burns and Elizabeth Robins among them. In particular, Harriot Stanton Blatch, who had married an Englishman and lived in England for a number of years, was a long-standing friend. Both had much in common: they were roughly the same age, were young mothers, newly converted to socialism, members of the Fabian Society and involved in the suffrage movement.[2] Eventually, in the summer of 1902, after twenty years of living in Britain and less than a year before the WSPU was founded in England, Blatch returned to the USA, where she focused on the campaign for women's suffrage.

A number of notable American writers and intellectuals were also involved in the British suffrage movement. Elizabeth Robins, an actress and writer, was on the executive of the WSPU and helped with suffragette propaganda and publicity, writing articles and novels such as *The Convert* and *Where Are you Going To?* to promote women's suffrage; the historian Mary Ritter Beard had worked in the WSPU; the journalist Rhetta Childe Dorr, who accompanied Emmeline Pankhurst to America in 1913 and who ghosted her autobiography, was an activist in the WSPU. Various other Americans became involved in illegal activities. Two of the most famous American militants, Alice Paul and Lucy Burns, played an important role in the WSPU before eventually returning to America to take a leading role in the suffrage movement back home.

Yet not all American suffragists were sympathetic to Emmeline Pankhurst. The American suffrage movement was, like the British movement, divided into two main groups. Harriot Stanton Blatch and Alice Paul represented the radical militant wing, whereas Anna Shaw, President of the National American Women's Suffrage Association (NAWSA), and Carrie Chapman Catt, President of the International Woman's Suffrage Alliance, represented a more conservative and cautious group. Carrie Catt, ambivalent about the tactics of Emmeline Pankhurst, likened her to John Brown, saying that 'my heart aches for that woman who is either a liberator of her sex or a serious trouble-maker. Time will tell which.'[3]

This was the political context in which, on October 13th 1909, Emmeline (accompanied by Mary Pethick, sister of Emmeline Pethick-Lawrence) sailed first class on the *Oceanic* from Southampton to New York. Less than a week later she arrived in New York. She had come with a two-fold purpose: to collect money for her son Harry and to spread the message of the WSPU. Her son was gravely ill at this time and in need of expensive medical treatment so she had written to Harriot Stanton Blatch to ask her to organise a lecture tour for her since money was urgent. She also claimed that 'the movement, to be a thorough success, must be international'.[4] Elizabeth Robins warned her that she might have difficulty entering America, but the suffragette leader smoothed her worries by writing: 'I don't think there is any need to fear trouble about my landing. Should there be, it will be a splendid advertisement of the Cause ... I shall make friends with all on board and I don't think the authorities will care to make a martyr of me.'[5]

It was to be a busy schedule. She left New York the day after her arrival on the 10 a.m. New York express train to give her first lecture in Boston on 22nd October, the Friday night. On Saturday she travelled to Worcester, Massachusetts, to return to New York on the Sunday for an afternoon reception and a big evening meeting at Carnegie Hall. She spoke in several cities: Louisville, Cleveland, St Louis, Kansas City, Cincinnati, Philadelphia and Connecticut. On November 5th 1909 in Washington she was given lunch at the Teacup Inn by the College Equal Suffrage League, delivered a lecture on women's suffrage at the Masonic temple and met with the heads of various local organisations.[6] On November 25th she visited Chicago. At 3.30 p.m., dressed in her familiar lavender and carrying a bunch of violets in her hand, she stepped down from the train that had brought her from Detroit.[7] When asked about her journey, her first need, she said, was for a cup of tea. She had arrived on Thanksgiving Day, the most important American national holiday, resulting in many traditional turkey dinners being postponed so that leading women suffragists could meet her.[8] Not all suffrage societies welcomed her so enthusiastically; she was only allowed to speak to the Greenwich Equal Franchise League after a two-hour discussion, since they feared that her presence might lead to a loss of public support for women's suffrage in America.[9]

At each meeting she wore her purple 'uniform' and gave her standard 'American' speech. Wherever she spoke, the focus of her lectures was always the same: 'I shall tell the Americans the story of the militant Suffragette movement and how it became into being. I cannot forget that it had its inception in America.'[10] As ever, she was a consummate politician, constantly making links between Britain and America in her speeches and insisting that she owed 'all her interest in the movement' to the American heroine Susan B. Anthony. In Chicago she drew comparisons between the women's suffrage movement and the Boston Tea Party. American men and women, she argued, had organised numerous meetings against taxation without representation, but it was not until the Boston Tea Party and subsequent events that independence was eventually won. Suffragettes, she maintained, copied this type of direct action and had only turned to militancy when it became the only way left to obtain justice. In one impassioned plea she beseeched Americans not to criticise her methods of securing the vote unless they knew of the conditions that drove her to it. 'We took to stone throwing', she

insisted, because it 'seemed to be the only method the men could understand. But even then no stones were thrown until we were refused permission to call upon the Prime Minister.'[11]

When she spoke at meetings, Emmeline made no effort to urge her audience to pursue militant tactics in America.[12] In private, she was not so circumspect. On her first visit to America she met Elizabeth Robins' sister-in-law, Mrs Raymond Robins, who had welcomed her to America on behalf of working women. In a letter to Elizabeth Robins she wrote that she hoped that she would meet Mrs Raymond Robins again to discuss the future of the women's movement in America. 'The orthodox suffrage movement,' she claimed, 'is just where ours was a few years ago and it needs women of your sister's stamp to get it out of the rut and bring it into real life.'[13]

Interestingly, her views on 'white slavery' and the vote were just beginning to emerge in public. On a few occasions she discussed the relationship between women's suffrage and 'white slavery' and drew links between single motherhood, infanticide and prostitution. In Chicago she spoke of her work as Registrar of Births and Deaths, recounting a familiar story of how a young domestic servant was convicted of murder for leaving her new-born baby outside to die of exposure. In her opinion the father (who was also the servant's employer) was equally guilty yet had not been prosecuted. The 'white slave' traffic in places like Chicago, she insisted, could be wiped out in a day if women had the vote.

CANADIAN TOUR 1909

In November 1909 Emmeline Pankhurst left Buffalo, New York, on the Grand Trunk express heading for Toronto. She was met by Flora Denison, an indefatigable worker for the suffrage movement, who contributed a weekly column on women's suffrage to the *Toronto Sunday World*. Flora Denison was a central figure in forging links between the WSPU and the Canadian suffragists, for her weekly column provided a major source of information about the WSPU. Certainly, Denison believed that the WSPU leader had kept votes for women 'a red hot political question' throughout the world. Until militancy was adopted, she argued, little notice was taken of the movement, maintaining that, as a result, 'from the prisons of Siberia to the capitals of life and fashion,

from the jungles of South Africa to the ships in mid-ocean the name of Mrs Pankhurst is known'.[14]

The majority of Canadian suffragists disagreed that militancy was the way forward. In contrast with both the British and the American women's suffrage movements, Canadian suffragists generally behaved rather decorously in their campaign for the vote, lacking the flamboyant militancy of some of their British and American counterparts. The methods used by the Canadian Suffrage Association (CSA) mirrored those of the NUWSS in England. Canadian suffragists rarely interrupted politicians and would never even contemplate the idea of breaking windows, pouring acid on golf courses, destroying works of art, burning down buildings or throwing themselves under horses. Theirs was a peaceful protest that used intellectual persuasion rather than physical force. Although Canadian suffragists might not have subscribed to militancy, they were very willing to listen to English suffragettes talking about their law-breaking activities. Emmeline Pankhurst exploited her extraordinary world celebrity to the full. On this trip she remained in Toronto and spoke to capacity audiences at three different venues: the Men's Canadian Club, Massey Hall and the Princess Theatre.

Emmeline Pankhurst was the first woman ever to speak at the Men's Canadian Club, an all-male organisation made up of prominent business executives. Fortunately, according to the press, she quickly enchanted them and 'before she began her second sentence she had captured the entire audience. Her manner, her voice, soft, yet distinct and winning, her clear reasoning and her calm faith in her subject and in herself, made it impossible to escape from her extraordinary influence.'[15] Of course, being Emmeline, she tailored her lectures to each audience. To the members of the Canadian Club she focused attention on the business side of the WSPU, emphasising repeatedly that she was a businesswoman and that the WSPU was essentially a business movement. This somewhat distorted account of the WSPU would have had an obvious appeal to business executives; it would have had the important effect of lessening their fears of extremist politics. In addition, cleverly, so as not to upset this predominantly Conservative masculine company, she added that women needed the vote because their point of view was essentially different from that of men. The female point of view, she argued, was needed to help frame domestic legislation since women could provide a unique perspective which men were unable to offer. She insisted that she

wanted to disabuse them of the idea that the movement consisted of 'a lot of irresponsible, hysterical women going about in an irresponsible way making scenes'.[16]

At her second meeting in Massey Hall she spoke to a mainly female audience estimated at over 5,000, which included women 'from the society dame, blasting with diamonds, to the plain working woman'.[17] Again, although many had attended out of curiosity rather than approbation, she allegedly charmed her audience with her presentation, transforming initial antagonisms and inquisitiveness to admiration. She spoke in 'a clear, sweet, womanly voice, and stood practically without bodily movement except the movement necessary to send her voice out to the farthest parts of the great hall … without apparent effort …. She made no gestures with her arms …. Her oration rose rapidly in its influence, not by increased forcefulness in delivery or by a louder voice or more rapid utterance but by a gradual increase in spiritual feeling and earnestness of purpose on her part.'[18] Moreover, Emmeline Pankhurst told them what she thought they wanted to hear. To this audience, she concentrated on conditions in England, giving them a history of the suffrage movement and of her place and the WSPU's within it, defending the tactics of the suffragettes on the ground that constitutional methods had either failed or been denied them. By the time she had finished, it was difficult for the people of Toronto to think of the suffragette leader as participating in, inciting or approving of the acts of militancy reported in the press. When she spoke of militancy, she played down her illegal activities, emphasising what the government did to WSPU members if they broke the law and giving vivid descriptions of the treatment of imprisoned suffragettes, especially of the forcible feeding process. She continually stressed that no serious harm had been done to life and property since it was the suffragettes, not the general population, who had suffered. Indeed, she complained that militants received four months' imprisonment for throwing a stone whereas many men received less 'for destroying the purity of a young girl'. It was also, she alleged, a much 'heavier sentence than a man got recently for holding the hand of a baby inside the bar of a fire'.[19] The audience, as in America, was enchanted. Such was her popularity that a third unscheduled meeting was held at the Princess Theatre.

It is safe to say that the press was overwhelmingly eulogistic, not so much because of what she said but rather because of the way she said it.

Prior to her visit the Canadian press had printed cartoons showing suffragettes as manly, unsexed and unattractive – the inference being that because suffragettes would never be able to get their way by charm they had to take it by force. 'In my mind's eye,' one commented, 'I imagined a hatchet-faced old dame.'[20] Emmeline's personal style, her demeanour and her dress all conformed to a particular female stereotype and played their part in convincing the Canadian press that she was safe. The Toronto newspapers echoed the reporter who spoke of his surprise at 'meeting instead of the Amazon type he had expected, the very reverse, the woman of palpable culture and refinement, low-voiced, courteous, well-bred. She is the last woman you would imagine leading a band of shrieking sisterhood against the blue coats of Westminster Personally she is charming, slight, graceful, and well groomed'.[21] All focused more on her appearance than on what she had to say. 'Mrs Pankhurst is a quiet-looking woman, still under middle age, of medium height, with abundant pretty brown hair, blue-eyed ... she has a gracious presence and a peculiarly rich voice, full of colour and sympathy.'[22] Moreover, because she appeared well groomed and respectable the press, as well as the audience, identified with her and were captivated. The reality, they all cried, differed from the reputation. 'They had read of the deeds of the militant suffragettes and they had received an impression of hysteria and violence but Mrs Pankhurst's addresses were calm, logical and weighty.'[23] Her lectures were characterised by perfect self-possession, a command of her material, a ready sense of humour, white heat enthusiasm and surprising self-control.[24] She had, they asserted, 'proved herself the cleverest of all the women that have ever stood upon a public platform in Canada.[25] 'There were no frothy appeals to sensibility, no mouthing of outworn phrases, none of the hysterical clap-trap that one might have been led to look for from newspaper accounts of suffragette methods. It was a plain strong story from beginning to end, and one of the best speeches ever heard from a woman in this city.'[26] Some even believed that future generations 'shall call her blessed'.[27] Emmeline Pankhurst's first Canadian tour was a triumph. As one newspaper report put it, 'she came, she saw, she conquered'.[28]

AMERICAN TOUR 1911

In October 1911 Emmeline returned to America and stayed until January 18th 1912, travelling an impressive 10,000 miles and deliver-

ing approximately 40 lectures on women's suffrage. It was an exhausting schedule. She wrote to Elizabeth Robins:

> This tour of mine is a strange experience. I do not stay long enough in any place to learn very much of either place or people and my mind is full of impression. I almost went to Florida but the distance was too great to cover for one meeting. What a huge country this is. I have lost count of the thousands of miles I have travelled. Out of all the confused impressions comes clearly the fact that everywhere the woman's movement is growing steadily.'[29]

Once again, she came as guest of Harriot Stanton Blatch, who had renamed her organisation the Women's Political Union (WPU) shortly after Emmeline Pankhurst's 1909 visit. The WPU not only echoed the name of the British organisation but replicated many of its principles and practices. It copied the less militant tactics of its British counterparts such as organising mass delegations and threatening to oppose candidates who did not endorse women's suffrage. In addition, it eschewed democratic convention. The WPU 'had no intention of ever calling the membership together and having majorities clip its wings. No time was to be wasted converting the laggards inside our organisation, manipulating our elections.' In Blatch's view, 'a small band, enthusiastic and determined, could remove mountains'.[30] The WPU also adopted the colours purple, white and green, and so souvenirs and banners which had been used in England were sent to the American organisation to add colour to its demonstrations.

According to the *New York Times*, Emmeline Pankhurst looked a lot healthier than she had in 1909. She had rosy cheeks and was without the 'careworn and weary expression' which was notable on her last visit.[31] It was not surprising that she looked better. At the time, the WSPU had 'laid down their arms' while a Conciliation Bill, that would have enfranchised women, was being debated in Britain. As in 1909, she spoke of the need for militancy and insisted that the stone throwing methods of the WSPU had been responsible for the formation of thirty other suffrage organisations in Britain. During this visit she felt confident enough to voice her opinions about American suffrage. Speaking under the auspices of the Cook County League of Women's Clubs in

Chicago, she maintained that peaceful meetings would never bring the vote to women and urged Chicago women to 'get out on the streets' [32]

By 1911, her ideas about the relationship between suffrage and white slavery had consolidated. Speaking to an audience of approximately 4,000 at the Brooklyn Academy of Music in New York, she proclaimed that white slavery occurred 'because women are cheap. Because they are not paid enough to keep body and soul together …. How can we overcome this traffic? Give us the vote.'[33] On some occasions, abandoning her previous caution in offering advice to the Americans, she drew upon American examples to argue her point. 'I have been irritated,' she claimed, 'by hearing people say that American laws were better than British laws because men would give women what they wanted.' This, she argued, was untrue, using examples of the age of sexual consent as proof. She told audiences about places in America where the legal age of consent was much too low: in Georgia and Mississippi the age was 10, and in Kentucky it was 12.[34] Once over the age of 10, she declared, a girl could 'consent to her own ruin', an iniquity that would cease once women were enfranchised because they would not allow such dreadful laws to continue. Pursuing this theme, she drew links between women, low pay and prostitution, arguing that young women were forced into selling their bodies because they could not earn enough to support themselves. The white slave traffic, sweatshops, poor parental care and educational ignorance were all attributed to male incompetence.

But Mrs Pankhurst was not always made welcome. On November 28th she was banned from speaking at Harvard University, the authorities claiming that university buildings were not the proper place for public political agitation, especially since Harvard was a men's college and it was inappropriate that a woman should speak there.[35] This prompted the son of the black activist William Lloyd Garrison to write that the 'University stupidly refused the use of any of the college halls for the lecture, and so gave it a splendid advertisement and ensured a packed house' when she spoke elsewhere.[36] Moreover, not all suffragists wanted to hear her. In Spokane suffragists declined to arrange a meeting for her because they disagreed with her militancy.[37]

CANADIAN TOUR 1911

In 1911 Emmeline visited Montreal, Port Arthur, Winnipeg and Victoria, as well as Toronto. On December 12th 1911 she once more enthralled a large audience of over 1,600 at Massey Hall, Toronto: 'without indulging in flights of oratory, she has the power of marshalling her facts in irresistible sequence, of making her points clear to the last degree'.[38] However, enthusiasm for her was waning; audience numbers were significantly lower than those she had attracted on her previous visit. In fact, Emmeline never received the same degree of adulation again. Audiences, their curiosity sated by her first visit, no longer flocked to hear the famous and notorious English militant. Equally, Canadians might well have abhorred the increase in suffragette militancy and did not wish to sanction it by attending her lectures. This time, as well as justifying the increase in militancy, Emmeline spoke of current affairs in Britain, the injustice of child labour and of the need for decent pay for women workers. She urged women to work for the vote in order to raise the moral position of their sex and to stop the white slave traffic, one of the greatest curses against women. Her arguments would have struck home in Canada, since the white slave issue was a burning one for suffragists who were concerned that lax moral standards were leading to a degeneration of the race.[39]

The focus of Emmeline's lectures was different from that of her last visit but, sensitive to local opinion, she still targeted each talk to her audience. For example, at the Women's Canadian Club she praised the formation of clubs for women.[40] In December 1911, when she visited the farming community at Winnipeg as the guest of the University Women's Club, she touched on the homestead issue.[41] Moreover, she continually emphasised the collapse of class divisions in the WSPU – which must have made her popular with Canadian audiences critical of the class structure in the home country. When she visited Vancouver, the largely Conservative audience was wooed by her ladylike demeanour; she confined her speech to the history of the suffragette movement, emphasising its constitutional work and avoiding any reference to militancy. 'Militant as she may be in methods she did not show it in her tones last night. She speaks clearly and distinctly but in the low-pitched and well-modulated tones of the educated Englishwomen,

and uses hardly any gestures, for the greater part of the time standing with her hands behind her back. She smiles slightly at times as she recalls some instance of defeating the watchfulness of the police or turns a neat phrase at the expense of the government but generally is grave-faced and earnest.'[42]

Two years earlier she had insisted that she had 'not sufficient knowledge of the conditions on this side of the water to give such advice. The women of Canada and the United States must choose their own methods.'[43] She insisted that her object was to explain and defend the British WSPU not to encourage Canadians to be militant. In private she told Elizabeth Robins that she believed 'Canada is quite ripe and is only waiting for leaders. Oh to be young again with all this wide world to conquer!'[44]

This time her visit provoked a mixed response. Her firmest supporter, Flora Denison, stated that she loved and admired Emmeline Pankhurst 'beyond any woman in the world'.[45] In her opinion, she had aided the Canadian suffrage cause tremendously by revitalising the movement. Nellie McClung, another leader of the suffrage movement, maintained that the suffragette leader's second visit had contributed to the founding of the Winnipeg Political Equality Club. Even her advocacy of militant tactics evoked sympathy and tolerance in some areas. Saint John Suffragists refused to 'condemn what must seem rude and mistaken methods to us who have had no experience with old country politics, but remember what these English women are fighting for'.[46] In contrast, some of the Prairie states resented 'very keenly the fact that some English woman came out and tried to stampede us into taking violent methods. We had not yet used peaceful methods and we refused to do anything violent until we had.'[47] The press was generally favourable. Many noted that 'she speaks quietly and composedly, she makes her points effectively and succinctly – never a word too little, seldom a word too much'.[48] However, when violence escalated in England, their sympathies declined. In 1913 a leading article in *Saturday Night* protested: 'that Mrs Pankhurst is no longer sane is quite obvious from her recent counsels of violence and even if votes were granted she could not receive the franchise because they clearly come under the classification of idiots and criminals'.[49]

AMERICAN VISIT 1913

In 1913 Emmeline returned to America only to become embroiled in more controversy than ever before. She had come to obtain money for the WSPU and to play the part of herself in an educational feature film, *What 8,000,000 Women Want*. When she arrived at Ellis Island, New York, on the French liner *La Provence* in October 1913, she was not allowed to land. American immigration law forbade the admission of foreigners convicted in their own country of a crime involving 'moral turpitude', so when she confessed to the interviewing immigration officer that she had been in prison, and had countenanced arson, she was refused entry.

The matter of the admission or detention of any American visitor ostensibly rested with the immigration authorities at Ellis Island, but Emmeline alleged that the procedure she went through was too slick and smooth to be authentic. She told the story of how 'the three men judging my case read typewritten papers … and had what looked like prepared documents and prepared questions about my name, how much money I had, where I was born etc'. The WSPU attributed her difficulties in entering the USA to the British government and accused Herbert Samuel (a member of the Liberal cabinet who was at the time visiting America) of trying to prevent their leader from entering the US by putting pressure on the immigration authorities. Their conspiracy theories may have been legitimate, although they criticised the wrong individual. Before her visit the British Ambassador, Cecil Spring-Rice, had telegraphed the Home Office, asking if the government wanted her detained. 'The Immigration authorities,' he wrote, 'have very wide powers of discretion, and it seems probable that Mrs Pankhurst could be prevented from landing, without its being known that the Embassy had taken any action, if his Majesty's Government wish her to be prevented from collecting funds for a fresh campaign in England.'[50] In reply, the Home Office declined the offer so the matter was officially dropped. Nevertheless, when, at the end of her immigration hearing, it was officially announced that she was to be deported on the grounds of having committed a felony and of 'moral turpitude', it is not surprising that she, and her sympathisers, were suspicious.

While she remained on Ellis Island she was given the private apartment of the Prison Commissioner as her accommodation. Rhetta Dorr, an American journalist who accompanied her, remarked on the amount of freedom given to them both. The Commissioner and his aides 'took us all over the island, explained the whole immigration system, and showed us real American hospitality. It amused me to see Mrs Pankhurst inspecting the kitchens, tasting the food, and giving our Commissioner the benefit of her experience in mass feeding during her Poor Law guardianship in Manchester.'[51] Although Emmeline viewed the whole affair as a 'thrilling adventure',[52] she had no wish to remain on Ellis Island nor to return to Britain, so an appeal was immediately lodged. The main suffrage organisations made the strongest possible protest against her detention and there was overwhelming support for her visit to continue. Eventually, President Wilson was forced to intervene on behalf of the suffragette leader. She was allowed to enter the United States on the condition that she leave no later than November 27th and that while in the country she must not advocate the use of violence by American suffragists. This she agreed to do. Of course, not all the press supported her entry, some calling her an 'ignorant and depraved woman' or a fanatic who had a 'brain out of equilibrium'.[53] The Chicago *Inter Ocean* declared: 'if deliberate incendiarism, if the incitement of half-crazed fanatics to assault, arson, pouring acids in mail-boxes, and the destruction of the property of peaceful citizens, does not present evidence of "moral turpitude"', they asked what did.[54]

The main object of Emmeline's lecture tour was to raise funds for the WSPU by arguing the case for women's suffrage, defending militancy and examining the links between the lack of the vote, white slavery and venereal disease.[55] 'The object of my voyage to America,' she told reporters, 'is to answer the question in the minds of the American people, namely why militants do the sort of things they do in England.'[56] Most of her speeches concentrated on the dual topics of militancy and white slavery, on the subject of which she berated all existing governments for not tackling the problem seriously, arguing that if there was no demand there would be no traffic.

As in 1909 and 1911, Emmeline earned her money on an exhausting and gruelling schedule of lectures, visiting Baltimore, Boston, Buffalo, Chicago, Cincinnati, Cleveland, Louisville, Nashville, New York, Providence, and Washington. On this occasion she did not visit Canada.

When she visited Chicago, she spoke to a predominantly African-American audience – a brave gesture in view of the racism which was currently infecting many of the American women's suffrage organisations. At first, early suffragists, like Susan B. Anthony and Elizabeth Cady Stanton, both of whom had learned their political skills in the anti-slavery movement, had championed equal suffrage for all women regardless of race, colour or creed. By the end of the nineteenth century a number of white female suffragists were using supremacist arguments in support of votes for women. A limited suffrage for white women, they argued, would increase the white vote and maintain Anglo-Saxon political hegemony in the South, since black men would be outnumbered. Moreover, the leading suffrage organisation, the NAWSA, endorsed the right of every state to organise as it saw fit, which was seen as an endorsement of the racist Southern suffrage movement. In the autumn of 1913, just before the arrival of Emmeline Pankhurst, white suffragists insisted that their black co-workers be relegated to the back of the demonstration held in Washington for fear of alienating white southerners. Although objections were raised by some, southern sensibilities prevailed over black ones.

Emmeline Pankhurst ignored the inherent racism of much of the American suffrage movement and spoke to a predominantly black audience at the Institutional Church. Here, according to the black press, she 'aroused the volatile emotions of the coloured women by picturing the good they could accomplish for their race by working for the reforms their white sisters advocated'.[57] The keynote of her speech to this black audience was social purity. Militancy was ignored. According to the press, Emmeline 'reechoed the great cry which is sounding in all countries in civilisation for knowledge and light upon insidious venereal disease as the best safeguard against them, for knowledge is always a power As colored people we listened with earnest attention to her remarks.' Interestingly, the *Chicago Defender* implicitly criticised her reluctance to talk about militant activities, as the article went on to say that there was a great battle to be fought against prejudice in America. 'How it could be fought without militancy we are at a loss to know. Militancy has always been the shibboleth since the world began in any cause which has won.'[58] Even so, the Pankhurst lecture was thought to be a 'rare treat'. The white press, which generally gave widespread coverage to her lectures, virtually ignored this talk.

For the most part, Emmeline's speeches concentrated on the twin topics of militancy and white slavery. She would commonly attribute the growth of British militancy to American influence as much as to tradition within British politics. The militant movement, she protested, had been initiated by Susan B. Anthony, who suggested it as the quickest means for British women to secure suffrage. She claimed that Anthony had put forward the idea when she had visited her in England. 'I was not immediately converted to the idea,' she said, 'but years afterward I found that Miss Anthony was right and I followed her suggestion'.[59] When challenged by a Chicago audience that militancy was degrading and detrimental to the cause for which it was used, Emmeline Pankhurst cited American examples to defend its use. 'What a question to ask in America,' she objected. 'You with your Daughters of the American Revolution who pride themselves on their ancestors; you with your revolutionary heroes,' she declared with emotion.[60]

This time she justified militancy as a response to white slavery, inadequate legislation for the protection of women and children and discriminatory laws against women. Although the focus of each talk was on militancy and white slavery, there is no doubt that she designed each afresh for its specific audience. When she was in Chicago, she praised the city's contribution to breaking down the conspiracy of silence surrounding venereal disease and other 'social evils'.[61] Naturally, when she spoke at the Irish club, her main references were to Irish heroes like Parnell, Redmond and Irish rebellion.

By this time, Emmeline Pankhurst had gained the confidence to express her own views about American suffrage. She was not so foolish as to advocate militancy, insisting that she had not come to America to persuade American women to take part in illegal activities but to justify her own. Each nation 'must work out its own salvation and so the American women will find their own way and use their own methods capably'.[62] Nonetheless, she participated in a number of suffrage activities. While she was in New York, she took part in a big procession in Brooklyn organised by the Woman's Political Union.[63] The ultimate object of her suffragette campaign, she maintained, was to unite women all over the world in a movement for the advancement of their sex: 'I want to make all women realise,' she said, 'that there is a bond that unites women of all lands. I want to make women the world over do as we have done in England and tear down all lines of class and organise a

great international movement to advance all women.'[64] She also witnessed some mild American suffrage militancy when Ava Belmont led other suffragists in a raid on a large department store to encourage the women workers employed there to strike because they were over-worked and exploited. A meeting was held by the side of Ava's limousine parked near the store – Emmeline sat inside applauding the speakers vigorously.[65]

Suffragists reacted to her visit in various ways. Ava Belmont considered her 'the most wonderful woman in the world today' and gladly opened the doors of her home to her. Her old friend Harriot Blatch arranged a dinner in her honour, and in 1912 the Daughters of Liberty was formed in her honour. Anna Shaw, who had hosted a meeting on a previous lecture tour, was not so welcoming and expressed regret that Emmeline Pankhurst was visiting America. Firstly, Anna Shaw insisted that the suffragette leader's visit would be an unnecessary distraction for American suffragists, who needed to focus all their attention on their own work and methods. Secondly, she and others thought that Emmeline's advocacy of illegal activities would be detrimental to American suffrage and lose them supporters. The WSPU campaign methods, they argued, were not theirs and 'they feel that theirs have been productive of more satisfactory results'.[66] Thirdly, Emmeline was accused of not reciprocating hospitality. When Anna Shaw and Carrie Catt had visited England, they were not 'treated to lunches, dinners or receptions in their honour, neither were they paid for any lecture they had given'.[67] Anna Shaw, National Suffrage President, referring to a fund raised for Emmeline Pankhurst in England as a token of sympathy and admiration, declared that charity began at home. 'I believe in being generous, in holding out the helping hand to any one fighting the same fight. But let us first pay our own bills …. The Suffragettes are splendid business enterprise …. They come over here and lecture to us for money … and our people rush to pay to hear them when they will not pay to listen to their own leaders. I have never yet known an American Suffragist … who has gone abroad, to be paid for any of the speeches we have made to English audiences.'[68] Emmeline was charged with being greedy because she demanded a guarantee of $1,500 for each lecture in addition to a liberal share of the gate receipts. Moreover, she was criticised for raising money in America to take back to England for illegal campaigning when so much money was needed in America for non-

militant suffrage work.[69] The *New York Times* agreed, claiming that the WSPU leader regarded American suffragists 'as a fat goose to be plucked for British profit.'[70]

Emmeline Pankhurst tackled the criticisms head on. In a speech at Hartford, she argued that 'other people have said: "What right has Mrs Pankhurst to come to America and ask for American dollars?" Well, I think I have the right that all oppressed people have to ask for practical sympathy of others freer than themselves. Men of all nationalities have come to America, and they have not gone away empty-handed, because American sympathy has been extended to struggling peoples all over the world.'[71] Some lecture organisers were not convinced. In Indiana the Women's Franchise League cancelled her lecture when they realised that she wanted to take up a collection for the WSPU as well as being paid for her talk.[72] Suffrage organisations boycotted meetings and leading suffragists declined to attend dinners held in Emmeline's honour. The Woman's Forum thought she would harm the American suffrage movement by introducing militancy and damaging their cause. If she had died, they insisted, woman's suffrage in England would have won long ago.[73] Of course, the hostility of Carrie Catt and her associates was as much to do with internal divisions within the American suffrage movement as with antagonism towards the WSPU and its leading representative. By this time, the temperamental and ideological tensions between the older suffragist societies and those influenced by the WSPU were growing more intense than ever.

In 1913 Emmeline Pankhurst polarised public opinion as never before. The Americans either loved her or hated her, using strong language to express their views. Some of the American press welcomed her visit, claiming that she was 'a stupendous aid to the American sisterhood in securing the measure of recognition they now possess. Her Herculean labours for the ballot in the British Isles were a constant inspiration and encouragement to the strugglers on this side of the Atlantic. Mrs Pankhurst is undoubtedly the greatest women's rights campaigner of this or any other generation.'[74] She was thought to be a spiritual descendant of all the martyrs who had ever worn themselves out in pursuit of an ideal. 'A little of the saintliness of Joan of Arc, a dash of the histrionic power of Bernhardt, a spice of the wit of Madame de Stael, something of the mother of the Gracchi added, and the compound is the character of Emmeline Pankhurst.'[75] Some believed it

unfair that others who had stirred up armed insurrection were still allowed to speak, and if such 'apostles of anarchy and bloodshed were allowed to speak their mind then it should not be withheld from Emmeline Pankhurst whose extreme counsels of militancy were mild in comparison' (ibid.). Her charm, they maintained, charmed them.

Those who gave her a much cooler reception believed that no supporter of women's suffrage could condone the recent excesses of the WSPU: a few more months of such militancy, it was claimed, then votes for women could be 'relegated to the category of lost causes'.[76] The *New York Times* contained an editorial that argued that the American Women's Political Union who had invited her had made a serious mistake by 'lowering themselves to meet an anarchist and endangering the prospects of success'.[77] It regretted that the President had allowed such an 'inciter of mob violence and arson' to enter America.[78] In transgressing the gender norms of the period, Emmeline had given her critics linguistic licence to insult. The Sheriff of Washington warned against listening to 'a woman militant agitator from England who is coming to our city to preach doctrines un-American' and compared her to 'dynamiters, arsonists, bomb-throwers, seditionists, silly fulminators, unwomanly actions, nihilistic flouterers, Amazon-mannishness, anarchistic portrayers, and cowardly assassins'.[79] Many believed she was over-rated, had brought no inspiration to the suffrage cause, had not contributed to any new theories, had appealed to prejudice rather than reason and had conducted an unnecessary and futile sex war. She and her followers were called 'the she-wolves of Satan', 'crazyjanes' and 'unmarried priestesses of the hell-roaring platform'.[80] She suffered, one paper accused, from militant dementia.

In particular, the press was polarised by her emphasis on the links between white slavery and militancy. The *La Moille Gazette* in Illinois believed that militancy was justified because of the extent of 'commercialised vice' which gave no protection to women, young girls and children. 'It is drunkenness and sex degeneracy,' they insisted, 'that has caused these women and men to resort to militant methods. Mrs Pankhurst is fighting for the salvation of the human race ... people will honour Mrs Pankhurst next to the Madonna.'[81] In contrast, others insisted that Pankhurst's obsession with white slavery fomented an unnatural interest in the traffic. During this visit Ava Belmont took her to the theatre to see *The Lure*, a melodrama about white slavery. When

the audience paid more attention to Mrs Pankhurst than to the play, she agreed to speak about the issues involved. Such plays as *The Lure*, she asserted, were not immoral, only the facts were immoral. Women, she argued, were too cheap. 'Even if the things which this play pictures were necessary for the so-called health of men, better that the race should perish than that women should be sacrificed in such traffic.'[82] By endorsing the *The Lure*, she was condemned for approving the most 'iniquitous dramatic and literary tendencies' in America.[83]

She was also criticised for discussing 'things no decent woman used to discuss' and for including 'atrocious material' in her newspaper.[84] She defended herself against this allegation, stating that the Social Purity League in New York had 'heartily' commended her campaign against white slavery. 'The Suffrage movement,' it argued, 'has a big problem before it in the reclamation of fallen women and also in the reclamation of fallen men.'[85] Unfortunately, the authorities disagreed. While she was in America, campaigners were charged under the Comstock Laws for selling *The Suffragette*. Anthony Comstock, who was also head of the Society for the Suppression of Vice, pronounced that he had found objectionable matter in four of the issues. It was an offence, he argued, 'to sell, lend, give away or show any obscene, lewd, lascivious, filthy, indecent or disgusting book, magazine, pamphlet or newspaper'. Ava Belmont intervened before any of the women selling *The Suffragette* could be sent for trial – and on her promise to stop selling the newspaper all prosecutions were dropped.[86]

Overall, the lecture tour was seen as 'triumphantly successful' – the financial proceeds from her visit amounted to £4,500, which she subscribed to the WSPU campaign fund.[87] Emmeline did not visit Canada on this trip, possibly because she had earned sufficient, possibly because her last Canadian tour had not been as successful as she might have hoped. However, her influence on Canadian politics was still apparent. Earlier on in the year the Canadian suffragist leader Flora Denison visited Britain, spending the summer studying the suffragette movement and becoming 'intimately acquainted' with Mrs Pankhurst and her methods. During this trip Flora Denison joined the WSPU and on July 21st 1913 was on the WSPU platform at the London Pavilion when her heroine was arrested.

When she returned home, Flora Denison continued to drum up support for Emmeline Pankhurst, insisting that, rather than reproach the

suffragettes, Canadians must condemn the Liberal government for its behaviour towards them. 'There is great drama,' she said, 'being enacted in London at the present time. In the play, there is a villain and a clown both of which characters are played by the British Government. The heroine is Mrs Pankhurst.'[88] Eventually Flora Denison persuaded the Canadian Suffrage Association to pass a resolution unanimously voicing their approval of the militancy of the WSPU. On one occasion she even justified murder, saying: 'I shouldn't condemn Mrs Pankhurst any more for shooting Premier Asquith than I condemned the British soldiers for shooting down the Boers in South Africa. This is civil war.'[89]

Flora Denison was criticised in the Toronto press for condoning the actions of Emmeline Pankhurst and 'putting herself on a level with the bloodthirsty hags who sat gloating round the guillotine in the Reign of Terror'. Everyone who believes in law and order, it was argued, was being alienated from the suffrage question by the 'diabolical actions of a few mentally unbalanced women If Mrs Pankhurst and her feeble-minded followers did not receive such free advertising they would soon drop the campaign.'[90] Flora Denison's increasingly uncritical support of the WSPU, on top of personal rivalries, created tensions within the Canadian suffrage movement. Many Canadian suffragists, brought up to regard the police with respect and MPs with deference, were deeply shocked by WSPU militancy.[91] Consequently, Emmeline Pankhurst was indirectly responsible for yet another split, this time in the Canadian suffrage movement, when those opposing militancy were forced to quit the main organisation.

Neither American nor Canadian women used militant methods in their fight for the vote, yet both national groups were enfranchised. Women in the United States gained the right to vote in several states before they enjoyed the federal vote. When Wyoming was given Territory status in 1869, women were automatically awarded the vote on the same terms as men; in the 1890s three more states enfranchised women. In January 1918 a federal amendment that enfranchised all women passed the House of Representatives and cleared the Senate on June 4th 1919. In the early morning of August 26th 1920, after a fierce battle with the Tennessee legislature, the Secretary of State announced the ratification of the Nineteenth Amendment, which meant that every woman in every state had the right to vote in a federal election. It had taken seventy-two years since the first protest at Seneca Falls. As with

American women, Canadian women gained the right to vote in provinces before they gained the federal vote: three Western provinces enfranchised women in 1916 – Manitoba, Saskatchewan and Alberta; Ontario and British Columbia in 1917 and Nova Scotia in 1918. Interestingly, all were Prairie provinces. On May 18th 1918 all female Canadian citizens aged 21 and over became eligible to vote in federal elections, whether or not they had attained the provincial franchise. Women were still excluded from the provincial ballot in four provinces; Quebec did not enfranchise women until 1940.

Plate 1 Emmeline Pankhurst on holiday on the Isle of Man.

Source: The papers of Sylvia Pankhurst, 1882–1960, at the Internationaal Instituut voor Sociale Geschiedenis, Amsterdam.

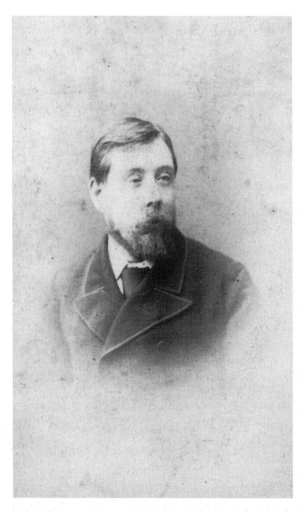

Plate 2 Richard Pankhurst 1879.

Source: The papers of Sylvia Pankhurst, 1882–1960, at the
Internationaal Instituut voor Sociale Geschiedenis, Amsterdam.

Plate 3 Mrs Pankhurst is arrested in Victoria Street, February 13th 1908.

Source: The papers of Sylvia Pankhurst, 1882–1960, at the Internationaal Instituut voor Sociale Geschiedenis, Amsterdam.

Plate 4 Emmeline and Elizabeth Wolstenholme-Elmy leading a suffragette demonstration, 1908.

Source: The papers of Sylvia Pankhurst, 1882–1960, at the Internationaal Instituut voor Sociale Geschiedenis, Amsterdam.

Plate 5 Emmeline recovering from hunger strike, 1913. The nurse is Kate Pine, who accompanied her to Canada.

Source: The papers of Sylvia Pankhurst, 1882–1960, at the Internationaal Instituut voor Sociale Geschiedenis, Amsterdam.

Plate 6 Emmeline and Christabel leading the Women's Right to Serve March, July 1915.

Source: Harry Ransom Humanities Research Center, the University of Texas at Austin, PO Box 7219, Austin, Texas 78713–7219, USA (Gernsheim Collection, Jimmy Hare).

Plate 7 Emmeline in old age.

Plate 8 Unveiling of the statue of Emmeline by the Prime Minister in 1930.
Source: *Manchester Guardian*, March 7th 1930, available from Colindale Newspaper Library.

Part III

LIFE AFTER THE VOTE
1914–28

9

THE FIRST WORLD WAR 1914–18

ATTITUDES TOWARDS GERMANY AND THE WAR

When Britain declared war on Germany on August 4th 1914, Emmeline Pankhurst was bathing in the sea at St Briac, France.[1] The 56-year-old suffragette was recuperating from her tenth hunger strike. Emaciated, exhausted and suffering from nausea, gastric disturbances and neuralgia, she was taking a short break to recover some strength before returning to head the militant campaign. However, once home she decided there was no point in continuing to fight for the vote when there might be no country to vote in. Democracy, Emmeline insisted, was under threat. Hence, she suspended all suffrage activities, called upon WSPU members to support the war effort, advocated military conscription for men, industrial conscription for women and the abolition of trade unions. Nevertheless, she remained committed to a number of her feminist principles, insisting that women workers be regarded as equal to men and that high moral codes continue.

War seemed to raise the emotional intensity of her leadership to a new xenophobic level as Emmeline adopted an increasingly nationalistic position. At first glance, her volte-face is surprising. In the past she had drawn comparisons between male and female responses to violence, arguing that she had never been 'reckless with human life ... we leave that to the enemy. We leave that to the men in their warfare.'[2] Women, she had once insisted, were more disposed to be peace-loving, and

would favour arbitration as a mechanism for settling international disputes rather than war. Emmeline's newly adopted jingoism can appear hawkish to modern observers but it is important to understand that these beliefs had been held since childhood. It was her love of France, as much as her allegiance to Britain, which fuelled her war fever rather than unthinking patriotism or government propaganda. She had lived in France as a young woman, had had a close friendship with Noémie de Rochefort, almost married a French man, chosen Bastille Day, one of the most important days in the history of French radicalism, as her birthday, claimed Joan of Arc as her favourite heroine, had the Marseillaise played at the end of each of her trials, and had probably influenced her daughter Christabel to live in France. Sylvia, her other daughter, speaking to Henry Woodd Nevinson, 'lamented her mother's attitude on war: traced it to school in France soon after 1870'.[3] Moreover, living in France at the outbreak of war, she was undoubtedly swept away by French patriotism as much as British.

In addition, it is important to remember that she was a democrat who believed that 'our ideal of civilisation is greater than the German ideal of civilisation'.[4] Germany's parliament, the Reichstag, was elected by universal male suffrage but, she believed, the veneer of democracy was very thin: the country was under the authoritarian control of Kaiser Wilhelm who placed men of his own choice in key ministerial positions. The war was viewed as a battle between the enlightened democracy of Britain and the autocratic militarism of Wilhelmine Germany. Germany was depicted as the world's bully who would override every principle of humanity and morality and whose unbridled aggression had most certainly caused the war. By contrast, France and Britain were deemed to have a fully fledged democracy (even though women remained disenfranchised in both countries). Indeed, France was seen as the Mother of European Democracy, with its people 'ready to sacrifice life ... sacrifice money ... sacrifice everything for an ideal'.[5] Again, her emotional temperament would not allow for any nuance of opinion or doubt. Her Manichaean view of the world meant that Germany was seen as Satan whereas God was epitomised by France. It was Good versus Evil. The Kaiser had replaced Asquith as the devil incarnate.

Mrs Pankhurst believed that Germany would impose its quasi-democracy on other nations. As a young woman, she had observed the aftermath of an earlier German offensive and had witnessed the humilia-

tion suffered by occupied France at first hand. Not surprisingly, she condemned Germany for invading and colonising France, insisting that ever since the Franco-Prussian war Germany had 'been preparing by subtle means to take possession of Europe ... they want to rule the whole world'.[6] In her view, the Kaiser wanted to be a twentieth-century Julius Caesar or Napoleon and to create a German empire greater than the world had ever seen. She argued that Germany wanted to break up the British Empire and replace it with one of its own. The spread of what she termed the 'GERMAN PERIL' was thought to be calamitous for 'individual and national liberty, for freedom of spirit, for grace and beauty of life'.[7] To her, the war was a struggle 'between two opposite ideals – between civilisation and liberty on the one hand and barbarism and despotism on the other'.[8] Civilisation, she believed, would disappear if Germany won the war. In addition, she was convinced that the Prussian attitude towards women was negative.[9] In a speech delivered at the Sun Hall, Liverpool, the virtues of France were extolled and pleas were made for Britain to support the 'feminine' state of France which had been menaced by an 'over-masculine' Germany. In contrast, 'the ideal of women in Germany is the lowest in Europe. Infant mortality is high, immorality is widespread and venereal disease is rampant'.[10] Germany, she argued, 'is masculinity carried to a point of enormity and obscenity'.[11] It was therefore a moral duty thoroughly and decisively to defeat the enemy.

In her opinion, there were two kinds of wars: wars that were unjust and aggressive and wars that were fought for humanity and the defence of liberty and civilisation. In a meeting at the Kingsway Hall in December 1914 she stated: 'The views I have always held I still hold. Nothing is more horrible than wars of aggression. But I believe that, whatever faults we have had in the past now we are engaged in a righteous war. Much as I love peace, I believe there are times when it is right to fight.'[12] She did not justify war for war's sake. In fact, she answered those who said that 'I thought you were against war, that women were against war and that you had denounced war' by arguing that you could not say 'We won't fight' to an enemy determined to conquer you. For Emmeline Pankhurst the war was a 'war of liberation' against an aggressive foe.[13]

It is also difficult to square Emmeline's abandonment of the vote issue without an understanding of her commitment to a nineteenth-

century philosophy of rights and responsibilities. In normal times she considered it legitimate for individuals to claim their rights to citizenship, whereas in times of national emergency responsibilities came much more to the fore. 'We have fought for rights because, in order to perform your duty and fulfil your responsibilities properly, in time of peace, you must have certain citizen rights. When the state is in danger, when the very liberties in your possession are imperilled, is above all the time to think of duty.'[14] She was not prepared to see British citizenship, for which she had been campaigning before the war, destroyed or even weakened by a foreign enemy. For her, the war against Germany was part of the same struggle 'in which all fighters for freedom have been engaged'[15] and she would 'rather die a thousand deaths than see my country a province of Germany'.[16] She was concerned that British subjects, women as well as men, were in danger of becoming subjects of Germany and deprived of free institutions. They must, she urged, fight together against a common foe until Germany was crushed and rendered helpless. The war, she believed, was not the time to settle internal difficulties since all available energies were needed to prosecute the war against Germany. 'There is no woman in this country,' she argued, 'who has done more, or sacrificed more for her enfranchisement than I have and when the proper time comes, there is no woman who will be readier to do and to sacrifice again than I shall be.'[17] At no point did she consider pressurising the government into giving women the vote immediately so that they would work more wholeheartedly for victory. Only one battle could be fought at a time and she could not support the war effort and support the emancipation of women in the same period. Of course, Emmeline Pankhurst, as with so many others, believed that the war would be over by Christmas and that there would be plenty of opportunity to campaign for the vote once victory had been achieved.

In a speech at Plymouth late in 1914, where she appeared at the invitation of Nancy Astor and Mrs Dacre Fox, she summed up the reasons for abandoning suffrage and supporting the war effort.

> We have now suspended our work for women's suffrage, and are taking part in a national effort to prepare to resist the reign of militarism as an ideal in Europe. (*applause*) ... It is perfectly true that until the war broke out we were engaged in a civil war the purpose of which was to win from a reluctant government the citizenship of the women

of this land. (*applause*) But never throughout the whole of that fight did we for one single moment forget the love we had for our country, nor did we relax one jot of our patriotism, it was because we love our country so much that we could not bear to be the serf sex in that country. (*applause*) When war broke out the situation was changed. We said to ourselves it is true we have had an inter-family quarrel with those who govern the country but the country is ours as much as theirs. (*applause*) And when the country is in danger and it is their duty to prepare for the defence of the country then it is our duty to help them to do it. (*applause*) It is a much bigger question to ask that [sic] whether a particular Government is doing its duty to us or not. The question is one of national existence, national honour and if that is so there is no doubt as to what our duty should be. (*applause*)[18]

On August 13th 1914 she wrote to every member of the WSPU explaining why the organisation had discontinued the suffrage campaign. It is obvious, she insisted, 'that even the most vigorous militancy of the WSPU is for the time being rendered less effective by contrast with the infinitely greater violence done in the present war ... to human life'.[19] Not all WSPU members agreed with this pronouncement. Many suffragettes deplored the abandonment of the suffrage struggle and the withdrawal from an international women's movement where nationality, political creed and class distinction had allegedly disintegrated.[20] Consequently, two different groups split from the WSPU to form their own suffrage organisations: the Suffragettes of the Women's Social and Political Union (SWSPU) in October 1915 and the Independent Women's Social and Political Union (IWSPU) in March 1916. With a rather poignant irony, suffragettes who wanted to continue with the suffrage struggle often interrupted Emmeline's speeches. She criticised these hecklers by arguing that the fight against Germany was 'a very much bigger thing than the Vote itself ... what we are asking for and working for and longing for is to preserve those institutions which would admit of women having the Vote. If we lose this war then ... not only is the possibility of women voting going to disappear, but votes for men will be a thing of the past.'[21] She dismissed their efforts as misguided and maintained that war work gave to every woman a 'splendid opportunity of showing the world that she is fit for the vote.'[22] In her

view, the war was a crusade to save civilisation from destruction by evil forces, and therefore eminently justifiable.

Consequently, the outbreak of war enabled the suffragette leader to abandon militancy and to demonstrate her patriotic loyalty. She took this as a key opportunity for herself and other women to show that they fully deserved the right to vote. Any sign of pacifism was condemned as traitorous. When, in 1915, a group of women, including her daughter Sylvia, took part in a Peace Conference at the Hague to try to end the war, she vehemently disapproved of their action. In her view, Germany had forced the war upon the Allies and so must be the ones to apply for peace. 'We did not want this war. France did not want this war. Belgium did not want this war It has been forced upon us For us to talk of peace now ... is to make the condition of those men who are laying down their lives for us in France more terrible than it already is.'[23] To talk of peace, she argued, was 'very sinister and dangerous ... because nothing heartens the Kaiser and his advisers so much as weakness in any of the Allied nations'. She pleaded that 'if you take part in any of these peace movements, you are playing the German game and helping Germany'.[24] She condemned what she called 'sham internationalism' whereby workers from enemy countries united to end an imperialistic war. Nationalism, she insisted, helped freedom and democracy by 'providing the best practical restraint upon the selfishness of the individual, the best practical safeguard of the liberties of the people'.[25] By the middle of 1915 those who opposed the war were seen as 'apologists for the Germans ... more likely to serve the enemy than their own people ... to her mind it was something like treachery'.[26]

Internment of enemy aliens and a 'drastic reform of the Naturalisation Laws in order to prevent Britain from being permeated and undermined by the Germans' was advocated.[27] She demanded that all government officials having 'enemy blood or connections' and all officials who have 'pro-German leanings' be dismissed.[28] Officials of long-standing British descent should man public services, industry should be under strictly British ownership and control and Germans prevented from acquiring British nationality.[29] 'If the Germans came here,' she insisted, 'they would outrage women and children, shoot the men to force submission, and then they would Germanize us.'[30] Germany, she insisted, was responsible for devastating Belgium, 'even today driving

thousands of innocent, helpless people at the point of the bayonet, outraging women and burning homes',[31] and they would do the same in England. She, along with most Britons, believed reports of German atrocities in Belgium and France, where Germans were accused of the systematic massacre of civilians, of raping women and cutting off the heads of babies. She spoke at meetings where a propaganda film portraying these alleged German atrocities was shown and referred to soldiers 'whose vile deeds were done not merely by a few men brutalised by drink ... but were organised and were done by officers carrying out instructions'.[32] German soldiers may have shown ruthless brutality, destroying historical centres, massacring civilians and forcing massive numbers of Belgians to flee their country, but German warfare never reached the oppressive levels claimed by Emmeline Pankhurst and British propaganda.

During the war her jingoism verged on the extreme. Shedding her subversive, iconoclastic role of the pre-war years, she became an arch-patriot. This was not as great a break as might be supposed, for she was merely exchanging one extremist garb for another, thus showing continuity of emotional outlook. Within a few days of war, she threw herself into a vigorous campaign in which the defeat of Germany took priority over everything else, including women's suffrage. With alarming alacrity she placed the WSPU organisation, and its funds, at the disposal of the government, which by 1915 was desperate to recruit women workers. Yet throughout this period she never abandoned her fundamental ideals: she continued to campaign for equal pay for women workers and to speak out vigorously against the sexual double standard.

WOMEN AND THE WAR EFFORT

Since two million men had joined the armed forces, at a time of pressing demand for munitions there was a great shortage of labour from 1915 onwards. Factories, desperate to increase production, brought in unskilled women to make the ammunition, the guns and the high explosives necessary to carry the country to the end of the war. Lloyd George, who became Minister of Munitions in 1915 and Prime Minister in December 1916, worked amicably with Emmeline to help fulfil the prodigious demand for military weapons. On at least one recorded occasion they met secretly and privately at the house of a mutual friend.[33]

Here her contribution was vital. 'It was the Pankhursts who first persuaded Lloyd George to establish training schools for women in munitions works. It was they who first preached the gospel of a women's land army and encouraged the thousands of 'farmerettes' who left their homes.'[34] She suggested a range of training schemes for women workers keen to take on traditionally masculine jobs. Unfortunately, there was a reluctance by British men to train women so, in a letter to Lloyd George, she advised that they be trained in France, in particular at the Renault factory, where managers enthusiastically favoured the employment of women. She also proposed that women be trained at technical schools and university engineering departments, and that American technical teachers be employed to support the training initiative.

Emmeline supported industrial, as well as military, conscription. On June 3rd 1915 she chaired the first of her weekly War Service Meetings – held every Monday afternoon – at the London Pavilion, the venue where she had once urged suffragettes to break the law. She criticised the fact that, a year after war had been declared, Britain remained unorganised: millions of capable women who were longing to do war work were not called upon.[35] At one of the first meetings she invited 'the Government to establish universal obligatory national war service for men and women'[36] As she pointed out, women served in banks, insurance offices, in post-offices, in businesses, in industry, in agriculture and even in counter-intelligence. Time after time she urged the government to set up a national organisation and to treat women as a reserve army of labour. She offered to hold great organising meetings all over the country to recruit and enlist women for war service so that they could replace skilled men needed at the front.[37] As a reward for her efforts, and keen to utilise her celebrity status, Lloyd George invited her to become a member of an Employment Committee set up to deal with the employment of women munition workers. She refused, stating that her experience of public work 'has convinced me that it is a mistake to have a committee if one wishes effective work to be done'.[38] Typically, she preferred direct action.

By this time Emmeline was regarded as respectable. Even King George wrote to Lloyd George to ask 'whether it would be possible or advisable for you to make use of Mrs Pankhurst'.[39] He did. Emmeline helped set up a National Register of women workers and charged

employers a small fee if they chose and appointed someone from the list. She urged women to register for work. Eventually, on July 15th 1915, a National Register Bill was passed through the House of Commons, under which all people, male or female, between the ages of 15 and 65 had to register. When Lloyd George announced this initiative, Emmeline was inundated with women asking where they could obtain work. By the autumn of 1915 more than 110,000 women had volunteered, but there was no organisation to match workers to jobs so only about 5,000 were ever employed. Employers also wrote to Emmeline asking her to recommend workers. For example, Robert Boby, from St Andrews Iron Works in Bury St Edmunds, wrote to her asking for the services of 10 to 15 women who were able to work lathes, radial drills and other machinery used in the manufacture of high explosive shells.[40]

Demonstrations were planned to recruit women for the labour force. Once more, her organisational genius was put to the test when she co-ordinated a Women's Right to Serve March on July 17th 1915. This procession was a smaller version of the suffrage pageants with 125 contingents, 90 bands and about 6,000 demonstrators. The leaders of the procession sat in a car decked out in white, red and green flowers and marshals wore the Union Jack colours of red, white and blue instead of the old WSPU colours of purple, white and green. A 'girl in tattered dress' carrying a torn flag personified invaded Belgium. Other countries were represented by standard bearers wearing national costumes and carrying their country's flags – French women wore their red caps of Liberty; Serbian and Montenegro women wore peasant costumes; and Japanese women carried flags with the 'great sun with its crimson rays' on them. Each British contingent held Union Jack flags so that the demonstration, like the suffragette marches, seemed to be 'an endless wave of colour'.[41] Lloyd George spoke from a specially constructed platform overlooking the Embankment outside the Ministry of Munitions, praising the procession as representative of all women.

Although the government had agreed to subsidise the demonstration, there was dispute between Emmeline Pankhurst and the Treasury over its cost. The Ministry stated that it had 'agreed to pay a lump sum of £3,500 towards the expenses of the WSPU in organising a procession of women in London',[42] but the WSPU wanted more. Unfortunately, according to Treasury minutes, the government found it very difficult to

obtain any accounts from the WSPU and was therefore reluctant to pay up. In the end, after much discussion, the Treasury paid out £4,174 towards the costs of the demonstration.

Despite these financial wranglings, the relationship between Emmeline and Lloyd George continued to improve. After the 1915 demonstration she led a deputation to Lloyd George which, unlike previous suffragette deputations, was welcomed. 'So grave is our national danger, and so terrible is the loss of precious lives at the front due to shortage of munitions,'[43] she told Lloyd George, that she wanted the government to use women 'as a great reserve, and to train us.'[44] Even so, she insisted that women munition workers received the same pay as men. 'We do urge upon you,' she said, 'that wherever a woman is engaged to do work previously done by a man, if she does the work equally well, and does it exactly like a man, she should be paid the same rate of wages.'[45] Lloyd George was now more courteous to the former suffragette, deferring to her on several occasions and reassuring her that the government would not tolerate sweated labour. According to Grace Roe, Emmeline Pankhurst and Frances Stevenson, Lloyd George's secretary, met frequently at Downing Street to discuss policy. Frances supported votes for women, had formally been a member of the WFrL and had attended WSPU meetings at the Queen's Hall and Albert Hall to hear the suffragette leader speak. In turn, Emmeline Pankhurst's attitude towards Lloyd George altered significantly as the war progressed, and she began to refer to him as a 'courageous man' rather than a bitter enemy. Enmities between the two had long been forgotten. However, relationships with Asquith continued to deteriorate. She and Christabel constantly criticised Asquith, complaining that the Prime Minister was mainly to blame for the lack of success in the war effort.[46] On one occasion she was banned from the Albert Hall because of her accusation that Asquith and Edward Grey were unfit for office. Her malignant attacks on Asquith and Edward Grey continued until Lloyd George replaced the Prime Minister in 1916.

On July 22nd 1916 Emmeline organised a second demonstration of women war workers as a patriotic gesture of support. The *Guardian* published a photograph of the munition workers on the demonstration carrying a placard with the message 'Drop Every Mortal Thing and Send Them Munitions'. 'The little company of nurses marched demurely, the three green-suited girl commissioners with high top boots were

imperturbably dignified, the picturesque girl gardener who sat on a trolley among yellow chickens ... or marched at the rear with hoes and spades Following them came the women tram conductors, girls from the buses, and from the underground railways and then led by the women's reserve in khaki ... came hundreds of munition workers.'[47]

Emmeline's recruitment of women workers was criticised by some. Opponents argued that she had undermined 'everything she had striven for all her life',[48] because of the conditions and wages in munition factories. She was also censured for wanting women to work so that men could be released for the front. Trade unions objected to women working in skilled trades such as engineering because they feared women would undercut men's wages. In February 1915 this problem was resolved – for men at least – when a Treasury Agreement was signed between the government and trade unions to allow women to do parts of skilled men's jobs. This 'dilution' of labour meant that women would never achieve the same rate of pay as men. Characteristically, Emmeline objected to this and continued to support equal pay for equal work. She also advocated equal marriage laws, equal parental rights, equal employment opportunities, and the raising of the age of sexual consent, matters which continued to concern her.[49]

SEXUAL POLITICS

During the war the government became increasingly concerned about the health of the armed forces, and less concerned with sexual morality. Regional councils, especially in military areas, called for a renewal of the notorious Contagious Diseases Act (CD Acts), which were designed to protect men against venereal disease. Emmeline Pankhurst objected to these proposals. She began her campaign on October 16th 1914, immediately after the Plymouth Watch Committee had passed a resolution re-enacting the CD Acts.[50] Later in October 1914 she addressed a meeting in Exeter and visited the heads of over 100 local institutions, all of whom were given a copy of *The Great Scourge* and interviewed about their views on the regulation. In 1918, despite her efforts, Reg. 40d of the Defence of the Realm Act (DORA) permitted a woman to be given a compulsory medical examination if a member of the armed forces accused her of infecting him with venereal disease. (This deeply offensive piece of legislation was revoked after eight months.)

As a Poor Law Guardian Emmeline had been all too aware of the problems of the single mother. Newspaper reports about the increase in illegitimacy, she said, had 'made it clear to me that the time had come and that something that had always been very close to my heart, could effectively be done'.[51] Encouraged by the House of Commons, she led a campaign to adopt girl babies born to single mothers whose partners were in the armed forces. At the time there was increasing concern about the declining birth rate and the increasing number of war casualties.[52] The government wanted a higher birth rate regardless of its fear that giving public acknowledgement to 'illegitimate unions' would unleash general immorality, increase venereal disease and lead to the moral and physical collapse of Britain. As the war progressed, single mothers became more and more associated with patriotic virtue than with immorality: children of unmarried parents were termed 'war babies' rather than 'bastards' or 'illegitimate', terminology which went some way towards excusing, if not sanctioning, pre-marital sex. Emmeline, however, did not abandon her moral principles. In supporting war babies, she argued for the rights of children rather than the rights of adults. Children, she maintained, should not be held responsible for the acts of their parents. 'Every child has the right to be loved and cared for and to be prepared for the work of life. Yet the illegitimate child is by law and custom denied its full birthright.'[53] Typically, the sexual double standard continued to be condemned. In her view, both parents should be held fully responsible. 'Ever since there has been a woman's movement and perhaps longer,' she said, 'the problem of the illegitimate child has weighed upon women's mind and heart.'[54] She wrote to Nancy Astor that war babies were to be adopted to save them 'for useful service to the state, children who otherwise would die in infancy or grow up to be a national danger'.[55] 'I have been sorrowing over them for 30 years,' she remarked, and 'I seldom blame either young men or young women There is among [illegitimate babies] an appalling death rate and of those who survive I should think the majority become criminals and prostitutes.'[56]

Emmeline wanted to adopt as many war babies as funds would allow. She aimed to 'surround them with loving care; to give them individual treatment when they come to an age when they can be influenced; to adopt the very latest methods of training children'.[57] She wanted to

protect children and 'prevent them from growing up to be bad citizens and a danger to the community.'[58] Her war babies were to be 'reared under good conditions and provided with a good general education followed by a training adapted to the natural ability and special gifts of each individual child. The children will be brought up together in a home in which they will receive that loving care which is necessary for their happiness and full development.'[59] She wanted, as in the past, to prevent babies and children entering 'crowded institutions',[60] and so she toured the country appealing for money to establish a home for illegitimate children. She was never as successful in raising money for her war babies scheme as she had been in funding suffragette activities. At Hull on June 4th 1915 she only managed to raise £20 towards her home. Consequently, she used the remaining funds of the WSPU to purchase and furnish an Adoption Home for Female Children at Tower Cressy, Campden Hill. Annie and Jessie Kenney were put in charge of the Home, which was furnished luxuriously with chaises-longues and elaborate armchairs. When Ethel Smyth visited the Home, she was horrified by its combination of luxury and austerity. It was very well furnished but 'it was the best place to commit suicide'[61] because of the wire-netting across the windows. The Kenney sisters, under Emmeline Pankhurst's guidance, adopted the Montessori method to teach their young charges.[62] The Montessori method, with its emphasis on creating an environment which fostered the spiritual, emotional, physical as well as intellectual potential of each child, appealed to radicals like the Pankhursts. Unfortunately, despite the efforts of those involved, the Home was not a great success and was later presented to Princess Alice and Miss Andrews as a War Memorial Adoption Home.

Emmeline Pankhurst put her ideas into practice and adopted three girl babies, Mary, Cathy and Joan. Christabel adopted Elizabeth. The babies lived with her in London, where she found herself in the unfamiliar situation of living in a permanent home. For three years she rented a house for herself and her new babies at 50 Clarendon Road, Holland Park. In a letter to Ethel Smyth she wrote: 'I have got to love this home of mine; pray heaven I shall be able to keep it. Sometimes I feel appalled at the responsibility I have undertaken in adopting these four young things at my time of life …. I'll go on as long as I can.'[63] They were, she told reporters, being brought up without any regard to expense,

provided with decent clothes and nurses, 'scientifically' fed and given everything that would give them a chance in life. By the end of the war all the 'little refugee children' were calling her 'mother'.[64]

ENCOURAGING THE MALE WAR EFFORT

Immediately on the outbreak of war, the WSPU organised a series of meetings throughout the country to promote the war effort and accelerate the response to Lord Kitchener's appeal for recruits. Emmeline Pankhurst spoke in London, Birmingham, Bradford, Leicester, Brighton, Folkestone, Hastings, Exeter, Plymouth, Liverpool, Sheffield and Glasgow. Nancy Astor, who often spoke on the same platform, remarked that she wished that Emmeline was in the cabinet.[65] At one such meeting Emmeline appealed to the men in the audience to 'uphold the honour of the British nation and let us be proud of you'. She urged them 'to go into battle like the knight of old, who knelt before the altar and vowed that he would keep his sword stainless and with absolute honour to his nation'. 'If you go to this war and give your life,' she argued, 'you could not end your life in a better way – for to give one's life for one's country, for a great cause, is a splendid thing.'[66] With outrageous irony, she urged men to 'go and do what you have always said it was your work to do – go and fight. Did they not come to our meetings and say that men ought to have the vote because they fought for their country and that women ought not to have it because they did not fight for the land.'[67] Apparently, she held such an appeal that, when she tried to enlist men in Bradford, one man said that 'all the Cabinet Ministers put together hadn't made as many recruits as Mrs Pankhurst'.[68]

Factories and mines were visited to encourage male workers to increase their output. By this time Emmeline was antagonistic to trade unions because she thought they undermined the war effort. When a country was at war, she maintained, class conflict and industrial unrest equalled disloyalty to the nation. Consequently she spent much time 'in allaying strikes in the mines, shipyards and factories, when such action would have jeopardised the lives of the men in the trenches'.[69] In her view, much of the strike action and unrest occurred because most of Britain knew little about the war itself. She urged MPs to educate their constituents about the war and arrange for selected individuals to visit

the front and the scenes of the Zeppelin raids to see what was going on.[70]

In particular, she tried to influence a miners' ballot in South Wales, using her powers of persuasion to argue that the war effort and the survival of a free Britain were greater goals than the miners' claims for better pay and conditions. 'If our Navy is crippled and paralysed,' she told them, 'you'll sing no more "Land of our Fathers"'.[71] She called the miners potential 'traitors'. In a letter to Lloyd George she urged that the situation in South Wales was very serious and he must try to counteract the 'pernicious influence' of the Union of Democratic Control (a coalition of socialists and Liberals committed to a negotiated peace). She recommended that Lloyd George use 'Ministers of Religion' and the 'Welsh Bards' to persuade miners to continue to work and to encourage 'a great wave of the red Welsh spirit which would sweep all the poison away'.[72] Not surprisingly, she was made unwelcome by the miners. In Bargoed, South Wales, she faced a hostile and difficult audience who were sullen during her speeches and heckled her.[73] Moreover, despite the best efforts of Emmeline Pankhurst and Lloyd George's punitive legislation, the strike took place and the government conceded to trade union demands. Nonetheless, in a letter to Bonar Law, Lloyd George paid tribute to Emmeline Pankhurst and her colleagues: '[they have] been extraordinarily useful, as you know, to the Government – especially in the industrial districts where there has been trouble during the last two very trying years. They have fought the Bolshevist and Pacifist element with great skill, tenacity and courage, and I know especially in Glasgow and South Wales their intervention produced remarkable results.'[74]

In February 1915 Emmeline Pankhurst visited the Elswick Ordnance Works and shipyard in Newcastle to thwart an expected strike. On February 17th the Amalgamated Society of Engineers, the Machine Workers' Society and the Steam Engine Makers' Society held a mass meeting at St James's Hall, Newcastle, to discuss possible strike action. They were protesting against unskilled or semi-skilled workers, i.e. lace-makers, jewellers, copper smiths and textile workers from Lancashire and elsewhere, being brought in to do fitters' work at fitters' pay. Strong feelings were expressed and it was agreed that the three unions would cease work the following Wednesday, if satisfaction from

the Company was not provided. The strike was eventually averted,[75] but, while she was there, she found out the names of the ring-leaders and promptly sent them to Lloyd George. Some time later, she asked Frances Stevenson what had happened to the ring-leaders. They had, she was informed, been sent to the front.[76] Her reaction to these events is not recorded but it is safe to say that she would probably have supported this outcome. Indeed, she wrote to Lloyd George suggesting that trade unionists should visit the front and soldiers be brought back to talk to unionists to convince them of the need for industrial peace.[77] In July 1915, in an attempt to avoid further disruption to industry, the government passed the Munitions of War Act, which made it compulsory for specified trades to go to arbitration and imposed severe penalties on those who went on strike.

Trade unions were disliked for their lack of national spirit and their attitude towards women. 'Sink self, sink sectional interests,' Emmeline insisted, enquiring 'what did the strong men's trades unions ever do for the working woman?'[78] She reproached male trade unionists who complained that women workers under-cut their wages, arguing that men should turn their attention to securing equal pay for equal work and making sure that women's work was properly recognised and remunerated.[79] Moreover, she believed that the unions were responsible for keeping male wages unnecessarily high, thus leading to low rates of production. Time, she argued, was deliberately wasted in some of the munitions factories because workers wanted to protect their piece rates rather than meet government demand for munitions. Trade unionists were also criticised for disapproving of women workers in general and for objecting to the fact that women might remain in their jobs when peace was declared. Emmeline countered the accusations that women would take away men's jobs after the war by saying that 'the idea that women by producing wealth were impoverishing the country is so absurd'.[80] Women's work, she insisted, would still be needed after the war to discharge debts and to replace the work of men killed or disabled. The trade unionist who put up barriers to stop women working was criticised for not being 'a patriot but a traitor'.[81]

By now Emmeline had completely renounced her former socialism, seeing it as a discredited force, discredited by pacifism and pro-Germanism.[82] She considered the Labour Party's programme to be 'hopelessly old-fashioned and out of date'. The Labour Party, she argued,

wanted to abolish the bourgeoisie, whereas she wanted to abolish the proletariat by wiping out class differences and giving a middle-class lifestyle to the working class. She would not tolerate 'the fact that manual workers are separated from their fellow citizens by inferiority of speech and manner, by ugliness and poverty of clothes, by brutality of thought and action'. The real obstacle, she believed, to social progress was the theory that 'humanity is and always must be divided into two sections whose interests are diametrically opposed'.[83] In a real democracy, she argued, there would be no inherent difference between the various social classes since all were necessary to the prosperity of the nation.

At a meeting held in the Albert Hall in March 1918 Emmeline argued that the other political parties had done nothing for women in the past, whereas the WSPU had been 'faithful and loyal to women, ... worked for them and suffered for them'.[84] She urged women to keep clear of men's political machinery and to support her and Christabel's newly constituted Women's Party, which was, like the WSPU, for women only. This party was open to women of all classes with 'room for the woman of high rank and room and warm welcome for the working woman'.[85] She called upon 'women of all classes to forget their class and unite in common service of the nation'. The Women's Party, she maintained, put first and foremost the 'safeguarding of the Empire's existence, the upholding of national honour, and the defeat of the pretensions and claims of the enemy to force their conception of life and of civilisation upon other nations besides their own'.[86] It stood for Victory, National Security and Social Reform. In addition, the Women's Party wanted to bring equality to everyone by increasing wealth and raising the standard of living of manual workers. In her view, everyone's home life would improve if they were provided with large community houses. In these houses families would share a number of modern conveniences such as central lighting and heating, hot and cold water, a communal laundry and a communal kitchen where food could be cooked and distributed to each family. Each community would have its own nursery and crèche, infant school, library, gym and hospital. In this ideal environment children would be well cared for and women, 'relieved of useless and soul-killing drudgery', would be able to do remunerative work. In turn, national production and wealth would increase and lead eventually to a six-hour day with more leisure for all workers. She also pressed her usual demands: equal pay for equal work, equal marriage

and divorce laws, equal parental rights, equal employment opportunities and the age of consent to be raised.[87] It was a visionary if somewhat muddled communitarian message which came embellished with her newly conceived ideas of Empire and nationhood.

By now her belief in Irish Home Rule had been revised. The Union between Ireland and the rest of Britain, she believed, ought to be maintained 'in view of the German peril and German designs upon Ireland as a German naval base'.[88] In her opinion, the British Empire needed to be strengthened and the countries belonging to it drawn into closer co-operation for defence. All the natural resources, the essential industries and the transport system of the Empire, she argued, ought to be brought under British ownership and control. Her old belief in the rights of nations to self-determination had been abandoned because demanding such rights threatened parliamentary democracy.

VISITING RUSSIA

In June 1917 the British government sponsored Emmeline's journey to a collapsing Russia so that she could persuade the country to stay in the war. At the time of her visit, Russia was losing a great many battles – over a million Russian soldiers had been killed, German propaganda was making great headway, the economy was collapsing, and enthusiasm for the war declining. In the midst of this the Tsar had been forced to abdicate, leaving two rival socialist parties in power, the Provisional Government and the Soviets, who were themselves under threat from the forces of Lenin and the Bolsheviks.

Emmeline Pankhurst arrived in Russia in the middle of this political maelstrom. During her visit she met most of the political elite, including the leaders of the Provisional Government, Kerensky and Prince Yusopov. She was also invited to inspect Madame Botchkaveva's Women's Death Battalion, a special armed unit of women. The Tsar and Tsarina, who were in prison, sent a message asking to see her but she refused, claiming that she was in Russia on behalf of the Allied cause and that it was her duty to work with the government in power. Characteristically, despite the revolutionary context, she refused to dress like a proletarian, wearing elegant and expensive dresses.[89] The Russian authorities, fearful of the potential influence of this radical female, kept a tight rein on her activities – they limited her talks to drawing rooms

and halls and refused her permission to make contact with the peasants or the working class.[90] Kerensky vetoed her outdoor meetings for 'fear of stirring up the Bolshevik mobs'.[91]

In later interviews Emmeline maintained that Kerensky had the most unpleasant personality of any man she had met. She told the *New York Times* that 'only a few minutes in his presence was enough to convince me that he was not the man to save Russia He never raises his heavy eyelids to look one squarely in the eye, and has an uneasy manner that does not inspire confidence.'[92] He was the 'biggest fraud of modern times',[93] whose government would 'result in the disintegration of society and go far to destroy civilisation'.[94] Moscow, she asserted, was in a poor condition under his rule because too many committees settled everything in daily life. In hospitals 'patients decided whether they should follow the rules of doctors and nurses; soldiers decided in committee whether they should obey orders; big businesses were conducted by committees selected for their talking capacity.'[95] In her view, it was social chaos because no one was in authority. She sent messages to Lloyd George, reporting prophetically that Kerensky's days were numbered and that the Bolsheviks would replace him.

Emmeline was no stranger to controversy, and in Moscow she was present at an extraordinary and surprising event. A summer uprising, known as the July Days, took place at which, she stated, 'a regiment of cossacks and a loyal Siberian regiment arrived and by their courage and discipline saved the situation for a time'.[96] This was, in effect, an unsuccessful bid by the right wing to undermine the emerging socialism of the Mensheviks and replace the new regime by a military dictatorship. Although the attempt fizzled out, it led to an increase in support for the Bolsheviks who had helped defeat it. She remained in Russia for several months and returned to London in November 1917 just as the Bolshevik revolution was taking place.

Emmeline was even more antagonistic towards the Bolsheviks than the Mensheviks, accusing them of being organised and financed by the German government. The Germans had helped Lenin, the Bolshevik leader, to return to Russia by allowing him to cross Germany in a private train because they saw him as a force who could bring about the withdrawal of Russia from the war. The Bolsheviks, proclaiming a slogan of Peace, Bread and Land, seized power in November 1917. In March 1918 they signed a humiliating peace treaty whereby Russia lost

a third of her population, half her industry and a quarter of her land. This association of socialism with what she saw as an unjust peace reinforced Emmeline's growing antagonism towards socialists.

Emmeline Pankhurst was equally appalled by the new moral code alleged to be emerging under the Bolsheviks, complaining that 'all girls 18+ were compelled to register in the "Free Love Dept of Bureau of Public Assistance" where they could either choose a mate or have one chosen for them'.[97] Her comments here were ill-founded, since the Bolsheviks were committed to greater sexual equality than she gives them credit for. Under the influence of Alexandra Kollontai, a feminist revolutionary, the Bolsheviks equalised the marriage laws, permitted men and women to choose which surname to take on marriage and allowed women to sue for divorce and receive alimony. In addition, they granted sixteen weeks' paid maternity leave, factory nurseries and protective legislation for women. Nevertheless, this form of socialism, based on a one-party state, was anathema to her since it was seen to eclipse democracy and erode morality.

VISITING THE UNITED STATES AND CANADA

In January 1916 Emmeline, accompanied by the ex-Secretary of State for Serbia, visited America to collect money for a destitute and defeated Serbia and to drum up support for the Allied cause.[98] (Serbia had initially catapulted the rest of Europe into the First World War.) When she arrived in America, immigration officials immediately sent her to Ellis Island but released her swiftly when they realised she came as a government representative rather than a rebellious and seditious dissident.

The image of a small defensive Serbian state crushed by the might of the German and Austro-Hungarian empires was plainly emotive, and she exploited it to the full. Aflame with patriotism and elegantly attired in plaid silk and soft grey chiffon, with a 'frivolous little black-plumed hat and a cape of Hudson seal, edged with grey fox', Emmeline was as politically wily as ever.[99] She began her lectures with the history of the Serbian people, declaring that its enlightened educational ideas, its cultural background and its legal system made the country worthy of defence. It was a Christian nation, she insisted, which had saved Europe from the spread of Islam. She extolled the high moral principles of the Serbian people, laying special stress on its female citizens, who formed a

powerful reserve army, cultivating the fields and working in industry.[100] Serbia, Emmeline eloquently argued, was being plundered by ruthless and powerful foes (i.e. Germany and Austria-Hungary) who had forced thousands of Serbian inhabitants to flee into the snow-covered mountains, 'which necessitates their walking for sixty days over the wild mountains in zero weather. Many of them die in that march in which they are blown like chaff in a windstorm, fearing both their enemies behind them and the lawless bands which inhabit those mountains.'[101] If Germany won, she maintained, it would mean the ultimate defeat of American values.[102]

On March 1st she arrived in Canada and addressed meetings in Quebec, Sarnia, Cornwall, North Bay, Toronto, Ottawa, Montreal, Hamilton, London, Peterboro, Winnipeg, Victoria and Western Canada. Here she told audiences that the Serbian soldier was the most moral soldier on earth. 'There is,' she insisted, 'less of disease of a certain kind among the Serbian soldiers than in any other army, because the Serbian soldier believes that when he is fighting for his country it is a disgrace for him to indulge in irregularities.'[103] Canada, as a member of the British Empire, had already joined the war, so Emmeline Pankhurst concentrated more on how to obtain victory than on raising money for Serbia. Lectures entitled 'Women's Part in the Great War' and 'Ideals of National Service' were given to various audiences. She told them about her adopted war babies, using this subject as an opportunity to stress the importance of an equal code of morals and responsibilities for both sexes. She was scathing about American neutrality to her Canadian audiences, telling them that, when she crossed the border into Canada, she drew a big breath of relief when she saw men in khaki. Canadians were praised for the way in which they had responded to the war effort even though they were geographically far from the heart of the Empire.[104]

At the time of her visit Canada was suffering from its own internal crisis. Canadians were at loggerheads over the issue of Canadian identity: French-speaking Canadians were demanding that Canada be French whereas the English Canadians wanted to maintain an English dominion. Always fearless in the midst of controversy, she beseeched them to settle their own internal differences (just as British suffragettes and the British government had done) and to unite and fight a common enemy. She declared that she would grant equal rights to English and

French, that she would make the teaching of both languages compulsory and that she would place both nationalities on the same legal footing. French Canadians, however, were not convinced and many gave her a hostile welcome.

In spring 1916 she visited French-speaking Quebec. During her visit the provincial parliament was deciding whether to admit women to the Bar. Emmeline Pankhurst supported female barristers, arguing that 'it is only by the vote that you will succeed in obtaining your rights'.[105] Several groups, especially Roman Catholics, were outraged by her comments, believing them to represent the evils of feminism. The Catholic press reminded their readers that the former suffragette leader was a law-breaker and a felon, insinuating that she was collecting funds for Serbia as a pretext for her political ends. Her real reason for coming to Canada, they claimed, was to found a league of suffragettes and warned that, if women heeded her words, it might give rise to another 1789 revolution.

Two years later, in June 1918, Emmeline Pankhurst returned to America to 'speak to women about the spirit of England and France and the conditions of the Front',[106] leaving her newly adopted babies to be looked after by others. Although America had joined the war in April 1917, the women's suffrage movement there continued to fight for the vote, increasing its militant activities. In this atmosphere she 'thought it would be a good thing to bring to American suffragettes a greeting from the patriotic women of England, where we are worrying over one thing, and that is war. When the great struggle commenced,' she told her audiences, 'the women of England put aside the suffrage question because it would be of no use having a vote if there was no country to vote in'.[107] She also lectured on the perils of Bolshevism.[108] She remained in America for almost four months, speaking to workers in munitions factories across the country. In her lectures she spoke of national service, of women employed in the munitions factories, of how she tried to prevent industrial unrest, and of how she tried to inspire industrial workers to greater efforts.[109]

In the autumn she visited Canada. By now Emmeline was an out and out imperialist, passionately opposed to internationalism because its adherents preached peace with Germany. She praised the British Empire, drawing distinctions between what she called a 'good and a bad kind of Empire'. She viewed the Empire as an opportunity to unite

working and non-working women, to remove class distinctions, and to 'shoulder the vast Empire responsibilities that have come upon us with the vote'[110] by promoting gender equality in all countries. 'Millions of women,' she argued, 'were in subjection of the most abject kind, without rights of any kind.' Had she the power, 'she would abolish suttee, child marriage and other customs and when she thought of these things she rejoiced to think that English women had now some power to influence imperial politics to help these unfortunates'.[111] In this respect she had returned to the older Liberal principles of those like Joseph Chamberlain who justified imperialism because the British system was thought to be morally superior to that of the nations it conquered.

During her visit a former suffragist founded a Canadian Woman's Party. Its manifesto mirrored that of the British party. It advocated food rationing and the reduction of non-essential industries. It wanted government departments to get rid of pacifists and pro-Germans, tougher immigration laws and the closure of German banking systems. Members of the Woman's Party had to pledge 'not to buy, sell or use any article made in Germany or by her allies; to overcome all social and industrial unrest and enemy propaganda'.[112] It also had a feminist agenda and proposed equal pay for equal work, equal marriage laws, equal parental rights and raising of the age of sexual consent. Finally, the Woman's Party put forward a housing scheme involving the principle of co-operative housing. Unfortunately, despite the vigorous efforts of its members, the Canadian Woman's Party failed to make any significant headway.

Towards the end of the war Emmeline Pankhurst maintained that steps should be taken 'to prevent German economic and financial penetration and German exploitation of British industry'.[113] Not surprisingly, she supported the Treaty of Versailles whereby Germany lost land to France, Poland, Denmark and Belgium, had her colonies confiscated and had to agree to pay further reparations in hard currency. She held Germany responsible for the outbreak of the First World War so thought it 'should be made to pay, to become poor, and to work, learning to abandon dreams of world conquest.'[114] She criticised those who raised objections to the punitive settlement, asserting that 'the allied Premiers acted upon the advice of financial experts'.[115] The apocryphal statement that Britain should 'squeeze Germany until the pips squeak' was a sentiment Emmeline Pankhurst shared. In a manifesto for her newly formed

Women's Party, she argued that subject populations be withdrawn from German control, that Germany should have her mineral resources reduced and that the Allies should make it physically impossible for Germany to wage war ever again.[116] In addition, she called for the British Empire to be strengthened 'and its component parts drawn into closer co-operation for defence and development'. It had become abundantly clear that Emmeline Pankhurst now placed country and its welfare, and the integrity of the Empire, before all else, a fact signified by renaming *The Suffragette* as *Britannia* in October 1915.

CONCLUSION

It is commonly assumed that Emmeline Pankhurst jettisoned the campaign for the vote for national security reasons. According to Sylvia, her mother fiercely opposed all attempts to bring women's suffrage forward until after the war, arguing that it was more the duty of militant suffragettes to fight the Kaiser than it was to fight anti-suffrage governments. Even more surprising, she insisted that votes for soldiers and sailors must take precedence over votes for women. However, her overall dedication to women's emancipation should not be underestimated. The vote, after all, was only ever seen as a means to an end of greater social and economic justice; once that same justice was threatened, the vote became less meaningful. Moreover, although she threw herself into a wide range of different activities during the war, she never lost her commitment to women's suffrage, raising the question of the franchise at any given opportunity.[117] The struggle for votes for women was not abandoned with the war, merely placed in abeyance. Emmeline insisted that 'when the clash of arms ceases, when normal peaceful, rational society resumes its functions, the demand will again be made. If it is not quickly granted, then once more the women will take up the arms they today generously lay down.' On her overseas trips she continuously claimed that women's efforts in the war had shown that they were ready for the franchise. 'We're like a dog that has buried a bone,' she argued. 'They think we have forgotten all about it.' But, she added, 'we've got the place marked.'[118]

On Thursday March 29th 1917, Emmeline Pankhurst accompanied by Millicent Fawcett and others walked to 10 Downing Street to meet Lloyd George and W. Astor. According to reports, the suffragette leader

spoke in a subdued way, reminding Lloyd George that she and the WSPU had abandoned all suffrage work to devote themselves to national service of every kind. She urged him to take personal responsibility for women's suffrage so that it could be settled with as little contention as possible.[119] By this time the government was more favourable to women's suffrage and, with the influential Lord Northcliffe, owner of a number of key newspapers, promising that the whole of his press would give support to votes for women because they had 'proved' themselves worthy of the vote, success was assured. When the division bell sounded in the House of Commons, 385 MPs voted in favour and 55 against the clause in the Representation of the People Bill supporting votes for women. Women over the age of 30, subject to property qualifications and other restrictions, now had the vote. The Bill then passed smoothly through the Lords, largely because Lord Curzon, one-time President of the League for Opposing Woman Suffrage, encouraged peers to abstain from voting if they could not support it. And so, on February 6th 1918, votes for women – after more than 50 years of campaigning – was at last achieved.

It is assumed that women were granted the vote because they had contributed to the war effort. Emmeline certainly believed that this was so. Women, she claimed, had proven the claims they had put forward before the war, had fought shoulder to shoulder with men and had demonstrated their worthiness for the franchise. The *Labour Woman* believed otherwise, claiming that the fear of a fresh outbreak of militancy after the war was 'far more the reason for granting the suffrage in 1918 than was gratitude to women workers for what they had done in the War. Indeed the majority of the "war workers" were not included in the Act …. Women's suffrage was a result of revolutions after the War in Germany and in Austria. We had no revolution here but our governments feared one. And militant suffrage, joined to a people's discontent, would have brought a dangerous situation.'[120]

It would be naive to believe that women received the vote solely for services rendered in the First World War. It must be remembered that only women over 30 were given the vote, and they were not the ones who had made the most substantial contribution towards the war. Indeed, the very women who had helped in the war effort – the young women of the munitions factories in particular – were actually denied the vote. Moreover, women may well not have been granted the vote if

the suffragists and suffragettes had not campaigned so effectively before the war. Undoubtedly, the pre-war suffrage movement prepared the ground for votes for women. French women, for example, were not enfranchised despite their participation in the war effort, largely because there had been no women's suffrage movement pre-war. Furthermore, as Emmeline threatened, it seemed likely that the women's suffrage movement would regroup once the war had ended, with perhaps a renewal of the militancy which had plagued previous governments. One can only assume that, because the political climate was very different in 1918 from that in 1914, it would have been inconceivable for the government to have imprisoned those self-same women who had so publicly participated in the war effort.

In many ways the war may have delayed the extension of the franchise to women rather than expedited it. Just before the outbreak of war there were conciliatory gestures by key MPs: Asquith received deputations from the NUWSS and the ELFS; Sir John Simon emerged as a cabinet supporter; and Lloyd George offered a place on his platform to suffrage speakers. There was also evidence to suggest that the Liberal Party was pressurising prospective MPs to support women's suffrage and replacing those unsympathetic to the suffrage cause with those who agreed with it. Sandra Holton argues that 'only two weeks before the outbreak of war, negotiations between suffragists and government were taking place'.[121] In addition, the Liberal leadership seemed ready to make women's suffrage part of its party programme. This of course is mere speculation. Negotiations between the government and women's suffragists had taken place many times before but had never provided votes for women. There was no guarantee that it would have been the case this time.

Of course, neither the view that women achieved the vote because of their pre-war campaigns nor the view that women achieved the vote because of the war is ultimately sustainable. As with most historical judgements, there are a number of reasons for such a significant event and historians much prefer a synthesis of causes to crude over-simplification. It must also be remembered that the vote was still not entirely won, as full adult universal suffrage was not achieved until 1928.

Nonetheless, in the November 1918 general election women had their first ever opportunity to vote and to stand as parliamentary candidates. Approximately 8.5 million women had been enfranchised and 17

women from across the political spectrum stood for election as MPs. Christabel Pankhurst was one of them, standing first as candidate at the Westbury Division of Wiltshire, then as nominee for Smethwick, a new constituency near Birmingham. Christabel Pankhurst, the only woman who received Lloyd George's 'coupon', stood as the Women's Party and Coalition candidate. Lloyd George wrote to Bonar Law, saying 'I am not sure that we have any women candidates, and I think it is highly desirable that we should.'[122] She also received press support from Lord Northcliffe and family support from her mother. Northcliffe was especially keen and promised to run a special edition of the *Evening News* to promote Christabel Pankhurst's candidature. Emmeline organised an educational campaign, a campaign fund and arranged meetings to drum up support for her daughter.[123]

Christabel Pankhurst suffered a narrow but nonetheless humiliating defeat, losing the seat by a mere 775 votes. She never stood for Parliament again. The only woman to be elected was Constance Markievitz, who, because she stood as a Sinn Fein member (whose policy at the time was not to recognise the British government or its mechanisms), refused to take her seat in the House of Commons. According to Sylvia Pankhurst, the defeat in Smethwick not only sounded the death knell for the Women's Party but also for her mother's own hold on politics.[124]

From 1914 it is said that Emmeline's politics spiralled swiftly down to Conservatism. Undoubtedly the war was a turning point for her as much as the country. Three quarters of a million British men and 200,000 men from the Empire were killed in the First World War. Women, left at home, had taken on greater civilian responsibilities, working in occupations previously denied them. The world, not just Emmeline Pankhurst, would never be the same again. Her commitment to national independence, to Irish Home Rule, to any remaining vestiges of socialism were not so much replaced as transformed by a new social and historical understanding. War and Empire had been substituted for Peace and Internationalism. The emancipation that women would inevitably achieve, she believed, must take place within a reconstituted imperialism.

10

LIFE AFTER THE WAR 1918–28

With the war ended and the vote won, Emmeline Pankhurst was at a loss: what was she going to do with herself? 'She was secretly bored to death when former suffragettes fell to expatiating on the brave old days of militancy. The Suffrage? Yes ... but that was done with now.'[1] In a world of happy endings she would have flourished as a much-loved national figure, dividing her time between shopping, looking after her adopted children and being consulted as an elder stateswoman. But politics is an unforgiving business and post-war England at peace had little time for the former jingoist. In Britain she had become a political embarrassment; her Women's Party had done disastrously at the polls and the Coalition Government had little use for such a propagandist now that the war was over. As Annie Kenney remarked at the end of the war: 'We gained nothing by our patriotism. No money, no lasting position. By Armistice we were tired out, no homes, no job, no money, no cause. Forgotten.'[2]

In September 1919, now aged 61, Emmeline landed with a group of war brides at New York harbour. This time she had come to America to earn money to support her newly adopted children. Her lectures were to focus on the terrors of revolutionary socialism. She wanted to warn Americans about what she called 'the disease' of Bolshevism and to persuade women that they could put an end to it 'by applying the same spirit that prompted them to turn out the munitions and stand behind the men behind the guns'.[3] 'Reds in America,' she insisted, 'will make

no appreciable progress, if the enfranchised women are alert and vote.'[4] This volte-face from someone who had once fiercely defended socialism is remarkable. Pankhurst's conversion to a form of radical feminism during her suffragette years, combined with her experiences in the First World War, had encouraged her to turn away from traditional left-wing parties. Throughout the First World War trade unions and socialism were seen to have consistently undermined British endeavours, and Russia, under the Bolshevist leadership, had reneged on the Allies by seeking peace with Germany. In her view, socialism – now seen as a predominantly male movement – was a spent force that had hindered women, the war effort and the British nation. Pankhurst remained in America for almost a year, speaking on the dangers of revolutionary socialism to declining American audiences. People no longer flocked to hear the once-notorious suffragette.

SEX AND EMPIRE: EMMELINE PANKHURST IN CANADA

After leaving America, she toured Canada, planning to stay three months. In August 1920, after a busy summer lecturing on the west coast, she settled in Victoria, British Columbia, for a long holiday. Before her visit was over, she decided to remain there permanently and sent for her three adopted daughters. She chose Victoria as her new home because 'it is the nearest thing we have to a bit of old England'. Moreover, she believed Canada to be a 'land of opportunity',[5] which offered a future for her adopted children since there was greater equality between the sexes in Canada than anywhere else. Furthermore, she liked the experience of 'watching the growth of a new country and seeing what use people make of their opportunities'.[6] Not surprisingly, given her love of France, she was attracted by the bi-nationality of Canada. One of Canada's greatest possibilities, she asserted, 'lies in the fact that its pioneers come from the two greatest races in the world – the British and the French. What a wonderful thing it would be for the generations to come if we could have a bilingual nation, the arts and traditions of both races being handed down to the children'. Furthermore, she wanted to live in Canada so that she could 'do her bit' towards preserving the unity between Canada and Britain. By this time she had revoked her earlier commitments to national independence: 'I am an imperialist and I have even been called a reactionary because I am an imperialist'[7] who

wanted to keep the British Empire intact. 'My hope and belief,' she said, 'is that we British women – whether born in Canada or the Mother Country – have the power as well as the opportunity to develop this wonderful country and make it one of the biggest and best in our wonderful Empire.'[8] Canada of course offered something more important – a salaried post to a cause in which she believed. With three young children aged between 7 and 8 to support, she needed a job. In a letter to Ethel Smyth she stated: 'I do so long to come home, but how can I till I have earned enough to educate the babes and keep myself in my old age?'[9]

Her influence on post-war Canadian sexual politics was remarkable. In the early 1920s, at a time when most women were considered past the retirement age, Emmeline became a national figure. It was her fifth trip to Canada; she had been twice, in 1909 and 1911, to speak on suffrage and twice during the war (in 1916 to speak on women's war service and in 1918 to launch a Woman's Party). On this visit she lectured on the perils of Bolshevism before finding permanent employment with the Canadian National Council for Combating Venereal Disease (CNC-CVD), which had its headquarters in Toronto. Consequently, she moved from Victoria to Charles St West, a tree-lined avenue in central Toronto, became a Canadian citizen, and was eventually promoted to the post of Vice-President of the CNCCVD.

The CNCCVD

Emmeline believed that her work in the CNCCVD was 'the logical outcome of all the other campaigns'.[10] She had long been interested in the relationships between white slavery, prostitution, feeble-mindedness, race and venereal disease, so this was an excellent opportunity for her to crystallise her thinking and take it on in a new direction. She was 'returning to a branch of social welfare work which engrossed a good deal of her time and thought before and during the war'.[11] As she pointed out to Canadian audiences, she had visited male and female venereal wards in hospitals and had observed the tragic effects of the disease when she had been a Poor Law Guardian. As a member of the Manchester School Board and a Registrar of Births and Deaths, she had learnt that venereal disease was responsible for a high infant death rate. 'The culmination of these experiences came when I and my daughter

Christabel began the campaign. We realised that no medical cure of such disease was sufficient. We knew that women would not be satisfied to have as husbands, men who were merely physically cured.'[12]

The Canadian National Council for Combating Venereal Disease (it changed its name to the Canadian Social Hygiene Council in 1923 and in 1935 to the Health League of Canada) was an ideal forum for her. It was founded and led by Dr Gordon Bates, who had served with the Canadian Army Medical Corps in the First World War and who had been alarmed by the high incidence of venereal disease among the troops. Venereal disease was a metaphor for all the ills of society – it was linked to various social problems, to national survival and to the Empire. It is therefore not surprising that the CNCCVD appealed to Emmeline Pankhurst. 'I look upon this work,' she told her audiences, 'as the greatest of all crusades'.[13] Looking back on her life, she claimed that 'she had become so impressed with the need for combating venereal diseases that she had decided to go about it via the suffrage-for-women route'. The 'big motive of her suffrage movement,' she confessed, 'was to put in the hands of the women of the British Empire the means of clearing up social diseases'.[14] Of course, much of this was rhetoric to justify her newest campaign since in the past she had claimed that she wanted suffrage to end a range of injustices, not just sexual ones. She took up the cause in Canada because she believed that, as it was an integral part of the Empire, it could be a force in bringing about the social reform of the whole world. It was here that she drew links between eugenic failure, prostitution and venereal disease, insisting that the latter was very closely related to Bolshevism.

She told her audiences that she had come to realise that it was 'not enough to secure political power for women in order that social evils could be eliminated'. By this time she had changed her opinion over how social change occurred. 'In the pre-war days,' she said, 'I believed that if we could improve political conditions and give women power to make better homes ... the conditions of life would be changed. My views have been modified largely as the result of the war.' The only way to eliminate 'the state of things that exists today is by finding a change of heart and a new outlook on the facts of life ... we are endeavouring to change, if possible, the moral outlook on life. We shall not get a cure until the people have taken it up along with their other racial responsibilities and insure against the passion of those who communicate diseases to

innocent victims'.[15] In her view, the prevention of venereal disease could not be divorced from wider moral issues.

Work in the CNCCVD

As soon as she started work, Emmeline's obsessional streak and indefatigable energy took over and she put as much effort into her new responsibilities as she had done elsewhere. For example, in her first six weeks in Toronto she addressed the Masonic Lodge, the Canadian Manufacturing Association, the Imperial Order of the Daughters of the Empire, Women's Institutes, the Women's Law Association, the Women's Press Club and Mothers' Meetings. She also spoke at factories, several men's luncheon clubs, undergraduate colleges, women's college alumni associations, theological colleges, church congregations, female reformatories and drawing-room gatherings in the homes of the elite of the city. In one month alone she visited Fort William, Saltcoats, Regina, Prince Albert, North Battleford, Saskatoon, Swift Current, Weyburn, Wynyard, Yorkton, Calgary, Lethbridge and Medicine Hat.[16]

As she was very aware, arranging meetings required an immense amount of organisation. More politically experienced than Gordon Bates, she used the strategic skills developed in the WSPU and during the war to orchestrate the CNCCVD. She believed that 'to have good meetings you must arouse public interest either through hard personal work or expensive advertising'.[17] Emmeline believed in free publicity. An organiser was sent in advance to rouse public interest and obtain local support. On arrival, she invited the editors of local newspapers, the mayor and other public officials, leading clergymen, prominent women and other leading members of the town to meet her. Her lectures were advertised in church and film theatres and sympathetic individuals and organisations were encouraged to sell tickets in advance. In each town supporters were asked to telephone fifteen others to persuade them to buy and sell tickets for her forthcoming lectures on a sale or return basis.

Before Emmeline began her lectures, an eighty-minute silent feature film was shown which dealt with the ravages and the fundamental causes of venereal disease. Designed to raise awareness about the dangers of venereal disease, *The End of the Road* was an expensively made feature film starring some of the leading actors of the time. It deals with venereal diseases in a daring, realistic manner, exploiting the thrill and sus-

pense of a clever dramatic shape to provide the most crushing indict-ment of free love and loose living. The heroine, Mary, whose very name conjures the mother of Christ, is neat, trim, tidily dressed in white – in marked contrast to Vera (subliminal echoes of venereal), who is por-trayed, even at a young age, as untidy and sloppy. Not surprisingly, given the background of these two women, their prospective lives turn out differently. Mary works for the good of others, training as a nurse and rejecting the offers of a suitor whose moral values are suspect. Poor Vera, bored with working in a department store (a symbol of immoral-ity), succumbs to the overtures of a rich man and becomes his mistress. Soon her health suffers and she is found to be venereally infected. Initially, Vera resists treatment so is taken to a hospital for patients suf-fering from venereal disease. This gives the filmmakers the opportunity to show the horrific effects of the disease: madness, blindness, severe loco-motor impairments, sores, lacerations and gross physical deformi-ties. Vera, recognising the futility of ignoring her complaint, undergoes treatment, is reformed and ends up working for the war effort, happy to sacrifice herself for others rather than indulge in her usual selfish plea-sures. Once again, the moral of the story reinforces the need for good parenting, sound moral values and of course the desirability of subli-mating personal desires into work for the good of others.

After the film was shown, Emmeline Pankhurst took the stage. For her, as with the film *The End of the Road*, the cure and prevention of venereal disease was a moral rather than a medical problem. Her speeches were laced with phrases which resonated with her own sense of moral purpose. She continually stressed the need for a higher moral standard, improved home conditions, leisure time and an end to white slavery. There could be no such trade unless there was a demand for it, and the demand for this evil traffic was to be traced to the so-called double standard of morals. 'Get rid of the double standard in morals,' she would urge, 'and the traffic in women will cease.' She blamed the high incidence of venereal disease on a wider cultural climate. 'Think of the magazines they read, the literature ... their amusements, the movies ... everything to stimulate before the right time their sex instincts.'[18]

By now she had sharpened her oratorical skills to perfection. On one occasion, speaking at an all-male Rotary Club banquet, she prefaced her address with the remark that she understood it was the custom at men's banquets to tell stories. And because she did not want the audience to

change any custom they might have, she would begin the programme with a story. 'At a club banquet,' she told her audience, 'the men were extolling the graces of their children – their gifts, their promising futures, the success some of them had already attained.' At this point, she said, a bachelor interrupted to tell them a tale from Guy de Maupassant 'of a youth who was dismissed from college on account of ill-health and who went to a secluded country village to recuperate. All summer he made love to the maid at the inn, and in the fall went back to college. Years after he passed through the village again on another holiday … and asked the village characters at the inn 'where's that pretty girl you used to have here?' 'Oh Mary – you didn't know about Mary? … She got into bad ways and had a child and she died. And that's her boy passing now.' The man looked and saw the village idiot – his own son.'[19] Using a third person as narrator and a context familiar to her audience, Emmeline Pankhurst was able to make her point without antagonising her audience. Nevertheless, her speeches were thought to have sprung from 'dark and somewhat bitter waters. Her metaphors are shapes of gloom.'[20]

To a more general public she focused on the responsibility of parents to breed healthy children and to bring them up morally. 'There is no crime to compare with that which causes the early death or lifelong suffering of innocent people,' she told one audience at Saskatoon. 'To bring into the world a child that is blind through venereal disease, is a crime. To cause the lifelong invalidism of a woman, and deny her that greatest joy, the joy of motherhood, is a crime. To cause a child to be born doomed to die, and to suffer every minute during its life, is a crime.'[21] Twenty thousand babies, she claimed, during the first year of their life died every year in Canada from the disease. Sometimes the leaps of imagination in her discourse bore little relationship to the facts. She would tell the story of a 75-year-old woman who lived on Vancouver Island and who had been forced by lack of money to take in washing. The woman, said Emmeline Pankhurst, had contracted syphilis from some article of clothing sent to her to be washed, a commonly held fallacy of the time.

At a talk to the Women's Canadian Club she emphasised the importance of 'race betterment', insisting that 'woman enfranchised ought to turn her attention first to racial improvement'.[22] Here she stressed the importance of motherhood and women's role in the destruction of the

disease that menaced Canada. 'Now that citizenship had been won for women,' she argued, women must face the same duties and responsibilities as men. 'It is the first duty of the woman who has become a citizen ... to defend her own self-respect by fighting the social evil of traffic in human lives that eventually attacks the family.'[23] She insisted that 'the safety of our race depends upon our citizens and the mothers of the race are entitled to all the protection which can be afforded'.[24] Her early eugenic beliefs had also come to fruition.

By now Emmeline had rejected her past commitments to internationalism. Her freshly acquired patriotic convictions, formed in the First World War, had transformed her into an out and out imperialist. The gap between her earlier socialism and this new ideology seemed unbridgeable. However, she would defend her latest dogma against possible criticism by stating that:

> it has become fashionable nowadays to talk of empires as oppressive. History shows that a great deal has been accomplished by empires. In my opinion, the British Empire has great responsibilities towards the world. It would be cowardice to break up the empire into separate parts. Separated, the units would be of little influence: together they can be a tremendous influence and power for good. If, in our modern idea of empire, we eliminate the oppressive, and work for the noble, we will be much better off.[25]

Emmeline believed that the British Empire should and could eliminate inequalities between classes and sexes by forbidding practices such as suttee in India. The socialist dreams of the First and Second International, ideals which once might have been shared by Emmeline, were thus given a paradoxical twist into an international imperialism. Certainly, the language, rhetoric and philosophy of a newer imperialist thinking appealed to women like her. Leading imperialists of the time had recently turned away from regarding imperialism simply as conquest and domination. Rather, they saw it as building 'a sustainable, civilising Empire dependent upon female as well as male virtues'.[26] As with many female imperialists, she did not want to imitate the actions and propaganda of the masculine elite. Instead, she used a remodelled language of empire, emphasising the shared cultural heritage between England and Canada.

Her unabashed belief in the best of the colonial heritage, especially her emphasis on the domestic and familial, brought her into contact with the Imperial Order of the Daughters of the Empire. The IODE, formed in 1900, aimed to preserve the unity of the British Empire. In 1920, when she was lecturing on venereal disease in Calgary, the IODE was holding its Annual Convention, so she spoke at their conference too. Here she met Mrs Gooderham, a former president of the IODE who was sympathetic to women's suffrage and ideas of social hygiene. Mrs Gooderham also liked Emmeline and in later years formed part of the Canadian Committee which raised funds for a statue of the suffragette leader.

Emmeline did much to publicise the CNCCVD and its work. Audience sizes were respectable and the press was largely sympathetic, often paying tribute to her tireless energy and her fixation with political justice. 'She nurses, as it were, a fire in secret, has that independent life of the mind which seems unconscious of all external motive …. She seems to have no personal life and no emotions except that overmastering one of abstract justice – a stern, tyrannic thought that makes all other things its slave.'[27] The CNCCVD, and Gordon Bates, were also pleased. According to executive minutes, she was a valuable addition to the lecture circuit and so was promoted to Vice-President of the organisation. As an additional mark of gratitude, a brooch she had created, in the form of a shield with a crusader's sword on it in the colours of the WSPU, was adopted and sold by the CNCCVD.

Resignation from the CNCCVD

Emmeline's longer trips were gruelling experiences: she travelled huge distances in the hot, humid summer, undoubtedly plagued by mosquitoes, in stuffy, uncomfortable trains without air-conditioning. In the last stages of one tour, while visiting her twelfth town, she complained of hard and exhausting travelling with roads 'in a terrible condition due to heavy rainfall. Prairie "gumbo" is the nastiest and stickiest material I have ever met with.'[28] No doubt fed up with using public transport, she asked for a car. 'I am sure a Ford Sedan even on deferred payment plan would be a good investment or perhaps one of the wealthy members of the business committee may have an old car he would give or lend for the purpose. The arrival of the Social Hygiene Car in a town would be an advertisement for the meeting.'[29] Emmeline

never got her car and continued to travel on public transport. When she returned to England, she put her ill health down to the difference in temperature of the trains and between the insides of buildings and the outdoors in both winter and summer. She found the contrast between the suffocating heat of indoors in winter and the icy cold of outdoors too great and debilitating to be endured.

In 1923 Kate Pine left with Kathleen and Joan, two of the three adopted children, to find other homes for them in England. At first, the two young girls were looked after in the home set up at Tower Cressey. Later Kathleen was re-adopted by John Coleridge Taylor, a journalist on the *Evening Standard* and Joan re-adopted by Mr and Mrs Russell, a wealthy Scottish couple. An increasingly fidgety Christabel stayed on with her own adopted daughter, Betty, and with Mary, Emmeline Pankhurst's favourite. In March 1924 Emmeline requested that she be granted indefinite leave of absence, to start immediately. 'I want to go off the "payroll" at the end of this month and to cancel or postpone the tour in Nova Scotia. As I have told you, I have not been well or equal to my conception of my work for some time.' By this time, she had mellowed considerably, coming across as a delightfully well-mannered, quaintly old-fashioned lady so that even the notoriously irascible Gordon Bates was charmed. Her relationship with the CNCCVD leader remained cordial. 'I feel it impossible to write all I would like to say about the privilege I have felt it to be to work with you,' she wrote in her letter. 'Your enthusiasm and unselfish devotion to the Cause have been a constant inspiration and I shall always cherish my personal friendship with Mrs Bates and yourself.' She signed her letter, 'believe me, dear Mr Bates, yours most sincerely'.[30] Her request for a leave of absence coincided with a time of financial crisis for the CNCCVD, because it had just had its government grant cut by half.[31] Of course, this loss of government income might have contributed to her decision to take unpaid leave, since Emmeline said that she would be very glad to return to the Council if her services were required in the future. 'You will get some relief from your heavy financial strain when you have not to consider me If in the autumn there is need of me and my health permits you know with what enthusiasm I would respond to the call.'[32] Undoubtedly, her expenses would have been a heavy drain on the CNCCVD's much reduced budget, for 'desperate attempts' were made to put her expenses in order.[33] 'My observations have led me to advise

you that it is most imperative that strong efforts be made to have some amicable arrangement whereby these travelling expenses may be kept in a more strict and clear manner'.[34] Her leave of absence, unpaid, was granted. The CNCCVD did not ask her to resume her post. Emmeline never returned to Canada.

In the summer of 1924 Emmeline left for a long holiday in Bermuda with Christabel, Mary and Betty. She had 'fallen in love' with the idea of Bermuda when she had visited an exhibit of the country at the Toronto Annual Exhibition. At first the family stayed at a guest house in Paget, before renting a house, Roche Terre, on a hill overlooking the sea. Emmeline, now 65, enjoyed bathing in the sea – she would wear a modest, loose-fitting, high-necked blue serge suit trimmed with red braid that extended to the knees. The children, who were generally looked after by a black nanny, were taught to swim the Bermudan way: they were thrown into the sea from a boat and left to struggle. Apart from one occasion when she spoke at the Mechanics' Hall on women's suffrage, she did not engage in any political activity.

In 1925, after an absence of over six years, she returned to England. Shortly afterwards she left for Juan Les Pins in the south of France with Mabel Tuke to open a tea-shop. Unfortunately, 'The English Teashop of Good Hope' failed, as had all her other business enterprises, and after a short stay in Paris Emmeline returned to England. She was invited to work for the Six Point Group at a salary of £400 a year but declined their offer. Even though her hair was now white, she looked much stronger and 'had a bright colour in her cheeks She has the same erect bearing, the same bright, watchful eyes and the old skill in answering or turning difficult questions.'[35] At first she stayed with one of her sisters, Ada Goulden-Bach, and spent her time talking to old friends and avoiding her daughter Sylvia. For Emmeline never forgave her daughter for delivering a son out of wedlock, for her continuing commitment to socialism and for her anti-war propaganda. On one occasion when Sylvia visited, she walked out of the room immediately, leaving Sylvia weeping in consternation – the two women were never reconciled.

JOINING THE CONSERVATIVE PARTY

In 1926, to the surprise of most contemporary newspapers and many erstwhile supporters, Emmeline Pankhurst joined the Conservative Party

and became a Conservative parliamentary candidate for Whitechapel. Her metamorphosis from a disreputable radical to a respectable Conservative was complete. In the past she had revelled in the opportunity to move away from the conventional world – now she seemed to want to return to it. This might seem quite an odd position for an ex-socialist to take: to some of her contemporaries it was a denial of her whole life's work and of her earlier commitment to socialism. The *Labour Woman* stated that: 'A woman whose fame grew out of her fiery, passionate and sacrificial rebellion against injustice, allowed herself to be drawn in her later years ... into the maintenance of that very society of privilege, prejudice and oppression that she had so long hated and fought.'[36] Or as the *Evening Standard* put it: 'It would have seemed rather a shocking end to a certain Manchester schoolgirl who, fifty years ago, stole time from her "prep" to hear Lydia Becker.'[37] On the other hand, her daughter Sylvia believed 'that she lost the reformer's quality in her declining years and grew as intolerant in her reaction as she had been stubborn in her pioneering'.[38] Emmeline seemed to confirm this by maintaining that as she got older she lost the radical and progressive outlook she had held in her youth. She no longer supported 'the view that state ownership means distribution of production and exchange and would be of any benefit to the community. My war experience and my experience on the other side of the Atlantic have changed my views considerably. I am now an imperialist.'[39]

Certainly, before the war the allegedly non-party WSPU had established more or less friendly relationships with the Conservatives, attracting a significant number of wealthy Tory women (such as Lady Constance Lytton) who donated large sums of money. Moreover, Emmeline Pankhurst's replacement of class politics with feminism and her commitment to national unity significantly diminished her previous animosity towards Conservatism. In some ways she was merely continuing a trend set by others and the actions of senior politicians may have informed her own decision to switch parties. During the First World War Lloyd George headed a Coalition Government which drew support from across the political spectrum. After the war he sought a realignment of politics by trying to amalgamate an element of the Liberal Party with a section of the Conservatives. This failed and instead Lloyd George's Coalition Government set the trend for a Conservative revival. A mixture of Tory grandees and those, like Churchill and Chamberlain,

who had either changed or were about to change sides in the House of Commons, dominated Lloyd George's post-war cabinet. Party politics, Emmeline must have realised, were not fixed like seats in the House of Commons but fluctuated according to historical circumstance.

Even so, the reasons why Emmeline became a Conservative Party candidate are complex. Indeed, it may have been as much historical accident as reasoned planning that made Emmeline join the Conservative Party. Both the Labour and the Liberal Party declined to offer her a seat since neither Party wished to take the risk of adopting a loose political cannon who had once formally opposed them. When it was suggested that she might stand as a parliamentary candidate, she stated: 'Today I am a Constitutionalist with friends in all parties, but so far I have not been approached by anyone.'[40] The Conservative and Unionist Party quickly said that it would give official support to her. Moreover, 'obliged to choose between a Liberal party torn by strife and a Labour party incapable of governing',[41] it is perhaps not surprising that she chose the Conservatives, who at least seemed electoral winners.

In effect, Emmeline was in an ideological vacuum: she had left Liberalism far behind, especially during her suffragette years, and any vestige of loyalty towards the Labour Party had disappeared during the First World War. In her view, socialists were now a discredited force, discredited by pacifism and pro-Germanism. There was only one viable party left, the Conservative Party, which had been in power since 1924.

Her friendships with the Conservative Prime Minister Stanley Baldwin and Nancy Astor undoubtedly helped her conversion. Baldwin apparently liked her and the regard was reciprocated.[42] Like Emmeline Pankhurst, Stanley Baldwin saw himself as above party politics. Although a Tory, he was a moderate who eschewed class politics in favour of national and reformist policies. 'He was associated with no particular policy or reform ... his was the voice of moderation and decency';[43] he was thought by many of his party to be 'half-way to socialism'. Baldwin certainly enunciated a more humane aspect of Conservatism that sought to conciliate and to 'blur the harsh edges of class conflict'. In 1919 he gave one fifth of his fortune, £120,000, to the Treasury in the hope that others would also contribute towards the national debt incurred by war. By recovering a large area of the middle ground, Baldwin made sure that the Conservatives had a new awareness of the social problems, such as poverty and unemployment, which faced

working people. Some claimed that he made an 'outstanding contribu-
tion to the development of the social services and social security'.[44]
Baldwin's persuasive rhetoric that 'Socialism divided, Unionism unites',
and that the Conservatives were a 'national party which puts the needs
of the nation before the needs of a class', struck a chord with Emmeline
Pankhurst. Moreover, his overriding concern to work towards increased
democracy also appealed. Throughout her life she retained certain
underlying values such as her commitment to democracy, and she car-
ried over from Liberalism to Labour to Conservatism her commitment
to women's rights within a democratic framework, an essential part of
her political identity.

At her last important public meeting at the Albert Hall in 1928 she
moved a vote of thanks to Stanley Baldwin, who had just promised
women full equality.[45] In the leaflets she wrote, she claimed that under
its leader the Conservative Party fully justified its claim to be the
Women's Party. Indeed, Baldwin's wife Lucy was a 'radical' Conservative
who supported votes for women, was active in the YWCA and pro-
moted maternal welfare, becoming Vice-Chair of the National Birthday
Trust Fund.[46] In citizenship, in peace, in housing, in health, in educa-
tion, in social questions, Conservatives, Emmeline argued, had delivered
a programme that had advanced the position of women. She referred to
a number of successes. Conservatives had, she noted, given votes to
women over 21 on equal terms to men and pensions to widows. They
had also strengthened the League of Nations, cleared slums and built
over 900,000 houses for over three million working people, given better
grants for maternity and child welfare, improved the position of teach-
ers and legitimised illegitimate children whose parents had subse-
quently married. In general, they had reduced the cost of living for
working women.

Baldwin did not act alone. Interestingly, two members of the govern-
ment who were most responsible for many of these Conservative poli-
cies, Neville Chamberlain (Minister of Health) and Winston Churchill
(Chancellor of the Exchequer), both had strong Liberal backgrounds.
However, Emmeline Pankhurst's belief that the Conservative government
was now a compassionate one with a progressive agenda was curiously
flawed. The Conservatives of the 1920s sit within the less-than-liberal
context of the General Strike and the curbing of the power of
'Poplarism' by giving the Ministry of Health the power to replace

Guardians who were too generous in their outdoor relief. But Emmeline Pankhurst was probably receptive to Baldwin's evident love of England: 'To me England is the country, and the country is England. And when I ask myself what I mean by England, when I think of England when I am abroad, England comes to me through my various senses, through the ear, through the eyes, and through certain imperishable senses.'[47]

Christabel suggests that, by this time, her mother wanted 'to strengthen the British Empire and draw closer together its lands and peoples.'[48] Emmeline Pankhurst finally decided to support the Conservatives 'even if through long tradition there were some things to which she could not give her full adherence'.[49] 'The main reason why she decided finally to join the Conservative Party ... was because the Conservative Party was the only party strong enough to defend the Constitution.'[50] Moreover, she asserted, the Conservatives and Liberal Unionists were the only party committed to the Empire, since the Socialists would want to get rid of it. Her long sojourn in Canada had convinced her that it was a 'tremendous privilege and a tremendous responsibility' to belong to the British Empire.[51] She believed that the 'bonds with England are very slight so far as English culture and ideas are concerned'[52] and expressed concern about the negative American influence on Canadian culture, especially 'their American movie-shows, and their American drug stores, where you buy everything, including American literature of the lowest type'.[53]

Of course, Emmeline may have been encouraged by the Conservative MP for Plymouth, Nancy Astor, the first woman MP to take her seat in Parliament. Nancy Astor, an American by birth, had been chosen to succeed her husband on his elevation to the peerage. She was sympathetic to women's issues and was on the progressive end of the Conservative spectrum. Nancy held the same caring social objectives as Emmeline: she supported welfare measures and legislation which promoted women's interests, and she founded the Consultative Committee on which representatives of over sixty large organisations met monthly with her to discuss women's affairs. She also shared much of Emmeline's thinking on sexual morality, criticising low standards and recommending changes in the way the law treated prostitutes. Nancy Astor had long been an admirer of the leader of the suffragettes, writing in a letter to her sister that she had never heard such a brilliant speaker. Emmeline worked with Nancy and her husband, Waldorf, during the war and had

been invited to Cliveden, their country house. She had written to Nancy: 'you may have seen in the Press that I am back again in England I should so much like to see you.' Nancy Astor wrote back inviting her to a party on February 25th 1926, 'when I think you will meet many old friends. Do come.'[54]

In March 1926 Nancy Astor spoke at a dinner hosted by the Six Point Group in honour of Emmeline Pankhurst. In her speech Astor announced to the assembled guests that 'she herself would gladly "get out of the House" to give Mrs Pankhurst her place'.[55] Nancy Astor's offer was declined by Emmeline 'because if I go to Parliament, I must fight for my seat with your help, and that seat I must win',[56] but she was deeply appreciative of the gesture, maintaining as ever that women always 'do stand by other women beautifully'.

Work in the Conservative Party

In 1926 the country faced one of its biggest industrial conflicts. Miners, whose wages were already far too low for a decent standard of living, went on strike on April 26th when mine owners threatened to cut their wages further. 'Not a penny off the pay, not a second on the day,' urged the miners' leaders. The TUC agreed and called for a selective sympathetic strike commencing on 4th May. Within a few days the trains, buses and trams came to a standstill, newspapers ceased to publish, all building works stopped, gas and electricity supplies were cut, and ships were unable to dock. Volunteers were used as strike breakers to drive the buses, lorries and trains and to unload ships at the docks, and the army was used to convey food. During the strike Emmeline Pankhurst, now approaching 70, wrote to both Mrs Baldwin and Nancy Astor offering her services. It seemed to her that, if the strike continued, 'we shall need all sorts of efforts to promote national unity and keep people loyal and patient as well as organise relief work just as we had to do during the war'.[57] She offered to do whatever was most needed, even peeling potatoes and scrubbing floors but thought she would be better placed 'enthusing others and making them realise the need for unselfish action'. In the end, Emmeline helped with the uniformed Women's Auxiliary Police, under the leadership of an old friend and suffragette, Commandant Mary Allen. A large number of these women were in training, she wrote, for 'special work', should it become necessary.

'A little fleet of motorcars is organised already to convey working girls to and from their work. It seems to me the most pressing work is to keep women cheerful and contented. As you say, the situation is horrible. The only thing is to keep level heads and do our "bit" .'[58] She led a section of the Women's Auxiliary in arranging relief entertainment for East End women with the object of keeping them off the streets and away from meetings.[59] In the event, the General Strike only lasted for nine days, from 4th to 12th May, before some semblance of order was restored. The miners, starved into submission, returned to work six months later on the owners' terms.

Emmeline was chosen as Conservative candidate for Whitechapel. Even though she thought there was little chance of her winning, she worked hard to increase the Conservative vote and opened her political campaign at the Whitechapel Town Hall in March 1927 with a 'rousing speech which made a great impression upon the large audience'. Here she demonstrated her newly found commitment to the Empire, saying that 'either the Empire would be made stronger or it would disappear …. One of the two questions … was whether they, as British citizens … were going to allow that which had been so hardly built up to be wiped out of existence … she had been prepared to die for the vote, now she was prepared to die for Empire'.[60]

Her conversion to the Conservative Party left her democratic and feminist principles intact. She had, of course, chosen and been selected for Whitechapel, a poor working-class district near the patch where her late husband had fought an unsuccessful campaign himself. Moreover, she maintained, the Conservative Party was committed to women's rights since 'one item which the Conservative Party proposed to introduce next session and which was of special interest to her, was the giving of votes to women at the same age as men. … The Conservative Party was now about to show its devotion to democracy by bringing into operation the complete enfranchisement of women on the same terms as men. … All her life she had believed in a policy of equality and opportunity for every woman and man, irrespective of class or creed.'[61]

Throughout her life she was passionate about promoting women and ameliorating the lives of the working class. She organised a 'Fuchsia Club' for women voters that held meetings twice a week and continued to criticise the class system, just as she had during her early political life. 'She was,' she insisted, 'against class rule of any kind, and as much

opposed to the rule of the aristocrat as she was to the rule of the manual worker.'[62] However, rather than class war she advocated class collaboration, believing that 'by getting rid of disputes, by co-operation between brain and hand, and by a greater distribution of wealth, greater prosperity than they had ever known in this land could be obtained. They wanted to get closer co-operation between employer and employed for with that would come industrial salvation.'[63] In spite of her Conservatism, and maybe because of it, many East Enders apparently adored her. According to her secretary, 'she was a lovely person to them, she never talked down to them, she was interested in them rather than expecting them to be interested in her'.[64]

Emmeline had never shrunk from personal self-sacrifice in her attempts to realise her aims. This time she moved to a flat above a barber's shop in the East End so that she should live in the constituency. 'It really wasn't her line of country at all; though it saved her endless journeys it lacked open-airiness and the noise for most of the 24 hours was difficult to bear.'[65] Ethel Smyth recalls that she visited every shop, every tenement, every public house, and even held open-air meetings. She also travelled around the country speaking in support of candidates elsewhere, a punishing schedule for a woman who was approaching 70. In her last years, partly because of her failing health and partly because of her advanced age, her energy levels declined. Emmeline used to slump into a chair motionless and speechless when she arrived at a venue, but 'once on the platform her whole being became transfigured. Radiant, inspired, she was as magnificent in attack, as irresistible in persuasion, as deadly in her methods with rowdies and hecklers as ever.'[66] Her secretary was Mrs Hall Humpherson, the daughter of her old friend Leonard Hall, who had been arrested with her at Boggart Hole Clough and was one-time paid organiser for the WSPU. She recalled that she arrived at Emmeline's home at 9 a.m. each morning to go through the letters to find her still in her dressing gown, sitting in front of the fire having breakfast. At this time her health was causing a great deal of disquiet; she was spending most of the day in bed and cancelling scheduled meetings.

On June 14th 1928 Emmeline Pankhurst died of septicaemia at a private nursing home in 43 Wimpole Street, London, before she could fight the Whitechapel seat. She was 69 years old and left an estate of £86. The Conservative staff, clearly not devoted to her, 'heaved a joint,

giant size, sigh of relief when they got the Hon. L. Guinness as the new prospective candidate'.[67] In contrast, the local press considered that 'she had already attained a considerable hold on the electorate, and had her health permitted, she could have been trusted to wage a vigorous campaign.'[68]

In the course of her life Emmeline changed from Liberal to socialist to Conservative. But the political world was also changing around her. The disintegration of the Liberal Party, the association of Labour with Bolshevism and pacifism (despite MacDonald's efforts) and the reforming nature of Baldwin's Conservative Party set the tone for her political shifts. Neither Labour, Liberal nor Conservative Party were the same as they had been in the nineteenth century. Moreover, by this time Emmeline Pankhurst had transcended factional party politics. Even so, she carried over to the Conservative Party many of her earlier beliefs, in particular her commitment to working-class women. Her Conservatism was a necessary alliance for a woman without a political home.

CONCLUSION

FROM HERETIC TO HEROINE

Emmeline Pankhurst's death in 1928 occurred just as the British electoral system reached full democracy. In April of that year the government had lowered the voting age for women from 30 to 21 and placed them on the same straightforward residence qualification as men. The House of Lords had approved the Equal Franchise Bill as she lay dying; royal assent to the Bill was given on the day of her funeral. 'One adult, one vote' had more or less been attained, except for the half a million people who had a second vote through a business and university franchise. Another 5 million women were added to the electoral register. In a letter to Nancy Astor, Eleanor Rathbone felt 'a little sad at the coincidence between Mrs Pankhurst's death and the final stages of the Franchise Bill'.[1]

Her daughters, Sylvia and Christabel, and her sister were the chief mourners at her funeral. Adela was notable by her absence. A large number of the dignitaries of the period, including Mrs Baldwin, Nancy Astor, George Lansbury, Eleanor Rathbone, Henry and Mrs Woodd Nevinson, Evelyn Sharp, Charlotte Despard and Emmeline and Frederick Pethick-Lawrence, were also present. They were joined by many of the women from her Fuchsia Club at Whitechapel.[2] Even Herbert Jones, the jockey who had narrowly escaped death in the 1913 Derby, came with a wreath bearing the inscription 'To do honour to the memory of Mrs Pankhurst and Miss Emily Davison'. A service held at St John the Evangelist, Westminster, included her favourite hymn 'Sun

of my Soul, Thou Saviour Dear, Abide with Me'. The feminist credentials of Emmeline Pankhurst were all too apparent. The coffin, draped in purple and covered in wreaths of lilies, was carried by ten women pall-bearers. Mrs Baldock, one of the first London members of the WSPU, walked in front of the hearse carrying a white, green and purple flag. Emmeline Pankhurst was duly buried at Brompton Cemetery with a headstone carved by Miss Julia P. Allan.

Within two years of her death Emmeline Pankhurst had become eminently respectable. Mrs Marshall, one of her old bodyguards, who wanted to ensure that her heroine held a lasting place within the historical canon, led a campaign to erect a statue in her honour. It was not an easy task. Firstly, the statue had to be commissioned and paid for. Money was raised by English and Canadian suffragists. Mrs Gordon Bates, Mrs Gooderham, ex-President of the Imperial Order of the Daughters of the Empire, and Dr Augusta Stowe Gullen, leader of the Canadian suffrage movement, were among those on the Mrs Pankhurst Memorial Fund Committee in Toronto. Over 700 people, including Eleanor Roosevelt, ultimately donated money towards it. Secondly, authorisation was needed to erect it. Eventually, after numerous meetings with the Office of Works, the government finally gave permission for the statue to be erected. The bronze statue was placed near the Houses of Parliament in Victoria Tower Gardens, where it remains today. The money left over from the statue was used to buy new choir stalls in the church at Ongar, a church Emmeline Pankhurst used to visit when she was recuperating from prison. In addition, a portrait by Georgina Brackenbury, daughter of one of the WSPU militants, was commissioned and hung in the National Portrait Gallery.

The unveiling of the statue in March 1930, like the funeral, drew an audience from the radical section of British society, including Flora Drummond, Viscountess Rhondda, Nancy Astor, Grace Roe, Evelyn Sharp, and Cecily Hamilton. A number of other suffragettes, wearing their academic robes and some with prison badges, also paid tribute to Emmeline Pankhurst at the ceremony. Of her immediate family only Sylvia Pankhurst was present: Christabel, now living in America, and Adela, now living in Australia, did not attend. The crowds, marshalled by the uniformed women's auxiliary police under Commandant Mary Allen, were impressive and the ceremony was broadcast to the nation. Representatives of Westminster, the police and the press who had

ridiculed, imprisoned, ignored or pilloried Emmeline Pankhurst were also present and gave an ironic twist to her new-found respectability. The Metropolitan Police Central Band, conducted by Ethel Smyth, played the music, including the works of four women composers and the suffrage song 'March of the Women'.[3] The Bishop of Gloucester said prayers and the Prime Minister, Stanley Baldwin, unveiled the statue. In his speech Baldwin paid tribute to a woman whose political action he had once opposed, remarking that Emmeline's 'childhood, her married life, her widowhood, seemed to have prepared her in a peculiar degree for the work she had to do'. As the *Guardian* mockingly stated: 'By canonising the heretic they close the door on the uncomfortable past, and banish for ever from their recollection those errors of judgement which caused them to miscalculate the verdict of future generations.' When Mr Baldwin unveiled her statue, the same article noted, 'he will be assisting in a process with which all historians are cynically familiar'[4] – that is the valorisation of a former heretic, rebel or revolutionary once their aims have been achieved and they are safely dead. Emmeline Pankhurst, it was pointed out, had been thoroughly tamed.[5]

IMPORTANCE TO SUFFRAGE

Heroines, however, are made not born. Political fame rests upon public opinion and acclamation as much as deeds performed. A one-time scourge of the establishment, Emmeline Pankhurst was transformed from a 'terrorist' to a 'freedom fighter' to become firmly established in the pantheon of suffrage history. Before the war she had faced crude abuse from most of the press, whereas immediately after her death the praise became overwhelming. The *Labour Leader* noted that she was the first woman to 'forge new weapons of a political kind adapted to women's use and for a purpose wholly concerned with women's demands. Other women in politics had used men as the channel of their influence. Mrs Pankhurst organised women to demand direct power for women.'[6] Similar accolades were given elsewhere. As Stanley Baldwin remarked, there would have been a Reformation without Luther, a Renaissance without Erasmus and a French Revolution without Rousseau, but, as in the case of Luther, Erasmus and Rousseau, it was she who provided the vital spark, the element of fire which woke the suffrage movement up.

In his speech at the unveiling of the statue Stanley Baldwin also pointed out that reform is not dependent on any one individual: 'Mrs Pankhurst did not make, nor did she claim to make or to have been the creator of the women's movement.'[7] There had been many other suffrage leaders in charge of other suffrage organisations who had quietly urged successive governments to enact reform. Suffragists had systematically and methodically over the years petitioned, lobbied, leafleted, demonstrated, published articles and newspapers and canvassed in support of MPs sympathetic to women's suffrage. The importance of their painstaking efforts in campaigning for the vote has been undervalued in comparison with the publicity-seeking activities and high profile of the Women's Social and Political Union. In Edwardian Britain a plethora of different groups emerged to fight for women's suffrage. Professional women founded their own suffrage societies: the Artists' Franchise League, the Actresses' Franchise League, the London Graduates' League and the Scottish Universities Women's Suffrage Union were amongst them. Similarly, different religious denominations set up suffrage groups: the Catholic Women's Suffrage Society, the Church League for Women's Suffrage, the Free Church League, the Friends' League and the Jewish League represented women from a variety of religious backgrounds. Women also organised suffrage societies that reflected their political affiliations, such as the Conservative and Unionist Women's Franchise Association. There were even organisations for sympathetic men, such as the Men's League for Women's Suffrage and the more militant Men's Political Union, which lent support to the campaign for women's suffrage. Together all these groups, not just the WSPU, helped to make votes for women one of the foremost political questions facing the Liberal government.

Nevertheless, if any one person was responsible for the increased interest in suffrage in Edwardian Britain, it was Emmeline Pankhurst. Her entry in British history books will always be assured: she was the woman who, after almost fifty years of peaceful campaigning, brought a new direction to women's suffrage and changed the political world for good. At a crisis in suffrage history she energised the movement and by her own magnetism encouraged others to do the same. Moreover, the combination of her arresting beauty and violent actions continues to generate continuing fascination because her appearance contradicted her behaviour. As a result of WSPU militancy and the publicity it

generated, women's suffrage became more than a fringe phenomenon. Emmeline Pankhurst was a woman of charismatic authority with an acute organisational intelligence and a political self-confidence that left most other suffrage leaders standing. Whatever criticism may be made of the suffragette leader, her contribution towards votes for women was unparalleled.

In fighting for the vote, Emmeline Pankhurst – and other suffragettes – broke every conceivable feminine standard. The question whether the violence of the suffragettes was self-defeating is often asked. It is sometimes argued that it lost her and the WSPU the sympathy and support of the country at large and provided the Liberal government with an ideal excuse to deny women the vote. Trapped by Emmeline's militant message and the massive violent build-up before the war, the WSPU is said to have alienated as many as it attracted. Often suffragettes were regarded as fanatics, hysterics, lunatics and martyrs to a ridiculous cause – worse, they were guilty of flouting sacred gender norms relating to femininity. Certainly, many groups in Edwardian Britain were critical of the suffragettes' behaviour in breaking gender boundaries. The age of genteel drawing-room meetings packed full with supporters had long since disappeared. In its place had come an age of public meetings held in the open air, where groups of hostile men would gather as a preliminary to roughing up the suffragettes and treating them lewdly and obscenely. For the term 'Votes for Women' (note, not 'ladies') meant associating with a 'common sort' – and suffragettes were definitely not regarded as 'ladies'. Moreover, the impatient Emmeline led a violent campaign that may have been winnable by other less destructive means. Over the years, suffragists had tried to prove that they (and, by association, women in general) were calm, sensible and rational beings and put forward measured arguments and used democratic methods to get their message across. It was feared that Emmeline Pankhurst's advocacy of violence discredited the suffrage movement and undermined suffragist efforts to be seen as mature adults who could be trusted with the vote.

Not surprisingly, Emmeline denied the accusation that violence was counter-productive. On the contrary, she insisted that to believe that militancy damaged the suffrage cause was to be ignorant of all the lessons taught by history. Violent behaviour, she proclaimed, was always rewarded. In her view, persuasive peaceful tactics, not militant methods,

were ineffective as the peaceful methods of the suffragists had brought the vote no further forward in 1905 (when militancy is said to have begun) than it had been fifty years before. Emmeline's patience was exhausted, and she hoped to force the government into conceding votes for women by using similar weapons of violence to those used previously by male suffrage activists. However, she drew upon a misbegotten sense of history to endorse her militancy. Men were enfranchised for a whole variety of reasons, not just because of allegedly violent behaviour. Nonetheless, as Sandra Holton ironically comments, militancy is said to have 'defeated the women's cause, not the prejudices of Prime Minister Herbert Asquith or the cynical wheeler-dealing of Chancellor of the Exchequer David Lloyd George'.[8]

Moreover, although Emmeline Pankhurst broke accepted codes of behaviour, she continued to use constitutional methods in her fight for the vote. Similar campaign tactics to those of the suffragists were used in conjunction with violent ones. There is no doubt that Emmeline was an inspirational speaker and a first-class leader who fully deserved the various tributes and accolades awarded her. In her speeches she was able to shift register with extraordinary skill, from historical and factual examples to emotional entreaties, all delivered in a calm, quiet and thoroughly professional manner. The clarity of her delivery, the empathetic way in which she focused on issues concerning each of her audiences, combined with her ability to get to the heart of a political issue, captured spectators world-wide, not just in Britain.

Critics pointed out that Emmeline Pankhurst's autocratic style sat ill with her claims for democracy. From 1906 policies were decided by an unelected central committee which was assisted by a sub-committee consisting of family and friends such as Mary Clarke (Emmeline's sister). Members did not participate in decision making but were informed of new policies and strategies during the 'At Home' sessions, which were held each Monday afternoon at the headquarters in Lincoln's Inn Fields, London. The leadership controlled their own publications, appointments to paid positions and of course the finances of the organisation, making it difficult for members to oppose them. Teresa Billington-Greig, a former leader in the WSPU, was among many who condemned Emmeline Pankhurst for her domineering and autocratic behaviour. 'To work alongside of her day by day was to run the risk of losing yourself. She was ruthless in using the followers she gathered around her as she

was ruthless to herself. She took advantage of both their strengths and their weaknesses ... suffered with you and for you while she believed she was shaping you and used every device of suppression when the revolt against the shaping came.'[9]

The organisational structure of the WSPU and Emmeline Pankhurst's leadership style were condemned for a number of reasons. Firstly, it was considered hypocritical of the WSPU to condemn the Liberal government for its reluctance to widen the suffrage while failing to practise democracy itself. Secondly, it was believed that the vote should be sought through a democratic organisation that mirrored a future body politic rather than one that clearly did not. Finally, it was thought that unquestioning obedience to a female oligarchy was inadequate preparation for the future female voter, who needed to evaluate the arguments of each political party. As one suffragette at the time commented, although Emmeline Pankhurst 'wishes women to have votes she will not allow them to have opinions'.[10] Certainly, Emmeline was a woman of strong emotions, hugely affectionate to supporters but often turning on those whom she felt had crossed her: her father, two of her daughters, Charlotte Despard and the Pethick-Lawrences among them. Undoubtedly, she was a dynamic and sometimes destructive force who was willing to break with friends and family and split organisations for causes she held dear.

However, although the WSPU was undoubtedly dictatorial in style and had no formal constitution, there are various points to take into consideration before it is condemned out of hand. As Emmeline argued, a democratic organisation was probably inappropriate for their style of politics. Indeed, the WSPU became less democratic as its activities became increasingly illegal. And as the WSPU operated within a hostile political climate, so planning and action assumed greater importance than constitutional democracy. The WSPU did educate its membership, encouraged their self-confidence and helped to develop political awareness. Many a suffragette spoke of the way in which they were taught the skills of public speaking and debate. In addition, although the London-based WSPU was undoubtedly undemocratic, this may not have been the case for the provincial branches and their regional offices. In 1909 there were at least 11 regional offices, in the West of England (with offices in Bristol and Torquay), Lancashire (with offices in Manchester, Preston and Rochdale), Birmingham, Leeds, Newcastle, Glasgow,

Edinburgh and Aberdeen, and numerous branches elsewhere. For the most part, these offices and branches enjoyed considerable autonomy, as the following extract from an Annual Report suggests: 'In all parts of London and in many provincial centres, there exist local Unions which, while working in close and harmonious relation with the National headquarters, are independent in the sense that they elect their own committee, and administer their own funds. ... They elect their own officers, raise and administer their own funds, and arrange their own schemes of organisation and propaganda.'[11]

Emmeline may have been despotic but she was never arrogant, leading by charm rather than procedure, by example rather than committee, by force of personality rather than debate. She may have been devoted to the maintenance and exercise of her own power and have adopted a cavalier attitude towards organisational democracy, but it was to wage a campaign for women's suffrage not for its own sake. Certainly, she was an indefatigable worker who put all her energies into campaigning for women's suffrage even when frail and physically ill. It is for this motivation, this drive, and this sheer force of belief as much as for her militancy that she will be remembered. She was prepared to sacrifice her home, her comforts, her family, her financial status, her health and ultimately her life for the cause she believed in. Enduring twelve hunger strikes in all, a middle-aged and menopausal Emmeline Pankhurst suffered both mental and physical torture. Kate Pine, who nursed her through eleven of her hunger strikes and accompanied her to Canada, claimed that many times she feared that Emmeline would not last through the night and was forced to give her saline injections to pull her through. This unstinting devotion to women's suffrage and her willingness to endure the same hardships as younger members of the WSPU provide moving evidence of her commitment and dedication to her cause.

It was her own peculiar, painstaking and original contribution to votes for women – which mainly lay in her leadership of the WSPU – that contributed to the success of the suffrage campaign. The source of her leadership lay in her inspirational zeal, for she radiated power and authority, a high-octane politician whose passion for justice could inflame others. One admirer said that the 'secret was her absolute sincerity, her freedom from all cant, pose and artificiality, her freedom from vanity, from self-consciousness and her power of self-sacrifice. Truly, she

was a mighty spirit in a fragile frame, endowed with superb courage, mental and physical, an indomitable will, great dignity at all times and the keenest sense of duty …. She had an indescribably gracious personality, and her courteous manner carried with it such straightness of purpose. Mrs Pankhurst was unique, because to know her was to love her, and to love her was to follow her in all admiration, love and respect.'[12]

OTHER POLITICAL INVOLVEMENTS

Emmeline Pankhurst was more than the sum of suffrage. Her parents had encouraged their young daughter to be aware of injustice, and Emmeline continued to be involved in social reform all her life. She devoted her whole being to politics, often at the expense of a personal existence. From the start of her political career she was involved in a range of issues and only later became preoccupied with the vote. A doer rather than a thinker, she was active on several fronts: as Poor Law Guardian, as a member of the Manchester School Board, and with local politics. She may have changed political parties at this time, from Liberal to Labour, yet some of her ideas remained consistent. Her commitment to democracy and to women's emancipation remained an essential part of her political identity. For Emmeline the vote was only ever a means to an end. She believed passionately that women's suffrage was the only realistic way to deliver social justice for women and to build a truly democratic Britain. Many reformers reach the end of their political careers without achieving any of their aims, but Emmeline Pankhurst's many achievements stand proud in the annals of radical social reform.

With the outbreak of the First World War, Emmeline forsook suffrage in favour of war work. This has led to accusations of xenophobia, jingoism and inconsistency. However, it is important to remember that, with the exception of the Women's Franchise League, all the other suffrage organisations also redirected their energies to supporting the war effort. Millicent Fawcett delivered a message to all her followers saying 'Women, your country needs you', insisting, like Emmeline, that the war was the gravest threat to British democracy. Consequently, large numbers of the NUWSS, as with the WSPU, immersed themselves in war relief work. They set up maternity centres, workrooms for the unemployed, organised recruits for the munitions factories, set up

employment registers, helped finance the Scottish Women's Hospitals Units which operated on the front line and established female patrols to 'protect the honour of young girls' and to guard against prostitution. Even her daughter Sylvia, who was opposed to the war, became engrossed in schemes to alleviate the suffering caused by war, setting up nurseries, child-welfare clinics and canteens for the poorest people in London's East End. Moreover, Emmeline's decision to promote the war effort was not inconsistent with her political ideals, since it was underpinned by a commitment to democracy and the democratic process which Germany, as she saw it, was determined to undermine.

It is true, nonetheless, that the war was a watershed for Emmeline Pankhurst. The Russian Revolution convinced her that socialism was an out-dated ideology. Socialism meant class war and internecine strife, whereas Emmeline was more interested in uniting not just women of all classes but the whole of the British nation. She criticised trade unions for their socialist ideals. Unions, she insisted, had tried to prevent women entering previously masculine trades and had encouraged strike action in the middle of war. Consequently, they were condemned for being both anti-feminist and traitors to Britain. Moreover, the expressed links between socialism and pacifism meant that socialism was now anathema to her. Too many socialists, including her daughter Sylvia, had attacked the war as an imperialist venture, refused to support the war effort and actively campaigned against it. Similarly, her commitment to Home Rule (which had taken a battering before the war when its MP supporters had blocked female suffrage and been finally shattered when Ireland colluded with Germany during the war) was now rejected in favour of a United Kingdom. National independence in its entirety had been jettisoned too, as Emmeline Pankhurst reconceptualised the British Empire from a force of oppression to one of liberation, because it brought democracy, and its civilising influence, to colonised countries.

After the war, with her own children grown up, she had assumed responsibility for three more daughters. America, with its emerging hostility towards socialism and communism, beckoned. After spending some time touring the American lecture circuits, proclaiming the evils of Bolshevism, Emmeline Pankhurst embarked on her third career, as a promoter of social purity. It was here that her formidable talents and beliefs bore fruit: her public speaking, her organisational skills, her

commitment to social purity and her feminism were all used to striking effect. In Canada she made a great impact on the social hygiene movement, helping it to gain a much higher public profile than it had hitherto enjoyed.

When she eventually returned to Britain, the world had changed but she had not moved with it. Certainly, the central phases of her life were her most successful, if not the most significant. Her influence reached its apogee just before the First World War – she was never to attract the same huge audiences again. Like so many other social reformers, Emmeline Pankhurst failed to move with the times. In a way she and her politics were irrelevant to the political future of the post-war world. Her time had gone. Undoubtedly, her campaign for women's suffrage was the summit of her life's work. After a meteoric rise in the pre-war political world, her slow decline, though not predestined, was predictable. In some respects she was trapped by her advancing years, becoming less and less at home in the new post-Edwardian age. By now in her mid-60s, she belonged to an earlier generation of feminists than the 'flappers' of the 1920s. She was essentially a Victorian, physically and mentally, who sat unhappily in the post-war world. With her unbobbed hair, her long dresses, her face free of make-up and her hat, she would be the most unfashionably dressed woman in the room. Her politics – and especially her ideas on sexuality – appeared equally drab to the new breed of political activists.

Emmeline Pankhurst's distaste for socialism did not make her right-wing, as is sometimes supposed, nor did it make her reject long-held beliefs. On the contrary, she remained dedicated to a radical agenda, maintaining her commitment to certain values and principles. In rejecting class politics, she neither denied working-class women's oppression nor the continuing inequality of their position. Rather, she came to believe that the class struggle undermined attempts at female unity and that women should work together in harmony regardless of their individual economic and social position. Her willingness to speak to an African-American audience is evidence of her continuing commitment to abolitionist politics at a time when so many white Americans had jettisoned these beliefs in favour of supremacist arguments. Likewise, throughout her life she remained critical of the double standard of morality which, she believed, led to the ruin of working-class young girls. Of course, Emmeline had never espoused revolutionary ideals,

only radical liberal ones which had been forged in the Victorian era. Even though she gained her greatest notoriety in the Edwardian era, she was unmistakably a Victorian. In many ways, she remained the embodiment of Liberal Victorianism: of individualism, personal liberty, rights and responsibilities, constitutional reform, democracy, and high standards of morality. Her inconsistencies, too, fitted in well with the Victorian age of contradictions: an age of equipoise and social unrest; an age of immense wealth and abject poverty; an age of splendour and of squalor; an age of great technological change and of primitive working practices.

Emmeline Pankhurst's move to Conservatism merely marked another stage in her recalibration as a feminist, not an effortless slide from socialism. When she joined the Conservative Party, it was because she was a woman committed to ideas rather than political parties, a doer rather than a thinker. She had little time for party factions and spoke her own mind whether or not it made her unpopular with the Liberals, Labour or Conservatives. This was not a cynical exercise in rebranding but a genuine political journey through suffrage, war and sexual politics. She chose to fight an East End seat rather than a safe Tory constituency, targeting women's clubs and women's issues in her campaigns. Her feminist credentials remained impeccable to the end: it was her commitment to class politics and socialism that she abandoned. Emmeline Pankhurst's main message remained unequivocal: she was committed to the emancipation of women. If she was elected to Parliament, she insisted, reforms concerning women and children would be among her chief concerns. For all the causes she espoused, from sex to suffrage and back again, she was known for her unremitting hard work, her enthusiastic passion, her ability to ignore setbacks and disappointments, her capacity to rise to new challenges and, of course, her considerable skills as an orator. She held powerful convictions and preferred always to speak from her heart rather than to use a reasoned, high-brow, more intellectualised approach.

Adored and reviled, praised and criticised, acclaimed and misrepresented, idolised and distrusted, eulogised and condemned, Mrs Pankhurst drew strong feelings from both her contemporaries and those who came after her. Indeed, part of her lasting appeal lies in the fundamental ambiguities and contradictions that have surrounded her life. Moreover, the combination of her arresting beauty and violent actions generates

continuous fascination. It is impossible to deny that there was something of greatness in Emmeline Pankhurst. Her name, as the *Sunday Times* obituary stated, 'will certainly live in British history. She shook the women of England awake. She gave them a consciousness of their disabilities and of their power to remove them that they had never had before. She organised them into a crusade that, if it was marked by many senseless excesses, elicited also a genuine nobility of spirit and sacrifice.'[13] Her voice spoke mostly to a younger generation, offering them not just the vote but a new freedom that their parents could never have envisaged. By defying the gender, class and cultural assumptions that underpinned the British establishment, she became the radical symbol of the Edwardian political age. Today there is a statue of her outside the House of Commons, a portrait of her in the National Portrait Gallery, a choir stall in her memory in Ongar church and a Pankhurst Centre built from one of her former homes in Manchester. These are just the physical remains of her past; Emmeline Pankhurst's political legacy lives on more significantly in her contribution to widening the base of British parliamentary democracy.

Notes

INTRODUCTION

1 Carol McPhee and Ann FitzGerald, *The Non-Violent Militant: Selected Writings of Teresa Billington-Greig* (London: Routledge and Kegan Paul, 1987), pp. 94–5.

2 *Saturday Night* (Toronto) November 27th 1909, p. 1.

3 Emmeline Pankhurst, *My Own Story* (London: Eveleigh Nash, 1914; reprinted by Virago, 1979). This book was ghost-written by an American, Rhetta Childe Dorr, and compiled on board ship on one of Emmeline's journeys to America.

4 Sylvia Pankhurst, *The Life of Emmeline Pankhurst* (Laurie, 1935).

5 Christabel Pankhurst, *Unshackled: The Story of How We Won the Vote* (London: Hutchinson, 1959).

6 Rebecca West, 'A Reed of Steel', in *The Young Rebecca: Writings of Rebecca West, 1911–1917* (New York: The Viking Press, 1982, first published in 1933).

7 Rupert Butler, *As They Saw Her ... Emmeline Pankhurst* (London: George Harrap and Co., 1970).

8 Harold Champion, *The True Book about Emmeline Pankhurst* (London: Frederick Muller, 1963).

9 David Mitchell, *The Fighting Pankhursts* (London: Jonathan Cape, 1967).

10 Martin Pugh, *The Pankhursts* (London: Penguin, 2001). Pugh's book was published just as my biography was going to press.

11 Roger Fulford, *Votes for Women* (London: Faber and Faber, 1957).

12 Andrew Rosen, *Rise up Women* (London: Routledge and Kegan Paul, 1974).

13 Jill Liddington and Jill Norris, *One Hand Tied Behind Us* (London: Virago, 1978).

14 Martha Vicinus, *The Widening Sphere* (London: Methuen, 1972).

15 Jane Marcus, *Suffrage and the Pankhursts* (London: Routledge and Kegan Paul, 1987).

16 June Purvis, 'Emmeline Pankhurst and Votes for women', in June Purvis and Sandra Holton (eds) *Votes for Women* (London: Routledge, 2000). This excellent edited collection has the best bibliography of women's suffrage history yet published.

17 See especially her chapters ' "In Sorrowful Wrath": suffrage militancy

and the romantic feminism of Emmeline Pankhurst', in Harold
Smith (ed.) *British Feminism in the Twentieth Century* (Aldershot:
Edward Elgar, 1990), and 'The Making of Suffrage History', in June
Purvis and Sandra Holton (eds) *Votes for Women* (London:
Routledge, 2000).

18 With the exception of David Mitchell's *The Fighting Pankhursts*
(1967), all the books mentioned above emphasise the suffragette
activities.

19 Cheryl Law, *Suffrage and Power: The Women's Movement 1918–1928*
(London: I B Tauris, 2000), p. 1.

20 Sandra Holton, 'Reflecting on Suffrage History', in Claire Eustance, J.
Ryan and L. Ugolini (eds) *A Suffrage Reader* (Leicester: Leicester
University Press, 2000), p. 30.

21 Ethel Smyth, *Female Pipings in Eden* (London: Peter Davies, 1934),
p. 266.

22 *Chicago Sunday Tribune*, November 28th 1909, p. 5.

23 Emmeline Pankhurst to Elizabeth Robins, July 16th 1909 (Elizabeth
Robins Collection, Harry Ransom Humanities Research Center,
University of Texas).

24 Emmeline Pankhurst to Elizabeth Robins, October 23rd 1908
(Elizabeth Robins Collection, Harry Ransom Center).

25 *The Observer Magazine*, May 28th 2000. I am indebted to Fiona
Terry-Chandler for this reference.

26 *The Suffragette*, July 17th 1914, p. 238.

1 SHAPING A LIFE 1858–80

1 Birth certificate of Emmeline Pankhurst (Greater Manchester County
Record Office).

2 *Votes for Women*, January 7th 1909, p. 250.

3 Sylvia Pankhurst states that Jane Quine was Emmeline Pankhurst's
mother. In fact, she was her grandmother. See *The Suffragette Move-
ment* (London: Virago, 1977 reprint), p. 53.

4 Goodwin's Scrapbook (Isle of Man Local History Centre).

5 *Chicago Sunday Tribune*, November 28th 1909, p. 5.

6 *Mona's Herald*, August 1st 1880, quoted in Melissa Butler and
Jacqueline Templeton, *The Isle of Man and the First Votes for
Women* (Sheffield: Sheffield City Polytechnic, 1980), p. 6.

7 *The Manx Quarterly*, October 1910, p. 826. See also Patricia de Ban,
'Suffragettes: The Manx Connections', *Proceedings of the Isle of
Man Natural History and Antiquarian Society*, Vol. X No. 4, April

1995–March 1997, pp. 382–92. I am indebted to Helen Leigh for bringing this excellent article to my attention.

8 Letter from Patricia de Ban to author.

9 Sylvia Pankhurst states that Emmeline's parents had ten children but this is not the case since she neglected to count the eldest son who died. See *The Suffragette Movement* (London: Virago, 1977 reprint), p. 53.

10 Marriage certificate (Greater Manchester County Record Office).

11 *Salford Reporter*, April 30th 1892, p. 8.

12 Private letter from Patricia de Ban to the author, March 2000.

13 *The Isle of Man Examiner*, May 14th 1892, p. 2.

14 *The Isle of Man Examiner*, May 14th 1892, p. 2.

15 *Salford Reporter*, April 30th 1892, p. 8.

16 W. Parkin, *Theatres and Music Halls in Salford 1880–1980* (Manchester: Eccles and District Historical Society Lectures, 1979–81).

17 Jill Craigie, Introduction to Emmeline Pankhurst, *My Own Story* (London: Virago, 1979 reprint), p. iii.

18 Emmeline Pankhurst, *My Own Story* (London: Virago, 1970), p. 9.

19 I have found no evidence from the Manchester National Society for Women's Suffrage (MNSWS) subscription lists that Sophia Jane Goulden ever belonged to the organisation.

20 *Manchester Critic*, February 28th 1874, p. 687.

21 *Chicago Sunday Tribune*, November 28th 1909, p. 5.

22 Unpublished play about the life of Emmeline Pankhurst (Sylvia Pankhurst papers, Amsterdam).

23 Sylvia Pankhurst, *The Suffragette Movement* (London: Virago, 1977), p. 54.

24 *Pendleton Reporter, Salford, Broughton and Weaste Times*, December 20th 1879.

2 THE LIBERAL YEARS 1880–94

1 Sylvia Pankhurst, Synopsis and draft of *The Suffragette Movement* (Sylvia Pankhurst papers; hereinafter SP papers), p. 5.

2 *Clarion Cyclists' Journal*, Sept. 1896 (SP papers).

3 Sylvia Pankhurst, *The Suffragette Movement* (London: Virago, 1977), p. 90.

4 Sylvia Pankhurst, Synopsis and draft of *The Suffragette Movement* (SP papers), p. 12

5 *The Guardian*, October 1st 1883, p. 6.

6 *The City Jackdaw*, December 7th 1877, p. 27.

7 June Balshaw, 'Suffrage, Solidarity and Strife: Political Partnerships and the Women's Movement 1880–1930', PhD, University of Greenwich, 1998, p. 45.

8 *Manchester Faces and Places*, p. 182.

9 Letter from Emmeline Pankhurst to Caroline Biggs, August 1885 (SP papers).

10 *My Own Story* (London: Virago, 1979), p. 18.

11 *Rotherhithe Advertiser*, July 18th 1885, p. 5.

12 Quoted in June Balshaw, 'Suffrage, Solidarity and Strife: Political Partnerships and the Women's Movement 1880–1930', PhD, University of Greenwich, 1998, p. 49.

13 Letter to judge in Sylvia Pankhurst's *The Suffragette Movement* (London: Virago, 1977), p. 77.

14 *Manchester Faces and Places*, p. 181.

15 Women's Franchise League (WFrL) leaflet (Local Studies Unit (LSU), Manchester, archive M50/2/32/1).

16 *The Graphic*, December 1891. (I am indebted to Mrs Goode and the late Mr Goode for this source reference.)

17 WFrL Report of the Executive Committee 1889–90 (SP papers).

18 WFrL leaflet (LSU archive M50/2/32/1).

19 WFrL leaflet (LSU archive M50/2/32/1).

20 *The Graphic*, December 1891.

21 Sylvia Pankhurst *The Life of Emmeline Pankhurst* (London: T. Werner Laurie, 1935), p. 29.

22 WFrL Annual Report 1894–5 (Fawcett).

23 WFrL leaflet (LSU archive M50/2/32/1).

24 Emmeline Pankhurst, *My Own Story* (London: Virago, 1979), p. 20.

25 *The Graphic*, December 1891.

26 WFrL Conference programme, December 1891 (SP papers).

27 Letter from Lil Ashworth Hallett to M.G. Fawcett, May 1891 (WFrL collection, LSU, M50/2/1/141).

28 Letter from Ursula Bright to Emmeline Pankhurst, Nov. 27th 1893 (SP papers).

29 See Sandra Stanley Holton's work for an exploration of these ideas.

30 Ellen Carol Dubois, *Harriot Stanton Blatch and the Winning of Woman Suffrage* (New Haven: Yale University Press, 1997), p. 70. See also Sandra Stanley Holton, 'From Anti-Slavery to Suffrage Militancy', in Melanie Nolan (ed.) *Suffrage and Beyond* (London: Pluto Press, 1994).

31 Chris Cook and Ian Taylor (eds) *The Labour Party* (London: Longman, 1980), p. 5.

32 June Hannam, 'Women and the ILP, 1890–1914', in D. James, T. Javitt and K. Laybourn (eds) *The Centennial History of the ILP* (Halifax, 1992), p. 205.

3 THE ILP YEARS 1894–1903

1 ILP Conference Reports, 1893–1898.

2 June Hannam and Karen Hunt, *Socialist Women* (London: Routledge, 2001), pp. 82–3. This excellent path-breaking book examines the experiences of women in the early years of the socialist movement.

3 Emmeline Pankhurst to Emma Sproson, July 26th 1906. I am grateful to Nicola Skett for bringing this letter to my attention.

4 Emmeline Pankhurst, *What Boards of Guardians Can Do* (National Administrative Council of the Independent Labour Party, 1895), p. 3.

5 Thelma Cazalet Keir, *I Knew Mrs Pankhurst* (Suffragette Fellowship, nd), p. 5.

6 *The Suffragette*, November 21st 1913, p. 127.

7 *Manchester Faces and Places*, July 1899, p. 182.

8 Patricia Hollis, *Ladies Elect* (Oxford: Clarendon Press, 1987), p. 229.

9 George Lansbury, *My Life* (London: Constable and Co., 1928).

10 Emmeline Pankhurst, *What Boards of Guardians Can Do* (National Administrative Council of the Independent Labour Party, 1895), p. 1.

11 Emmeline Pankhurst, 'Duties and Powers of Guardians in Times of Exceptional Distress', *Report of the Proceedings of the 21st Annual Poor Law Conference for the North Western District*, held in the Temperance Hall, Ulverston, September 27–8th 1895, pp. 298–306.

12 Leaflet published by the Women's Local Government Society, nd but post-1894.

13 Amelia Charles, *Women as Poor Law Guardians* (Women's Progressive Society, 1892).

14 Sylvia Pankhurst, Emmeline Pankhurst unpublished manuscript, nd but probably circa 1930.

15 *Manchester Guardian*, September 7th 1930. 'A Daughter's Memories' by E. Sylvia Pankhurst.

16 *Manchester Faces and Places*, July 1899, p. 183.

17 Emmeline Pankhurst, *My Own Story* (London: Virago, 1979), p. 25.

18 *Manchester Evening News*, January 18th 1895, p. 1.

19 North Western District Poor Law Conference, Blackpool, September 24–5th 1897, pp. 344–50.

20 Ibid.

21 Ibid.

22 Emmeline Pankhurst, *My Own Story* (London: Virago, 1979), p. 24.

23 Emmeline Pankhurst, *What Boards of Guardians Can Do* (National Administrative Council of the Independent Labour Party, 1895), p. 3.

24 *Manchester Guardian*, September 7th 1930. 'A Daughter's Memories' by E. Sylvia Pankhurst.

25 *Manchester Evening News*, January 11th 1895.

26 Alan Kidd, 'Outcast Manchester: voluntary charity, poor relief and the casual poor 1860–1915', in A. Kidd and K.W. Roberts, *City, Class and Culture* (Manchester: Manchester University Press, 1985), p. 60.

27 Sylvia Pankhurst, *The Suffragette Movement* (London: Virago, 1977), p. 34.

28 *Manchester Evening News*, March 8th 1895.

29 North Western District Poor Law Conference, Blackpool, September 24–5th 1897, p. 305.

30 *Manchester Guardian*, March 9th 1895.

31 *Manchester Guardian*, March 9th 1895.

32 Emmeline Pankhurst, *What Boards of Guardians Can Do* (National Administrative Council of the Independent Labour Party, 1895), p. 1.

33 Emmeline Pankhurst, 'Duties and Powers of Guardians in Times of Exceptional Distress', *Report of the Proceedings of the 21st Annual Poor Law Conference for the North Western District*, held in the Temperance Hall, Ulverston, September 27–8th 1895, pp. 298–306.

34 *Manchester Evening News*, February 15th 1895, p. 1.

35 *Manchester Evening News*, March 8th 1895.

36 *The Clarion*, January 19th 1895, p. 22.

37 Emmeline Pankhurst, *Suffrage Speeches from the Dock* (London: The Woman's Press, 1912), p. 30.

38 Letter to *Manchester Guardian*, July 11th 1895.

39 David Howell, *British Workers and the Independent Labour Party, 1888–1906* (Manchester: Manchester University Press, 1983), p. 224.

40 *The Labour Prophet*, August 1895.

41 ILP Conference Report, 1895, p. 11.

42 H.J. Perkins, 'Land Reform and Class Conflict in Victorian Britain', in J. Butt and I.F. Clarke (eds) *The Victorians and Social Protest* (Newton Abbot, 1973).

43 ILP Conference Report, 1896, p. 6.

44 Sylvia Pankhurst, Synopsis and draft of *The Suffragette Movement*, p. 12.

45 *The Courier*, May 23rd 1896 (SP papers).

46 *Manchester Guardian*, July 4th 1896 (SP papers).

47 Interview with Nellie Hall Humpherson (National Archives of Canada).

48 Letter from Richard Pankhurst to Tom Mann, April 11th 1897 (Francis Johnson Correspondence, John Rylands Library).

49 *Labour Leader*, July 16th 1898, p. 239.

50 Seventh Annual ILP Conference, held in the Albert Hall, Leeds, on April 3rd–4th 1899.

51 Seventh Annual ILP Conference, held in the Albert Hall, Leeds, on April 3rd–4th 1899, p. 5.

52 *ILP News*, December 1898, No. 21, Vol. 2, p. 6.

53 *ILP News*, November 1900, No. 44, Vol. 4, p. 2.

54 See Patricia Hollis, *Ladies Elect* (Oxford: Clarendon, 1987), for a discussion of this.

55 *The Manchester Courier and Lancashire General Advertiser*, November 17th 1900, p. 8.

56 For example, *Manchester Faces and Places*, July 1899, p. 182, states that she stood for election to the Manchester School Board in 1893 'under the auspices of the ILP' and failed, but Elizabeth Crawford states that EP was adopted as an ILP candidate for the Manchester School Board in July 1894 (*The Women's Suffrage Movement*, London: Routledge, 1999, p. 501).

57 *The Manchester Courier and Lancashire General Advertiser*, November 20th 1900, p. 8.

58 Minutes of the Manchester School Board, November 25th 1901.

59 Minutes of the Manchester School Board, February 3rd 1902.

60 Minutes of the Manchester School Board, September 22nd 1902.

61 *The Manchester Courier and Lancashire General Advertiser*, December 22nd 1900, p. 8.

62 *The Manchester Courier and Lancashire General Advertiser*, March 19th 1901, p. 8.

63 ILP Conference, Leicester, April 8–9th 1901, p. 42.

64 Minutes of the Manchester School Board, February 7th 1902.

65 Tenth Annual ILP Conference, held in the City Hall, Liverpool, between March 31st and April 1st 1902, where she was delegate for Chorlton-on-Medlock.

66 See Isabella P. Gleave, 'The Administration of Education in

Manchester, 1902–1914: The Transition from School Board to Local Authority', Ph.D., Manchester University, 1994, p. 479.

67 *My Own Story* (London: Virago, 1979), p. 34.

68 Minutes of the Manchester Central Branch of the ILP, September 5th 1905.

69 Manchester ILP Conference, April 24–5th 1905, p. 42.

4 SUFFRAGETTE BEGINNINGS 1903–07

1 Emmeline Pankhurst, *My Own Story* (London: Virago, 1979), p. 36.

2 Elizabeth Wolstenholme-Elmy, *Woman's Franchise: The Need of the Hour* (London: Congleton Press, 1907).

3 See Claire Hirshfield, 'Fractured faith: Liberal Party women and the suffrage issue in Britain, 1892–1914', *Gender and History*, Summer 1990, pp. 172–97, for a discussion of the relationship between the Liberal Party and the NUWSS.

4 Letter to the *Manchester Guardian* by Sam Robinson, March 8th 1907 (M/CR LSU archive M220/4,3).

5 WSPU leaflet, *What Women Demand*, circa 1907.

6 See, for example, Dale Spender, *Woman of Ideas* (London: Ark, 1983), as well as George Dangerfield and David Mitchell.

7 *A message from the WSPU* leaflet nd but between 1907 and 1912 (Suffragette Fellowship Collection, hereinafter SFC).

8 Emmeline Pankhurst, Hartford, Connecticut, 1913.

9 *Votes for Women* leaflet produced by WSPU and signed by Emmeline Pankhurst, circa 1907 (SFC).

10 Emmeline Pankhurst, *The Importance of the Vote* (London: Woman's Press, 1908), p. 1.

11 Emmeline Pankhurst, *Why Women Want the Vote*, WSPU leaflet 1907.

12 Emmeline Pankhurst, *The Importance of the Vote* (London: Woman's Press, 1908), p. 10.

13 Emmeline Pankhurst, *The Importance of the Vote* (London: Woman's Press, 1908), p. 9.

14 Emmeline Pankhurst, *The Importance of the Vote* (London: Woman's Press, 1908), p. 8.

15 *The Suffragette*, August 8th 1913, p. 738.

16 *Votes for Women*, October 15th 1909, p. 43.

17 Rhetta Dorr, *A Woman of Fifty* (London: Funk and Wagnell, 1924), p. 265.

18 Emmeline Pankhurst's defence in her conspiracy trial, in *Suffrage*

Speeches from the Dock (London: The Woman's Press, 1912), p. 34 (SFC).

19 C. Pankhurst, *Unshackled* (London: Hutchinson, 1959), p. 50.

20 G. Dangerfield, *The Strange Death of Liberal England* (Perigree Books, 1980), p. 154.

21 Brian Harrison, *Peaceable Kingdom: Stability and Change in Modern Britain* (Oxford: Clarendon Press, 1982), p. 46.

22 Sandra Stanley Holton, 'In "Sorrowful Wrath": suffrage militancy and the romantic feminism of Emmeline Pankhurst', in H.L. Smith (ed.) *British Feminism in the Twentieth Century* (Aldershot: Edward Elgar, 1990).

23 Emmeline Pankhurst speaking in New York, October 21st 1913, quoted in *The Suffragette*, November 14th 1913, p. 99.

24 See Sandra Stanley Holton's work and also Martin Pugh, *The March of the Women* (Oxford: Oxford University Press, 2000).

25 WSPU Annual Report 1907.

26 Letter from Louise Eates, Kensington WSPU, to Minnie Baldock, October 21st 1907 (SFC).

27 *How You Can Help* leaflet produced by the WSPU circa 1907.

28 *By-election Policy* leaflet produced by the WSPU circa 1907.

29 *Votes for Women*, December 1907, p. 39.

30 *Votes for Women*, July 30th 1909, p. 1014.

31 *Vanity Fair*, quoted in *Votes for Women*, March 1908, p. 92.

32 Letter from Emmeline Pankhurst to Helen Craggs, April 3rd 1907.

33 Letter from Emmeline Pankhurst to ILP, September 14th 1907.

34 See Paula Bartley, 'Suffragettes, class and pit-brow women', *History Review*, December 1999.

35 Emmeline Pankhurst, Hartford, Connecticut, 1913 (Fawcett).

36 Leah Leneman, 'A Truly National Movement', in Maroula Joannou and June Purvis (ed.) *The Women's Suffrage Movement* (Manchester: Manchester University Press, 1998).

37 *Votes for Women*, May 14th 1908, p. 165.

38 George Barnsby, *Votes for Women: The Struggle for the Vote in the Black Country* (Birmingham: Integrated Publishing, 1995), p. 8.

39 Ethel Smyth, *Female Pipings in Eden* (London: Peter Davies, 1934), p. 285.

40 *Votes for Women*, October 1907, p. 6.

41 Letter from Emmeline Pankhurst to Sylvia Pankhurst, June 22nd 1907 (SFC).

42 Letter from Emmeline Pankhurst to Elizabeth Robins, September 13th 1907 (Harry Ransom Center).

43 Letter from Emmeline Pankhurst to Miss Thompson, September 17th 1907 (SFC).

44 Letter from Emmeline Pankhurst to Elizabeth Robins, November 19th 1906 (Harry Ransom Center).

45 Letter from Emmeline Pankhurst to Elizabeth Robins, September 19th 1907 (Harry Ransom Center).

46 *Votes for Women*, October 1907, p. 6.

47 *Votes for Women*, October 1907, p. 2.

5 DEEDS AND WORDS 1908–09

1 *The Cambrian News and Welsh Farmers' Gazette*, February 21st 1908, p. 4.

2 *Votes for Women*, October 1st 1909, p. 8.

3 Leaflet on *Why Women Teachers Break Windows*, nd (John Johnson collection).

4 See Sandra Holton, *Feminism and Democracy* (Cambridge University Press, 1986), for a perceptive analysis of the question of militancy.

5 C. Eustance, 'The Women's Freedom League', in M. Joannou and J. Purvis (eds) *The Women's Suffrage Movement* (Manchester: Manchester University Press, 1998), p. 60.

6 *Torquay Times*, February 12th 1909. I am indebted to Bill Bartley for providing this information.

7 *The Trial of the Suffragette Leaders* (London: The Woman's Press, 1908), p. 21 (SFC).

8 *The Trial of the Suffragette Leaders* (London: The Woman's Press, 1908), p. 24 (SFC).

9 Leaflet produced by the WSPU, 1908 (SFC).

10 Interview of Emmeline Pankhurst, *Hereford Times*, February 22nd 1908, p. 3.

11 *Votes for Women*, April 1908, p. 114.

12 Henry Woodd Nevinson Diaries, March 20th 1908.

13 *Votes for Women*, July 2nd 1909.

14 NWSPU Fourth Annual Report 1909, p. 14 (SFC).

15 *Suffragist Prisoners are Political Offenders therefore they should be treated as First-class Misdemeanants*, leaflet produced by WSPU, nd (SFC).

16 Ethel Smyth, *The Memoirs of Ethel Smyth* (London: Viking, 1987), p. 300.

17 *Votes for Women*, April 30th 1909, p. 605.

18 *The Times*, August 6th 1909, p. 6.

19 Letter written by Emmeline Pankhurst to *The Times*, January 21st 1908, p. 4.

20 Letter from St John Ervine to the *Nation*, quoted in F.W. Pethick-Lawrence, *The By-election Policy of the WSPU*, c. 1909, p. 7 (SFC).

21 *Western Gazette*, January 18th 1908.

22 *Votes for Women*, March 1908, p. 84.

23 Joynson-Hicks, Conservative MP, quoted in F.W. Pethick-Lawrence, *The By-election Policy of the WSPU*, c. 1909, p. 10.

24 *Votes for Women*, April 1908, p. 187.

25 *Votes for Women*, June 25th 1908, p. 266.

26 *Votes for Women*, July 9th 1908, p. 293.

27 *Votes for Women*, July 16th 1908, p. 314.

28 NWSPU Fourth Annual Report 1909.

29 *North Wales Chronicle*, January 18th 1908, quoted in *Votes for Women*, February 1908, p. 76.

30 Letter from C.P. Scott to Emmeline Pankhurst, March 5th 1911 (JRULM).

31 *Torquay Times*, February 12th 1909.

32 *Votes for Women*, September 17th 1908, p. 452.

33 *Votes for Women*, September 10th 1908, p. 445.

34 Mary Phillips, 'A typical suffragist', in *Votes for Women*, December 1907, p. 35.

35 Cecily Hamilton, quoted in L. Whitelaw, *The Life and Rebellious Times of Cecily Hamilton* (London: Woman's Press, 1990), p. 51.

36 Katharine Willoughby Marshall, *Suffragette Escapes and Adventures*, unpublished manuscript, September 1947 (SFC).

37 *Votes for Women*, July 30th 1908, p. 348.

38 *New York Times*, October 26th 1909, p. 1.

39 See Lisa Tickner, *The Spectacle of Women* (Chicago: University of Chicago Press, 1988), for a superb overview of suffragette imagery.

40 *Votes for Women*, June 11th 1908, p. 233.

41 *Votes for Women*, June 25th 1908, p. 262.

42 *Votes for Women*, July 23rd 1908, p. 331.

43 *Votes for Women*, July 23rd 1908, p. 332.

44 *Votes for Women*, June 11th 1908, p. 227.

45 *Votes for Women*, June 18th 1908, p. 249.

46 *Votes for Women*, June 4th 1909, p. 751.

47 Henry Woodd Nevinson Diaries, March 19th 1908.

48 *The Hereford Times*, February 22nd 1908, p. 3.

49 *Votes for Women*, February 26th 1909, p. 378.

50 Letter from Emmeline Pethick-Lawrence to Minnie Baldock, June 10th 1909 (SFC).
51 *Votes for Women*, May 21st 1909.
52 Rachel Ferguson, *We Were Amused* (London: Jonathan Cape, 1958), p. 116.
53 Letter from Emmeline Pankhurst to C.P. Scott, February 7th 1909 (JRULM).
54 Leaflet produced by WSPU, 1909 (SFC).
55 NWSPU Seventh Annual Report 1913, p. 9.
56 Marie Brackenbury, unpublished manuscript, January 1930 (SFC).
57 Ethel Snowden to Fawcett, September 18th 1909, M50/2/1/283 (Manchester Central Reference, MCR).
58 Fawcett's reply to Brackenbury, October 15th 1909, M50/2/1/286 (MCR).
59 Helen Dawson to Fawcett, October 1909, M50/2/1/284–285 (MCR).

6 DEEDS NOT WORDS 1910–12

1 Ethel Smyth, *The Memoirs of Ethel Smyth* (London: Viking, 1987), p. 299.
2 *Votes for Women*, August 19th 1910, p. 763.
3 Grace Roe, interview with Brian Harrison, September 1973 (Fawcett library).
4 Sylvia Pankhurst, *The Suffragette Movement* (London: Virago, 1977), p. 324.
5 Emmeline Pankhurst to Elizabeth Robins, February 3rd 1910 (Elizabeth Robins Collection, Harry Ransom Center).
6 Emmeline Pankhurst to Elizabeth Robins, February 6th 1910 (Elizabeth Robins Collection, HRC).
7 Will of Sophia Jane Goulden, 1910.
8 Letter from Emmeline Pankhurst to C.P. Scott, December 27th 1910 (JRULM).
9 Emmeline Pankhurst to Elizabeth Robins, July 5th 1911 (Elizabeth Robins Collection, HRC).
10 Letter from Emmeline Pankhurst to C.P. Scott, December 27th 1910 (JRULM).
11 *The Suffragette*, October 25th 1912, p. 16.
12 *The Suffragette*, November 29th 1912, p. 101.
13 NWSPU Eighth Annual Report 1914, p. 4.
14 Henry Woodd Nevinson Diaries, June 27th 1910.
15 Emmeline Pankhurst, *Votes for Women*, October 25th 1912, p. 58.

16 Emmeline Pankhurst, *The Suffragette*, October 25th 1912, p. 16.

17 Emmeline Pankhurst, speech delivered in New York, October 21st 1913.

18 *The Suffragette*, July 18th 1913, p. 677.

19 *The Suffragette*, November 1st 1912, p. 40.

20 See June Purvis, 'The prison experiences of the suffragettes in Edwardian Britain', *Women's History Review*, Vol. 4, No. 1, 1995. June Purvis argues that many working-class suffragettes were active in the militant movement since only through militant action would they have been arrested, tried, sentenced and imprisoned.

21 Henry Woodd Nevinson Diaries, April 14th 1910.

22 Circular letter from Emmeline Pankhurst, October 27th 1910 (SFC).

23 Lisa Tickner, *The Spectacle of Women: Imagery of the Suffrage Campaign 1907–1914* (London: Chatto and Windus, 1987), p. 113.

24 NWSPU Seventh Annual Report 1913, p. 8.

25 *Votes for Women*, June 25th 1908, p. 266.

26 Letter from Emmeline Pankhurst to *The Times*, March 20th 1911, p. 20.

27 *Votes for Women*, May 13th 1910, p. 536.

28 Christabel Pankhurst, *Unshackled* (London: Hutchinson, 1959), p. 164.

29 *New York Times*, October 12th 1911, p. 18.

30 WSPU leaflet, 1912.

31 *The Treatment of the Women's Deputations by the Metropolitan Police*, copy of evidence collected by Dr Jessie Murray and Mr H.N. Brailsford and forwarded to the Home Office by the Conciliation Committee, 1911, p. 13 (SFC).

32 Henry Woodd Nevinson Diaries, November 22nd 1910.

33 Henry Woodd Nevinson, quoted on leaflet produced by the WSPU 1912 (SFC).

34 Emmeline Pankhurst, *The Argument of the Broken Pane*, Part of a speech delivered at the Dinner at the Connaught Rooms in Honour of the Released Prisoners, February 1912.

35 Katharine Willoughby Marshall, *Suffragette Escapes and Adventures*, unpublished manuscript, September 1947 (SFC).

36 *The Suffragette*, October 25th 1912, p. 16.

37 Sylvia Pankhurst, 'My mother', nd but probably 1930s.

38 Emmeline Pankhurst speaking at the Connaught Rooms, quoted in *Votes for Women*, February 23rd 1912, p. 319.

39 L. Leneman, *'A Guid Cause': The Woman's Suffrage Movement in Scotland* (Aberdeen: Aberdeen University Press, 1991).

40 *The Unholy Alliance*, leaflet produced by WSPU 1912 (SFC).

41 Letter from Emmeline Pankhurst to Miss Kelly, February 21st 1912 (SFC).

42 Letter from Emmeline Pankhurst to an unnamed colleague, February 29th 1912 (SFC).

43 *Votes for Women*, February 28th 1913, p. 308.

44 Interview by Margorie McEnaney with Mrs Hall Humpherson (National Archives of Canada, Ottawa).

45 Grace Roe, interview with Brian Harrison, September 22nd 1965 (Fawcett Library).

46 *The Suffragette*, October 25th 1912, p.16.

47 Rule 243A PRI COM 8/175 (Public Record Office, PRO).

48 Home Office daily reports on Emmeline Pankhurst, 25th May 1912 (PRO).

49 *The Times*, April 19th 1912, p. 19.

50 *Suffrage Speeches from the Dock* (London: The Woman's Press, 1912), p. 1.

51 *Suffrage Speeches from the Dock* (London: The Woman's Press, 1912), p. 8.

52 Prison Commission Reports, May 23rd 1912 PRI COM 8/175 (PRO).

53 Prison Commission Minutes, 17th June 1912 (PRO).

54 Quoted from Anne Digby, 'Women's Biological Straitjacket', in S. Mendus and J. Rendall (eds) *Sexuality and Subordination* (London: Routledge, 1989), p. 198.

55 Final Instructions to Members of Demonstration, November 21st 1911 (SFC).

56 Sandra Holton, 'Suffrage Militancy and Emmeline Pankhurst', in H. Smith (ed.) *British Feminism in the Twentieth Century* (Aldershot: Edward Elgar, 1990), p. 17.

57 Sandra Holton, 'Suffrage Militancy and Emmeline Pankhurst', p. 17.

58 See June Purvis, 'The prison experiences of the suffragettes in Edwardian Britain', *Women's History Review*, Vol. 4, 1995, p. 123.

59 *Suffrage Speeches from the Dock* (London: The Woman's Press, 1912), p. 25.

60 Letter from Emmeline Pethick-Lawrence to Evelyn Sharp, 1930, quoted in Elizabeth Crawford, *The Women's Suffrage Movement* (London: Routledge, 1999), p. 538.

61 Henry Woodd Nevinson Diaries, January 31st 1913.

62 *The Suffragette*, October 25th 1912, p. 14.

63 Letter from Emmeline Pankhurst to 'a friend', October 16th 1912 (SFC).

64 Henry Woodd Nevinson Diaries, December 23rd 1913.

65 *Votes for Women*, January 3rd 1913, p. 204.

66 *Votes for Women*, April 4th 1913, p. 376.

67 Frederick Pethick-Lawrence, *Daily Telegraph*, July 3rd 1930.

68 Letter from Emmeline Pankhurst to 'a friend', October 16th 1912 (SFC).

69 *The Suffragette*, October 25th 1912, p. 14.

70 *The Suffragette*, December 6th 1912, p. 116.

71 Kitty Marion's note-book (SFC).

7 THE HEIGHT OF MILITANCY 1913–14

1 Report of the Proceedings of the Visiting Committee at Holloway Prison on July 10th 1914 (Home Office, HO44 234646/149).

2 Ethel Smyth, *Female Pipings in Eden* (London: Peter Davies, 1934), p. 214.

3 *The Suffragette*, July 18th 1913, p. 677.

4 *The Suffragette*, February 27th 1914, p. 443.

5 *Votes for Women*, October 4th 1912, p. 841.

6 Elizabeth Robins, *Way Stations* (1913), p. 161.

7 *The Suffragette*, January 31st 1913, p. 241.

8 *The Suffragette*, January 31st 1913, p. 240.

9 *The Suffragette*, February 28th 1913, p. 309.

10 Emmeline Pankhurst, speech at the Town Hall, Chelsea, February 21st 1913.

11 Emmeline Pankhurst, *Votes for Women*, April 11th 1913, p. 398.

12 *The Suffragette*, July 18th 1913, p. 688.

13 Emmeline Pankhurst, speech at Hartford, Connecticut, 1913.

14 *The Suffragette*, April 10th 1914, p. 584.

15 *Votes for Women*, January 13th 1913, p. 217.

16 *The Suffragette*, January 24th 1913, p. 220.

17 *The Suffragette*, January 31st 1913, p. 116.

18 *The Suffragette*, February 28th 1913, p. 310.

19 Henry Woodd Nevinson Diaries, January 31st 1913.

20 Letter from Emmeline Pankhurst to WSPU members, January 10th 1913 (SFC).

21 *Votes for Women*, February 28th 1913, p. 308.

22 *Votes for Women*, February 28th 1913, p. 308.

23 NWSPU Seventh Annual Report 1913, p. 15.

24 Letter from Emmeline Pankhurst to Elizabeth Robins, April 1913 (Elizabeth Robins Collection, HRC).

25 *Votes for Women*, April 11th 1913, p. 392.

26 *The Suffragette*, April 11th 1913, p. 419.

27 *Votes for Women*, April 11th 1913, p. 393.

28 *The Suffragette*, April 11th 1913, p. 427.

29 Letter from Home Office to Holloway, April 14th 1913 (PRI COM 8/175).

30 Letter from Prison Governor to Home Office, June 4th 1913 (PRI COM 8/175).

31 Prison report, April 8th 1913 (HO144).

32 Letter to Ethel Smyth, December 19th 1913, quoted in Ethel Smyth, *Female Pipings in Eden* (London: Peter Davies, 1934), p. 217.

33 *The Suffragette*, July 24th 1913, p. 257.

34 Prison Commission Reports, June 15th 1913 (PRI COM 8/175).

35 Emmeline Pankhurst, *My Own Story* (London: Virago, 1979), p. 316.

36 Emmeline Pankhurst, *My Own Story* (London: Virago, 1979, p. 257.

37 Report from Medical Officer of Prisons, July 23rd 1913 (HO144 1254/234646).

38 *The Suffragette*, August 8th 1913, p. 738.

39 Emmeline Pankhurst, Prison Commission Reports, April 6th 1913 (PRI COM 8/175).

40 Home Office, June 19th 1912 (PRI COM 8/175).

41 *The Suffragette*, February 27th 1914, p. 446.

42 Daily prison report, April 6th 1913 (PRI COM 8/175).

43 Miss Richardson's statement reported in *The Suffragette*, July 18th 1913, p. 679. Miss Richardson had been sentenced to two months' hard labour for striking a police man.

44 *The Times*, March 11th 1914.

45 *The Suffragette*, May 8th 1914, p.16.

46 *Votes for Women*, April 11th 1913, p. 396.

47 *The Times*, December 6th 1913, p. 6.

48 *The Times*, December 16th 1913, p. 16.

49 *Votes for Women*, February 28th 1913, p. 308.

50 *The Suffragette*, February 28th 1913, p. 309.

51 Mrs Belmont talking to the *New York Times*, September 19th 1913, p. 9.

52 Prison Commission Reports, December 12th 1913 (PRI COM 8/175).

53 Prison Commission Reports, May 30th 1913 (PRI COM 8/175).

54 Medical Officer, Holloway, report to Home Office, June 24th 1913 (PRI COM 8/175).

55 *The Suffragette*, July 17th 1914, p. 238.

56 Interview by Jessie Street with Lilian Lenton, 1960 (SFC).

57 *The Suffragette*, July 4th 1913, p. 638.

58 Letter from Emmeline Pankhurst to Mrs Harben, nd but probably 1913 (Private collection, Mr and Mrs Goode).

59 Letter from Emmeline Pankhurst to Elizabeth Robins, July 30th 1912 (Elizabeth Robins Collection, HRC).

60 Report to Home Office, April 29th 1913 (HO144).

61 Mrs Hall Humpherson, Canada (NAC).

62 NWSPU Eighth Annual Report 1914, p. 20.

63 *The Suffragette*, July 25th 1913, p. 700.

64 *The Suffragette*, July 25th 1913, p. 700.

65 Rhetta Dorr, *A Woman of Fifty* (London: Funk and Wagnell, 1924), p. 252.

66 *The Times*, December 10th 1913, p. 10.

67 *The Times*, December 15th 1913, p. 15.

68 *The Suffragette*, February 13th 1914, p. 396.

69 Police report on Emmeline Pankhurst's arrest in Glasgow (HO144 1254/234646).

70 *Votes for Women*, April 11th 1913, p. 393.

71 *The Suffragette*, March 13th 1914, p. 483.

72 *The Times*, March 19th 1914, p. 5.

73 Dr Mabel Jones, quoted in *The Suffragette*, March 20th 1914, p. 511.

74 Leah Leneman, 'A Truly National Movement', in M. Joannou and J. Purvis (eds) *The Women's Suffrage Movement* (Manchester: Manchester University Press, 1998), p. 45.

75 *The Suffragette*, January 1914.

76 NWSPU Eighth Annual Report 1914, p. 5.

8 INTERNATIONAL FUND-RAISING 1909–13

1 *New York Times*, October 26th 1909, p. 1.

2 Ellen Carol Dubois, *Harriot Stanton Blatch and the Winning of Woman Suffrage* (New Haven: Yale University Press, 1997), p. 71.

3 Jacqueline Van Voris, *Carrie Chapman Catt* (New York: The Feminist Press, 1987), p. 109.

4 *Victoria Daily Times*, December 20th 1911.

5 Letter from Emmeline Pankhurst to Elizabeth Robins, August 17th 1909 (HRC).

6 *New York Times*, November 6th 1909, p. 9.

7 *Chicago Daily Tribune*, November 26th 1909, p. 3.

8 *Chicago Daily Tribune*, November 25th 1909, p. 5.

9 *New York Times*, October 28th 1909, p. 9.

10 *New York Times*, October 19th 1909, p. 3.

11 *Chicago Daily Tribune*, November 27th 1909, p. 1.

12 *New York Times*, October 23rd 1909, p. 8.

13 Letter from Emmeline Pankhurst to Elizabeth Robins, 27th October 1909 (Elizabeth Robins Collection, HRC).

14 Flora Denison papers (Man 31 Box 8B).

15 *The Canadian Magazine*, November 1913, p. 53.

16 *The Globe*, November 20th 1909, p. 1.

17 Flora Denison collection (Man 51 Box 8A).

18 *The Canadian Magazine*, November 1913, p. 54.

19 *The News*, November 23rd 1909.

20 *Saturday Night*, November 27th 1909, p. 1.

21 *The Globe*, November 20th 1909.

22 *Toronto Evening Globe*, November 20th 1909.

23 Unnamed newspaper, 1909 (Flora Denison Collection, Man 31 Box 8A).

24 *The Globe*, November 22nd 1909, p. 6.

25 *The News*, November 23rd 1909.

26 *Saturday Night*, November 27th 1909.

27 *Toronto World*, December 11th 1910.

28 *Toronto World,* November 28th 1909.

29 Letter from Emmeline Pankhurst to Elizabeth Robins, December 28th 1911 (Elizabeth Robins Collection, HRC).

30 Harriot Stanton Blatch and Alma Lutz, *Challenging Years: The Memoirs of Harriot Stanton Blatch* (New York: G.P. Putnam's Sons, 1940), p. 94.

31 *New York Times*, October 12th 1911, p. 18.

32 *Chicago Daily Tribune*, November 10th 1911, p. 3.

33 *Votes for Women*, November 3rd 1911, p. 67.

34 *The Woman's Journal*, October 28th 1911, p. 338.

35 *New York Times*, November 29th 1911, p. 1.

36 *Votes for Women*, December 29th 1911, p. 213.

37 *Women's Journal*, December 9th 1911, p. 386.

38 *The Toronto World*, December 13th 1911, p. 1.

39 See Carol Bacchi, 'Race regeneration and social purity: a study of the social attitudes of Canada's English-speaking suffragettes', *Social History*, 1978, pp. 460–74, for a discussion of this.

40 *Toronto World*, December 14th 1911, p. 3.

41 Deborah Gorham, 'English militancy and the Canadian suffrage movement', *Atlantis*, Autumn 1975, p. 109.

42 *Victoria Daily Times*, December 21st 1911, p. 13.

43 *The Globe*, November 20th 1909, p. 1.

44 Letter from Emmeline Pankhurst to Elizabeth Robins, December 28th 1911 (Elizabeth Robins Collection, HRC).

45 Unnamed newspaper, 1913 (Flora Denison Collection, Man 51 Box 8A).

46 New Brunswick Minute Books 1, 210, quoted in Catherine L. Cleverdon, *The Woman Suffrage Movement in Canada* (Toronto: University of Toronto Press, 1950), p. 189.

47 Letter from Mrs A.V. Thomas, a leading suffrage worker, to Catherine L. Cleverdon, quoted in Catherine L. Cleverdon, *The Woman Suffrage Movement in Canada* (Toronto: University of Toronto Press, 1950).

48 *Toronto Star Weekly*, 1911.

49 *Saturday Night*, March 1st 1913, p. 1.

50 Telegram from Spring-Rice, Washington, to Home Office, October 9th 1913 (HO144).

51 Rhetta Dorr, *A Woman of Fifty* (London: Funk and Wagnalls, 1924), p. 251.

52 Letter by Emmeline Pankhurst to a friend, quoted in *The Suffragette*, October 31st 1913, p. 52.

53 *New York Times*, quoted in *The Outlook*, November 1st 1913, p. 469.

54 Quoted in *The Outlook*, November 1st 1913, p. 469.

55 *New York Times*, September 5th 1913, p. 4.

56 *New York Times*, September 25th 1913, p. 3.

57 *Chicago Defender*, November 8th 1913, p. 2.

58 *Chicago Defender*, November 8th 1913, p. 5.

59 *New York World*, October 22nd 1913, p. 5.

60 *Chicago Daily Tribune*, November 3rd 1913, p. 1 .

61 *Chicago Daily Tribune*, November 2nd 1913, p. 8.

62 Emmeline Pankhurst, Speech at Hartford, Connecticut, 1913.

63 *New York Times*, October 3rd 1913, p. 8.

64 *St Louis Post Dispatch*, October 22nd 1913, p. 16.

65 *New York World*, November 19th 1913, p. 6.

66 *New York Times*, October 4th 1913, p. 8.

67 *Current Opinion*, November 1913, pp. 306–08.

68 Flora Denison papers, Call No. 51 Box 81.

69 *The Outlook*, Septenber 27th 1913, p. 155.

70 *New York Times*, October 4th 1913, p. 8.

71 Emmeline Pankhurst, Speech at Hartford, Connecticut, 1913.

72 *Chicago Daily Tribune*, October 28th 1913, p. 1.

73 *Chicago Daily Tribune*, November 3rd 1913, p. 8.

74 *Western British American*, September 13th 1913, quoted in *The Suffragette*, October 10th 1913, p. 909.

75 *Current Opinion*, June 1913, pp. 459–61.
76 *The Forum*, March 1913, pp 508–12.
77 *New York Times*, September 7th 1913, p. 12.
78 *New York Times*, September 9th 1913, p. 16.
79 *New York Times*, September 8th 1913, p. 3.
80 *Current Opinion*, November 1913, pp. 306–08.
81 *La Moille Gazette*, Illinois, quoted in *The Suffragette*, December 12th 1913, p. 198.
82 *New York Tribune*, October 23rd 1913, p. 3.
83 *New York Times*, October 27th 1913, p. 9.
84 *New York Times*, September 21st 1913, p. 14.
85 *The Sun*, October 23rd 1913, quoted in *The Suffragette*, November 14th 1913, p. 98.
86 *New York Tribune*, October 24th 1913, p. 1.
87 NWSPU Eighth Annual Report 1914, p. 14.
88 Unnamed newspaper, 1913 (Flora Denison Collection, Man 51 Box 8A).
89 *Toronto Star*, February 20th 1913, p. 1.
90 Unnamed newspaper, February 28th 1913 (Flora Denison Collection, Man 51 Box 8A).
91 *The Canadian Magazine*, November 1909, p. 809.

9 THE FIRST WORLD WAR 1914–18

1 Ethel Smyth, *The Memoirs of Ethel Smyth* (London: Viking, 1987), p. 313.
2 Emmeline Pankhurst, *My Own Story* (London: Virago, 1979), pp. 264–5.
3 Henry Woodd Nevinson Diaries, April 17th 1915. I am indebted to Angela V. John for all the references to Nevinson.
4 *The Suffragette*, April 16th 1915, p. 12.
5 *The Suffragette*, April 23rd 1915, p. 26.
6 *The Suffragette*, April 23rd 1915, p. 25.
7 *The Suffragette*, May 14th 1915, p. 69.
8 Circular letter by Emmeline Pankhurst regarding Deputation to Lloyd George, July 9th 1915 (SFC).
9 Grace Roe, September 23rd 1974, interview with Brian Harrison.
10 *The Suffragette*, April 23rd 1915, p. 26.
11 *The Suffragette*, June 25th 1915, p. 165.
12 *The Times*, December 1st 1914, p. 5.
13 *The Suffragette*, October 1st 1915, p. 349.

14 Emmeline Pankhurst, speech delivered at the Sun Hall, Liverpool, 1914.
15 *The Suffragette*, May 14th 1915, p. 69.
16 *The Suffragette*, June 25th 1915, p. 172.
17 *The Suffragette*, June 11th 1915, p. 137.
18 *The Western Evening Herald*, November 17th 1914, p. 10.
19 Circular letter sent by Emmeline Pankhurst to all members of the WSPU, August 13th 1914 (SFC).
20 *Labour Leader*, November 4th 1915.
21 *The Suffragette*, July 2nd 1915, p. 184.
22 *The Suffragette*, June 11th 1915, p. 137.
23 *The Suffragette*, April 23rd 1915, p. 26.
24 *The Suffragette*, April 23rd 1915, p. 26.
25 *The Suffragette*, June 11th 1915, p. 134.
26 *The Suffragette*, July 30th 1915, p. 246.
27 WSPU leaflet 'Women's War Procession', July 22nd 1915 (SFC).
28 Leaflet signed by Emmeline Pankhurst, produced by the Women's Party, nd (SFC).
29 The Women's Party Manifesto, 1918.
30 *The Suffragette*, June 4th 1915, p. 126.
31 *The Suffragette*, April 23rd 1915, p. 26.
32 *The Suffragette*, May 28th 1915, p. 111.
33 Emmeline Pankhurst to Nancy Astor, July 4th 1915 (Nancy Astor papers).
34 Unidentified typescript (NAC MG28 1332 145 13).
35 *The Suffragette*, July 2nd 1915, p. 184.
36 *The Suffragette*, June 11th 1915, p. 137.
37 *The Suffragette*, July 2nd 1915, p. 184.
38 Emmeline Pankhurst to Sir James Murray, July 25th 1915 (Lloyd George Papers D/11/2/9 House of Lords).
39 Buckingham Palace to Lloyd George, June 28th 1915 (Lloyd George Papers, F/94/1/49 H of L).
40 Letter from Roberty Boby to Emmeline Pankhurst, July 25th 1915 (Lloyd George Papers, D/11/2/11 H of L).
41 *Daily Telegraph*, July 19th 1915.
42 Ministry of Munitions Select Committee on National Expenditure 1917–18 (MUN 4/626).
43 Letter from Emmeline Pankhurst to Lloyd George, July 9th 1915 (SFC).
44 *The Times*, July 12th 1915, p. 5.
45 Minutes of Conference with Deputation from Women's Organisation

to Lloyd George, from notes of Frances Stevenson 17/7/15 (MUN 5/70/324/1).

46 *The Morning Advertiser*, November 19th 1915.

47 *Guardian*, July 24th, p. 4.

48 *Labour Woman*, July 1st 1928.

49 Leaflet signed by Emmeline Pankhurst for the Women's Party, nd (SFC).

50 Letter from Grace Roe to Mrs Archdale, November 21st 1914 (SFC).

51 *The Suffragette*, June 11th 1915, p. 138.

52 Susan R. Grayzel, '"The Mothers of Our Soldiers' Children": motherhood, immorality, and the war baby scandal, 1914–1918', in Claudia Nelson and Ann Sumner Holmes (eds) *Maternal Instincts: Visions of Motherhood and Sexuality in Britain 1875–1925* (London: Macmillan, 1997).

53 *The Suffragette*, May 14th 1915, p. 69.

54 *The Suffragette*, May 14th 1915, p. 69.

55 Emmeline Pankhurst to Lady Astor, May 29th 1915 (Nancy Astor papers).

56 Emmeline Pankhurst to Lady Astor, May 10th 1915 (Nancy Astor papers).

57 *The Suffragette*, June 11th 1915, p. 138.

58 *The Suffragette*, June 11th 1915, p. 138.

59 WSPU leaflet advertising Emmeline Pankhurst's public meeting concerning war babies, nd (SFC).

60 *New York Times*, June 7th 1918, p. 6.

61 Ethel Smyth, *Female Pipings in Eden* (London: Peter Davies, 1934), p. 243.

62 *New York Times*, June 7th 1918, p. 6.

63 Letter from Emmeline Pankhurst to Ethel Smyth, May 3rd 1917, quoted in *Female Pipings in Eden* (London: Peter Davies, 1934), p. 242.

64 *New York Times*, June 7th 1918, p. 6.

65 Christopher Sykes, *Nancy* (London: Collins, 1972), p. 165.

66 *Western Daily Mercury*, November 17th, no year (SFC).

67 *The Suffragette*, June 25th 1915, p. 172.

68 Grace Roe, Brian Harrison interview, 1974.

69 Grace Roe, 'Militancy and the war time truce', *Calling All Women*, February 1970, p. 9.

70 Emmeline Pankhurst to Sir James Murray, September 28th 1915 (Lloyd George Papers, D/11/2/19 H of L).

71 *South Wales Daily News*, October 25th 1915.

72 Emmeline Pankhurst to Lloyd George, October 14th 1915 (Lloyd George Papers, D/11/2/24 H of L)

73 Emmeline Pankhurst to Sir James Murray, September 30th 1915 (Lloyd George Papers, D/11/2/21 H of L)

74 Lloyd George to Bonar Law, November 21st 1918 (Lloyd George Papers, F/30/2/55 H of L).

75 *Newcastle Daily Chronicle*, February 18th 1915.

76 Grace Roe, Brian Harrison interview, 1974.

77 Grace Roe to Lloyd George, July 2nd 1915 (Lloyd George Papers, D/11/2/3 H of L).

78 *The Globe*, September 17th 1918, p. 4.

79 *The Suffragette*, August 6th 1915, p. 259.

80 *Daily Express*, July 19th 1915.

81 *The Suffragette*, October 1st 1915, p. 354.

82 *Liverpool Courier*, February 7th 1918.

83 Emmeline Pankhurst, 'The women's battle against Bolshevism in Russia', *Woman's Century*, January 1919.

84 Emmeline Pankhurst speaking at the Royal Albert Hall, London, March 16th 1918.

85 Emmeline Pankhurst speaking at the Royal Albert Hall, March 16th 1918.

86 Emmeline Pankhurst speaking at the Royal Albert Hall, March 16th 1918.

87 The Women's Party Manifesto, 1918.

88 Leaflet signed by Emmeline Pankhurst for the Women's Party nd (SFC).

89 Ethel Smyth, *Female Pipings in Eden* (London: Peter Davies, 1934), p. 243.

90 Notes taken from Annie Kenney's Diary, David Mitchell collection.

91 David Mitchell's interview with Annie Kenney, July 2nd 1963.

92 *New York Times*, June 9th 1918, p. 14.

93 *The Times*, April 9th 1919, p. 14.

94 *The Times*, April 9th 1919, p. 14.

95 *The Times*, April 9th 1919, p. 14.

96 *The Times*, April 9th 1919, p. 14.

97 *The New York Times*, June 7th 1918, p. 6.

98 *New York Times*, January 16th 1916, p. 6.

99 *New York Tribune*, January 17th 1916, p. 4.

100 *Washington Post*, February 21st 1916, p. 4.

101 *The Washington Herald*, February 21st 1916, p. 4.

102 *New York Tribune*, January 17th 1916.

103 *Montreal Gazette*, March 13th 1916.

104 *Ottawa Citizen*, March 3rd 1916, p. 6.

105 Gilles Gallichan, *Les Québécoises et le barreau* (Quebec: Sepentrion, 1999). I am grateful to Mary-Jane Mossman for this article and to Margarete Isherwood for translating the text.

106 *New York Times*, June 6th 1918, p. 13.

107 *New York Times*, June 6th 1918, p. 13.

108 *New York Times*, June 14th 1918, p. 7.

109 *The Outlook*, October 23rd 1918, p. 288.

110 *The Globe*, September 17th 1918, p. 4.

111 *The Toronto World*, September 18th 1918.

112 *Saturday Night*, October 5th 1918, p. 1.

113 Leaflet signed by Emmeline Pankhurst, produced by the Women's Party, nd (SFC).

114 *The Times*, April 9th 1919, p. 14.

115 *New York Times*, February 2nd 1921, p. 2.

116 The Women's Party Manifesto, 1918.

117 Grace Roe, Brian Harrison interview, 1974.

118 *New York Tribune*, January 17th 1916, p. 4.

119 Deputation to Prime Minister, March 29th 1917, unpublished memo (SFC).

120 *The Labour Woman*, July 1st 1928.

121 Sandra Stanley Holton, *Suffrage and Democracy* (Cambridge: Cambridge University Press, 1986), p. 125.

122 Lloyd George to Bonar Law, November 21st 1918 (Lloyd George Papers, F/30/2/55 H of L).

123 Emmeline Pankhurst circular letter to members of the Women's Party nd (SFC).

124 Sylvia Pankhurst, *The Life of Emmeline Pankhurst* (London: T. Werner Laurie, 1935).

10 LIFE AFTER THE WAR 1918–28

1 Ethel Smyth, *Female Pipings in Eden* (London: Peter Davies, 1934), p. 286.

2 Interview with Annie Kenney by David Mitchell, March 24th 1964.

3 *New York Herald Tribune*, September 14th 1919.

4 *New York Tribune*, September 28th 1919.

5 *Saskatoon Daily Star*, 1923.

6 *Macleans Magazine*, January 15th 1922, p. 44.

7 *Toronto Daily Star*, February 11th 1922, p. 8.

8 *Victoria Daily Times*, May 5th 1920.

9 Letter from Emmeline Pankhurst to Ethel Smyth, quoted in *Female Pipings in Eden* (London: Peter Davies, 1934), p. 239.

10 *Toronto Daily Star*, February 11th 1922.

11 *The Globe*, April 24th 1921.

12 *The Globe*, April 23rd 1921, p.18.

13 *Saskatoon Daily Star*, 1923.

14 *The Mail and Empire*, April 25th 1921.

15 *The Citizen*, Ottawa, December 2nd 1922.

16 Executive meeting, Monday October 8th 1923 (Provincial Archives of Ontario, PAO).

17 Letter from Emmeline Pankhurst to Gordon Bates, March 28th 1921 (National Archives of Canada (NAC) MG28 1 332 145–12).

18 *The Citizen*, Ottawa, December 2nd 1922.

19 *Macleans Magazine*, January 15th 1922, p. 44.

20 *The Telegraph*, April 20th 1921.

21 *Saskatoon Daily Star*, May 29th 1923, p. 9.

22 *Saskatoon Daily Star*, May 29th 1923, p. 4.

23 *Saskatoon Daily Star*, 1923.

24 *Toronto Daily Star*, February 11th 1922.

25 *Toronto Daily Star*, February 11th 1922.

26 Julia Bush, *Edwardian Ladies and Imperial Power* (Leicester: Leicester University Press, 2000), p. 2.

27 *The Star*, April 20th 1921.

28 Letter from Emmeline Pankhurst to Gordon Bates, June 1922 (NAC MG28 1 332 145 16).

29 Letter from Emmeline Pankhurst to Gordon Bates, July 9th 1922 (NAC MG28 1 332 145 16).

30 Letter from Emmeline Pankhurst to Gordon Bates, March 27th 1924 (NAC MG28 1 332 145 14).

31 Minutes of Business Management Committee, March 28th 1924, (RG10 1-A-1).

32 Letter from Emmeline Pankhurst to Gordon Bates, March 27th 1924 (NAC MG28 1 332 145 14).

33 Letter to Gordon Bates, March 25th 1924 (NAC MG28 1 332 194 11).

34 Letter to Gordon Bates, March 25th 1924 (NAC MG28 1 332 194 11).

35 *Manchester Guardian*, 28th January 1926, p. 12.

36 *Labour Woman*, July 1st 1928.

37 *Evening Standard*, June 14th 1928.

38 Sylvia Pankhurst, 'My mother', nd but probably 1930s.

39 *New York Tribune*, 15th June 1926.

40 *Evening Standard*, March 4th 1926.

41 Robert Blake, *The Conservative Party from Peel to Churchill* (London: Eyre and Spottiswoode, 1970), p. 244.

42 Katharine Willoughby Marshall, 'Suffragette Escapes and Adventures', unpublished manuscript, September 1947 (SFC).

43 Robert Pearce, *Britain: Domestic Politics 1918–39* (London: Hodder and Stoughton, 1992), p. 99.

44 T.F. Linday and Michael Harrington, *The Conservative Party 1918–1979* (London: Macmillan, 1974), p. 84.

45 Rosamund Masey, *Some Memories of Wonderful Days*, unpublished manuscript, nd (SFC).

46 A. Susan Williams, *Ladies of Influence* (London: Penguin, 2001).

47 S. Baldwin, in John Ramsden, *The Age of Balfour and Baldwin 1902–1940* (London: Longman, 1978), p. 212.

48 Christabel Pankhurst, *Unshackled* (London: Hutchinson, 1959), p. 296.

49 *Manchester Guardian*, November 11th 1926.

50 *Manchester Guardian*, August 18th 1927.

51 *Manchester Guardian*, March 4th 1926.

52 *Daily Chronicle*, January 28th 1926.

53 *Daily Chronicle*, January 28th 1926.

54 Nancy Astor papers.

55 *The Times*, March 4th 1926, p. 16.

56 *The Times*, March 4th 1926, p. 16.

57 Letter from Emmeline Pankhurst to Nancy Astor, May 3rd 1926 (Nancy Astor papers).

58 Letter from Emmeline Pankhurst to Nancy Astor, May 5th 1926 (Nancy Astor papers).

59 *New York Herald Tribune*, 15th June 1926.

60 *East London Advertiser*, March 5th 1927, p. 3.

61 *East London Advertiser*, October 29th 1927, p. 5.

62 *East London Advertiser*, October 29th 1927, p. 5.

63 *East London Advertiser*, March 5th 1927, p. 3.

64 Interview with Annie Kenney by David Mitchell, March 24th 1964.

65 Interview with Annie Kenney by David Mitchell, March 24th 1964.

66 Ethel Smyth, *Female Pipings in Eden* (London: Peter Davies, 1934), p. 263.

67 Interview with Annie Kenney by David Mitchell, March 24th 1964.

68 *East London Advertiser*, June 23rd 1928, p. 3.

CONCLUSION

1 Eleanor Rathbone to Nancy Astor (Nancy Astor papers).
2 Rosamund Masey, *Some Memories of Wonderful Days*, unpublished manuscript nd (SFC).
3 Katharine Willoughby Marshall, 'Suffragette Escapes and Adventures', unpublished manuscript, September 1947 (SFC).
4 *Manchester Guardian*, May 30th 1930.
5 Laura E. Nym Mayhall, 'Domesticating Emmeline: representing the suffragette, 1930–1993', *NWSA Journal*, Vol. 11, No. 2, 2000.
6 *Labour Woman*, July 1st 1928.
7 *Daily Telegraph*, July 3rd 1930.
8 Sandra Stanley Holton, 'The Making of Suffrage History', in S. Holton and J. Purvis (eds) *Votes for Women* (London: Routledge, 2000), p. 25.
9 Carol McPhee and Ann FitzGerald, *The Non-Violent Militant: Selected Writings of Teresa Billington-Greig* (London: Routledge and Kegan Paul, 1987), p. 95.
10 Brian Harrison, *Prudent Revolutionaries* (Clarendon Press, 1987), p. 41.
11 WSPU Annual Report 1908, p. 7.
12 Rosamund Masey, *Some Memories of Wonderful Days*, unpublished manuscript (SFC).
13 *Sunday Times*, June 17th 1928, p. 16.

BIBLIOGRAPHY

PRIMARY SOURCES

Until now there has been no scholarly biography of Emmeline Pankhurst so I have had to rely on primary and archival sources for the major part of her life. The Pankhurst family were prolific in writing about the suffragette movement. In the reprint of Emmeline Pankhurst's *My Own Story* (Virago, 1979) the reader is made aware of her enormous physical energy and emotional drive. However, the biography was ghost-written by Rhetta Childe Dorr, an American journalist, who interviewed Emmeline when she accompanied her on her 1913 boat voyage to America, and contains a number of factual errors. Sylvia Pankhurst's *The Life of Emmeline Pankhurst* (T. Werner Laurie, 1935) and Christabel Pankhurst's *Unshackled* (Hutchinson, 1959) are useful texts, but Sylvia's account is decidedly unsympathetic towards her mother. Sylvia Pankhurst's papers, housed at the Internationaal Instituut voor Sociale Geschiedenis, Amsterdam, are now widely available on microfilm and contain rich primary source material concerning the whole of her mother's life. Local archives were the most fruitful for Emmeline's early life. These include Annie Horniman Papers (John Rylands Library, Manchester), Independent Labour Party Conference Records (John Rylands), Minutes of the Manchester Central Branch of the ILP, 1902–1916 (Manchester Central Reference Library, hereinafter MCRL), Minutes of the Manchester School Board and Various Sub-Committees (MCRL), John Bright Correspondence (Rochdale Arts and Heritage Centre, Local Studies Library), Hannah Mitchell Papers (MCRL), Memoirs of the Manchester Literary and Philosophical Society, Reports of the Poor Law District Conferences. When she was Poor Law Guardian, Emmeline Pankhurst wrote several pamphlets (*What Boards of Guardians Can Do* (circa 1895); 'Duties and Powers of Guardians in Times of Exceptional Distress' in *Report of the Poor Law District Conference held during the Year 1895*; 'Increased Powers of Detention for Children of Degraded Parents and "Ins and Outs"' in *Report of the Poor Law District Conference held during the year 1897*), all of which help understand her political thinking of these years. Local newspapers and political journals (*Athenaeum Gazette, Gorton, Openshaw and Bradford Reporter, Lancashire Directory, Manchester City News, Manchester Courier, Manchester Director, Manchester Evening News, Manchester Faces and Places, Manchester Guardian, Manchester Official Handbook, Pendleton*

Reporter, Rochdale Monthly, Salford Reporter, Clarion, Labour Leader, ILP News and *Labour Prophet* supplemented these archives.

Emmeline's suffragette years are well documented in the Suffragette Fellowship Collection (Museum of London but also available on microfilm). Other useful collections used include the Autograph Letter Collection (Fawcett Library, London); Mary Blathwayt Diaries (National Trust, Dyrham Park); Brian Harrison interviews with former suffragettes (Fawcett); Henry Woodd Nevinson Diaries (Bodleian); Home Office Papers (Public Record Office); Annot Robinson Papers, Misc. 718 (MCRL); Francis Johnson Correspondence (John Rylands); John Johnson Collection (Bodleian, Oxford); C.P. Scott Correspondence (John Rylands); Elizabeth Robins Collection (Harry Ransom Center, University of Texas); David Mitchell Papers (Museum of London); and the Women's Suffrage Collection, M50 (MCRL). Many of the autobiographical memoirs and histories written by the suffragettes have either been reprinted or are available through libraries. C. Lytton, *Prisons and Prisoners: Some Personal Experiences by Constance Lytton and Jane Warton* (Heinemann, 1914); Sylvia Pankhurst, *The Suffragette Movement* (Virago, 1977); Sylvia Pankhurst, *The Home Front* (Hutchinson, 1932); Emmeline Pethick-Lawrence, *My Part in a Changing World* (Gollancz, 1938); Fred Pethick-Lawrence, *Fate has been Kind* (Hutchinson, 1943); Ethel Smyth, *The Memoirs of Ethel Smyth* (Viking, 1987); Rachel Ferguson, *We Were Amused* (Jonathan Cape, 1958); Thelma Keir Cazalet, *I knew Mrs Pankhurst* (Suffragette Fellowship, 1945); Ray Strachey, *The Cause* (G. Bell and Sons, 1928). The WSPU published two newspapers, *Votes for Women* and *The Suffragette*, both of which are invaluable documents which capture the increasing fervour and militancy of the movement. To counter their obviously partisan approach, other national and local newspapers (e.g. *Women's Suffrage Journal, The Guardian, Observer, Sunday Times, The Times, Torquay Times, Hereford Times*) were also consulted. There are also useful primary source collections. Three of the most important are from the Women's Source Library, all published in 1987 by Routledge, and have thought-provoking introductions to the source material. The first book, *Before the Vote was Won: Arguments for and against Women's Suffrage* (edited by Jane Lewis), traces the arguments mainly of those in support of women's suffrage. *Suffrage and the Pankhursts* (edited by Jane Marcus) contains many useful articles, documents and pamphlets written by and about Emmeline Pankhurst. *The Non-Violent Militant: Selected Writings of Teresa Billington-Greig* (edited by Carol McPhee and Ann FitzGerald) includes critiques of the WSPU and its leader. Emmeline Pankhurst's visits to the United States and Canada are well covered in the

American press and in the Flora Denison papers held in the University of Toronto archives. Nancy Farmer's interview with Bill McNeill (National Archives of Canada, Ottawa, hereinafter NAC) and Nellie Hall Humpherson's interview by Marjorie McEnaney (NAC) also provided useful information.

Emmeline Pankhurst's contribution to the war effort can be followed in the British and American press, Brian Harrison's tapes and Lloyd George's papers (House of Lords). Her life as a Canadian citizen and her work in the Canadian Society for Combating Venereal Disease are well documented in the Canadian Social Hygiene Council papers (Archives of Toronto; NAC, Ottawa) and in the newspapers of the period (e.g. *Toronto Star* and *Ottawa Citizen*). Nancy Astor's papers, the Conservative Party archives and newspaper accounts all provide evidence of Emmeline's life when she returned to England.

SECONDARY SOURCES

The following bibliography describes the published works most directly relevant to the life of Emmeline Pankhurst and the period in which she lived. As there is so little material available on her life outside suffrage, it will inevitably focus on this aspect. David Mitchell's *The Fighting Pankhursts* (Jonathan Cape, 1967) examines Emmeline's life in some detail but trivialises her political motivations. Martin Pugh's recent book *The Pankhursts* (Penguin, 2001), which was published just as this book was going to press, offers little that is new and ignores the feminist scholarship of the last ten years. Naturally, Emmeline Pankhurst appears in many standard texts of suffrage. A number of male historians, influenced by the scurrilously unsympathetic account of suffrage put forward by George Dangerfield in *The Strange Death of Liberal England* (Perigree, 1980), were critical of Emmeline Pankhurst. For example, Roger Fulford's *Votes for Women* (Faber and Faber, 1957) tends to belittle Emmeline's achievements.

The birth and growth of feminist politics brought new interpretations of suffrage history but not necessarily new interpretations of Emmeline Pankhurst. In *One Hand Tied Behind Us* (Virago, 1978) the two socialist-feminist historians Jill Liddington and Jill Norris broke new empirical and methodological ground by constructing an account of working-class suffragists. However, they tend to see Emmeline Pankhurst in a similar way to traditional male historians because she was seen to break with her socialist past. In contrast, historians who favour a radical-feminist interpretation have provided fresh insights into the motivations of the WSPU

leader. In particular, Jane Marcus's introduction to *Suffrage and the Pankhursts* (Routledge, 1987) and June Purvis's ' "A pair of infernal queens?" A reassessment of dominant representations of Emmeline and Christabel Pankhurst, first-wave feminists in Edwardian Britain', *Women's History Review* (Vol. 5, 1996) typify this genre. The rigorous scholarship of Sandra Stanley Holton is unsurpassed. In particular, her essay in Harold Smith's edited collection *British Feminism in the Twentieth Century* (Edward Elgar, 1990) raises important questions about Emmeline's militant origins.

For those who enjoy reading biographies, there have been several biographies of Emmeline's daughters. Feminist scholars have challenged David Mitchell's unsympathetic portrayal of Christabel in *Queen Christabel* (MacDonald and Janes, 1977) and a new biography is long overdue. Barbara Winslow, *Sylvia Pankhurst* (UCL, 1996), Patricia Romero, *E. Sylvia Pankhurst: Portrait of a Radical* (Yale University Press, 1987), and Vera Coleman, *The Wayward Suffragette* (Melbourne University Press, 1996), provide good overviews of the other daughters. Other useful biographies include Brian Harrison, *Prudent Revolutionaries* (Clarendon Press, 1987), Ann Morley and Liz Stanley, *The Life and Death of Emily Wilding Davison* (The Women's Press, 1989), June Hannam, *Isabella Ford* (Blackwell, 1989), Angela V. John, *Elizabeth Robins* (Routledge, 1988), and June Hannam and Karen Hunt, *Socialist Women* (Routledge, 2002).

Readers interested in the wider campaign for the vote might like to consult general histories of women's suffrage. Introductory texts include Diane Atkinson, *Votes for Women* (Cambridge University Press, 1988); Paula Bartley, *Votes for Women* (Hodder, 1998); Harold L. Smith, *The British Women's Suffrage Campaigns, 1866–1928* (Addison Wesley Longman, 1998). June Purvis's edited collection *Votes for Women* (Routledge, 2000) engages with the most recent research and provides an excellent bibliography of women's suffrage. Undoubtedly the best detailed source is Elizabeth Crawford's mammoth reference guide *The Women's Suffrage Movement* (Routledge, 1999). More specialist texts include Marion Ramelson, *The Petticoat Rebellion: A Century of Struggle for Women's Rights* (Lawrence and Wishart, 1967); Constance Rover, *Women's Suffrage and Party Politics in Britain, 1866–1914* (Routledge and Kegan Paul, 1967); Antonia Raeburn, *The Militant Suffragettes* (Michael Joseph, 1973); Andrew Rosen, *Rise up Women* (Routledge and Kegan Paul, 1974); David Morgan, *Suffragists and Liberals* (Basil Blackwell, 1975); Caroline Morrell, *'Black Friday': Violence against Women in the Suffragette Movement* (Women's Research and Resources Centre, 1981); R. West, 'A Reed of Steel', in Jane Marcus (ed.) *The Young Rebecca: Writings of*

Rebecca West, 1911–1917 (Macmillan, 1982); Les Garner, *Stepping Stones to Women's Liberty: Feminist Ideas in the Women's Suffrage Movement, 1900–1918* (Heinemann, 1984); Hilda Kean, *Deeds Not Words* (Pluto, 1990); Sandra Holton, *Feminism and Democracy: Women's Suffrage and Reform Politics in Britain 1900–1918* (Cambridge University Press, 1986) and *Suffrage Days* (Routledge, 1996); Ian Fletcher, ' "A Star Chamber of the Twentieth Century": suffragettes, Liberals and the 1908 "Rush the Commons' Case" ', *Journal of British Studies* (October, 1996); Cheryl Jorgensen-Earp, *'The Transfiguring Sword': The Just War of the Women's Social and Political Union* (University of Alabama Press, 1997); Angela V. John and Claire Eustance, *The Men's Share* (London: Routledge, 1997); Maroula Joannou and June Purvis, *The Women's Suffrage Movement: New Feminist Perspectives* (Manchester University Press, 1998); Jihang Park, 'The British suffrage activists of 1913: an analysis', *Past and Present* (August 1998); Claire Eustance, Joan Ryan and Laura Ugolini (eds) *Themes and Directions in British Suffrage History* (Cassell Academic, 1999); Laura Mayhall, 'Domesticating Emmeline: representing the suffragette, 1930–1993', *NWSA Journal* (Vol. 11, No. 2, 2000); Martin Pugh, *The March of the Women* (Oxford University Press, 2000) and Cheryl Law, *Suffrage and Power: The Women's Movement 1918–1928* (I.B. Tauris, 2000).

Local suffrage studies such as John Smethurst, 'The suffragette movement in Eccles', *Eccles and District History Society Lectures* (1971–2); Jacqueline Templeton and Melissa Butler, 'Looking the ladies in the face', *Manx Life* (Jan./Feb., 1981); Iris Dove, *Yours in the Cause: Suffragettes in Lewisham, Greenwich and Woolwich* (Lewisham Library Services and Greenwich Libraries, 1988); Patricia De Ban, 'Suffragettes: the Manx connections', *Proceedings of the Isle of Man Natural History and Antiquarian Society* (No. 4, April 1995–March 1997) and Katherine Bradley, *Friends and Visitors: A First History of the Women's Suffrage Movement in Cornwall, 1870–1914* (Patten Press for the Hypatia Trust, 2000) all provide an engaging contrast to the national picture. R.C. Owens, *'Smashing Times': A History of the Irish Women's Suffrage Movement, 1889–1922* (Attic Press, 1984); Cliona Murphy, *The Women's Suffrage Movement and Irish Society in the Early Twentieth Century* (Harvester Wheatsheaf, 1989); Dee and K. Keineg, *Women in Wales: A Documentary of Our Recent History* (Womanwide Press, 1987); Angela V. John (ed.) *Our Mothers' Land: Chapters in Welsh Women's History, 1830–1939* (University of Wales Press, 1991) and Leah Leneman, *'A Guid Cause'* (Aberdeen University Press, 1991) all too clearly demonstrate that the suffrage movement went beyond the borders of England. International suffrage connections are less well documented, but Caroline Daley and Melanie Nolan,

Suffrage and Beyond: International Feminist Perspectives (Auckland University Press, 1994) and June Hannam, Katherine Holden and Mitzi Auchterlonie, *International Encyclopedia of Women's Suffrage* (ABC Clio, 2001) are excellent introductions to this emerging field.

The American and Canadian suffrage movements were different from the British, but the links between them are well charted in Harriot Stanton Blatch and Alma Lutz, *Challenging Years: The Memoirs of Harriot Stanton Blatch* (G.P. Putnam's Sons, 1940) and Ellen Dubois, *Harriot Stanton Blatch and the Winning of Woman Suffrage* (Yale University Press, 1997). The best book on Canadian suffrage is Catherine Cleverdon, *The Woman Suffrage Movement in Canada* (University of Toronto Press, 1974), while America is well served by Christine Lunardini, *From Equal Suffrage to Equal Rights* (New York University Press, 1986). There have been a number of articles which explore these international connections. Deborah Gorham, 'English militancy and the Canadian suffrage movement', *Atlantis* (Autumn 1975); Jane Marcus, 'Transatlantic sisterhood: labour and suffrage links in the letters of Elizabeth Robins and Emmeline Pankhurst', *Signs* (No. 3, 1978) and Sandra Holton, ' "To educate women into rebellion": Elizabeth Cady Stanton and the creation of a transatlantic network of radical suffragists', *The American Historical Review* (Vol. 99, No. 4, 1994).

The literature and the iconography of the suffrage movement are just beginning to be analysed. Lisa Tickner's *The Spectacle of Women* (Chatto and Windus, 1987) set a new trend in examining the suffrage movement. Barbara Green's *Spectacular Confessions* (Macmillan, 1997); Glenda Norquay's selection of primary sources in *Voices and Votes* (Manchester University Press, 1995) and Paula Bartley and Rosie Miles' edited collection *Suffragette City! Cultural Representations of Women's Suffrage* (forthcoming) all provide innovative methodological approaches to history and equip us with a new way of looking at the suffrage past.

The political contexts of Emmeline Pankhurst's wider activities are best explained by the following. A.J. Davies, *To Build a New Jerusalem: The Labour Movement from the 1880s to the 1990s* (Michael Joseph, 1992) and Patricia Hollis, *Ladies Elect: Women in English Local Government, 1865–1914* (Clarendon Press, 1987) both provide a useful background for her early life. Martin Pugh, *The Making of Modern British Politics, 1867–1939* (Oxford University Press, 1982) supplies a political framework for this period. Emmeline's work in the First World War is highlighted by Jacqueline De Vries, 'Gendering Patriotism: Emmeline and Christabel Pankhurst and World War One', in Sybil Oldfield (ed.) *This Working-Day World* (Taylor & Francis, 1994) and is nicely contextualised by Deborah

Thom, *Nice Girls and Rude Girls: Women Workers in World War 1* (I.B. Tauris, 2000). Jay Cassel, *The Secret Plague* (University of Toronto Press, 1987) is useful for Emmeline's post-war Canadian work and, although Emmeline Pankhurst is not mentioned in Philip Williamson, *Stanley Baldwin* (Cambridge University Press, 2000), this book nonetheless helps explain her shift to Conservatism.

INDEX

The abbreviation EP is used for Emmeline Pankhurst and RP for Richard Pankhurst